Collectingphotography

GERRY BADGER

Collectingphotography

MITCHELL BEAZLEY

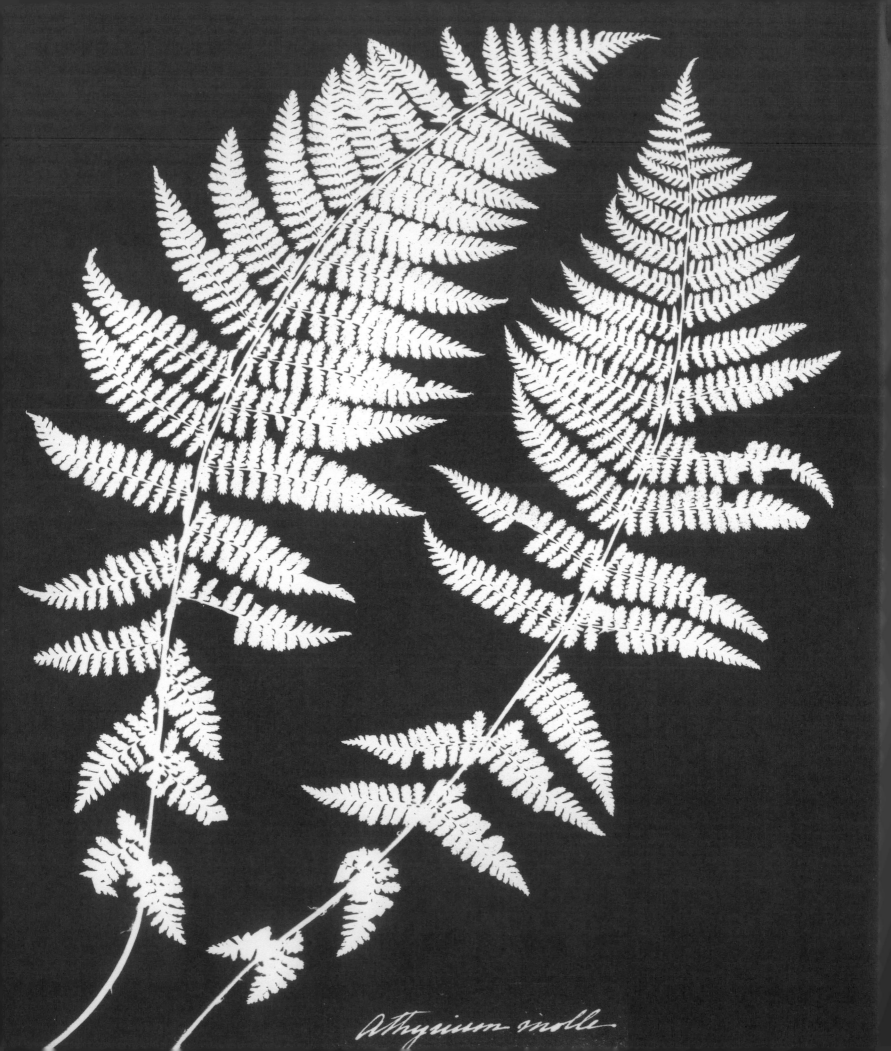

Athyrium molle

Introduction

We are all collectors of photography in one form or another, from the adolescents who line their bedrooms with posters of their favourite singers, movie stars or sports heroes, to proud parents who make snapshot albums of every significant moment in their children's lives. Photography is everywhere; we cannot escape it. If any medium could be said to dominate our cultural life – over the written word even – it is the photograph in its various forms. We are captivated by photography, this surrogate reality that has the power to conjure up times past, or transport us instantly to the furthest ends of this planet, and even beyond it

No matter how technically inept, how lacking in considered artistic qualities, a photograph must always stop us short. It puts us into immediate touch with the long ago and far away, with the quick and the dead. Photography makes known the unknowable. We may make the acquaintance of the masked young woman whom Yva Richard persuaded to pose so gracefully and yet alluringly in the 1920s. Such an image almost compels us to ask, what became of her? The same might be said of Rineke Dijkstra's gawky Polish adolescent, photographed in 1992 – not so long ago, yet now history.

We might marvel at the combination of skill and vision (and deserved luck) that enabled Henri Cartier-Bresson to encapsulate the joys of a simple French picnic in 1935 more precisely than the most adroit painter. Or the same qualities utilized by Gregory Crewdson in making his contemporary visions of bizarre happenings in the American suburban jungle.

The photograph, in still and movie form, has become arguably the greatest influence upon our contemporary myths, manners, and morals. From the very beginning, the medium was widely discussed, argued about, hailed as one of the great achievements of the 19th century, an offspring of both art and science.

Photography is indisputably a mass medium with an almost unrivalled reach and potency. Today, it is being increasingly appreciated as a major art form – perhaps the major art form of the 20th century and beyond. Nevertheless, in the art world, its position has generally been one of ambivalence. While recognized as an inestimable system for gathering visual evidence, there was a reluctance to acknowledge that photographs had the potential to equal the finest paintings.

The traditional objection came from those who regarded the craft element of art as being of crucial importance. Photography could not possibly be an art because it was mechanical. Anyone could do it. Photographers did not need the manual dexterity required of painters or sculptors. They merely pressed a button and the machine did the rest.

For many years after its invention, the medium was lauded by some, but derided by many others. Some photographers declared themselves artists, others categorically rejected the mantle of art. The debate "is photography an art?" ran and ran. Yet millions of photographs – good, bad, and indifferent – were being made, and the medium could not be ignored. Even when photography's artistic status was somewhat dubious, whenever a gallery

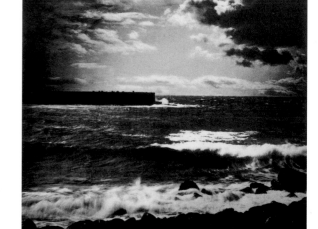

SONDRA GILMAN
GONZALEZ-FALLA
Collector, New York

" I had begun collecting painting and sculpture, and knew nothing about photography except family snapshots. But while I was on the Junior Council at MoMA, a Eugène Atget show was held at the museum and I had an absolute epiphany. I ran into John Szarkowski's office and asked him to teach me about photography. I went through all the Museum's Atget prints and John told me they were de-accessioning some duplicates, because MoMA had just acquired the Abbot-Levy collection; so I picked up three prints at $250 each. My family's response to this was, 'You spent $750 on three photographs? You're insane!'

We didn't realize there was any shape to the collection until we saw a lot of pictures together. And I think there were two unconscious threads running through it. Most of the images have a poetic quality, as well as being slightly on the edge, slightly unsettling. But these aspects came about in an absolutely unconscious way.

We mostly collect vintage prints, because we want each photograph to be a particular product of a time, a place, and the artist's soul at the point he or she made the picture.

My advice to anyone collecting photography would be: 'Look. Look. Look'. You must look before you can see. And then you'll suddenly recognize quality. All the reading in the world won't do it; you have to keep looking. "

or museum hung a photographic exhibition, it invariably attracted large audiences.

The pressure of lone advocates like the great American photographer and gallery owner, Alfred Stieglitz, or George Bernard Shaw, who was a fine photo critic, eventually paid off. It was gradually realized that some photographers, whether they called themselves artists or not, had been producing work of great formal beauty since the medium's inception. Alfred Barr, the first director of the Museum of Modern Art (MoMA) in New York, who believed that modern media like film-making, industrial design, and photography were as valid as painting, established a department of photography at the museum in 1941, and this was quickly followed by the International Museum

of Photography at George Eastman House in Rochester, New York, a year or so later.

Nevertheless, the collecting of photographs and its aesthetic appreciation was the province of a very small minority. Some institutions followed MoMA's lead, but most museums did not begin to collect photography seriously – as works of art rather than as illustrations – until the 1970s. During that period also, universities started to offer photography courses as an academic rather than a vocational option. Historians, curators, and critics began to establish an art history of photog-raphy, and galleries – somewhat tentatively at first – exhibited the work of photographers and offered photographic prints for sale. Crucially, the major auction houses established regular sales and

strengthened the market for collecting photo-
graphs. Photography was finally recognized
as an important art form, which in turn led to
more photographers making photographs for
themselves, for the sole purpose of self-expression
and gallery exhibition rather than for magazines
or commercial clients.

The 1970s also saw the beginnings of the
controversial art movement, conceptual art,
which with its emphasis on concept rather than
craft, its interest in popular art forms, and its
increasing awareness of the camera's cultural

importance, has led to many artists making
photographs. This has resulted in a rapid increase
of photographic work in contemporary art
galleries, and a plethora of young artists today
who utilize the camera rather than the brush,
producing and selling their products in the same
way as paintings. Therefore for the potential
collector of photography today, its status as an
art form, and the strength of the market in both
contemporary and historic photographs, is well
established and secure. Or at least as secure as
any art market can be. The prices paid today for

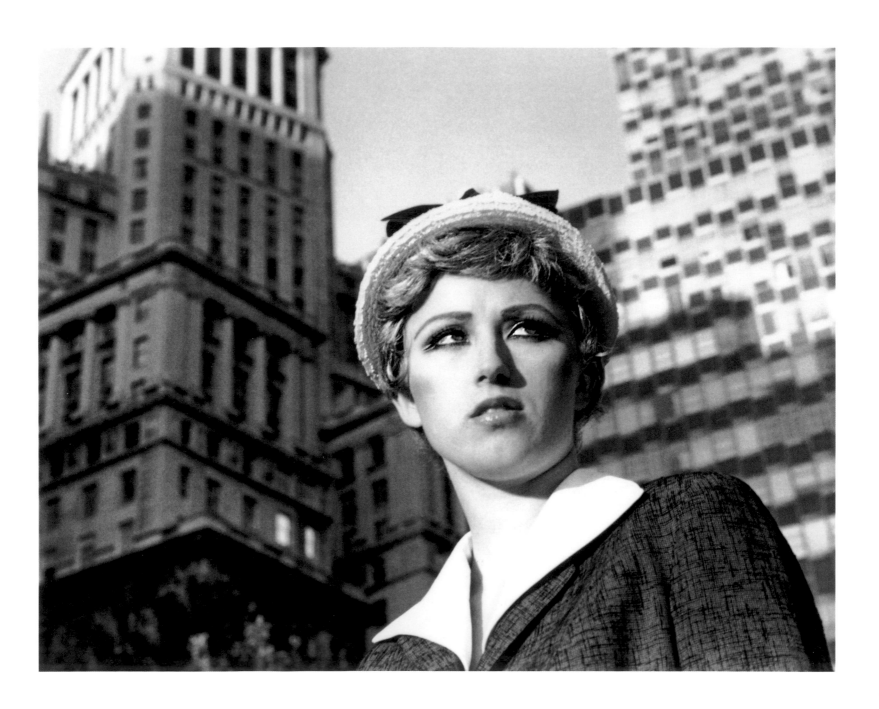

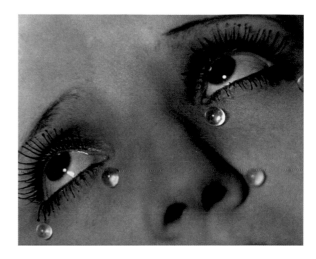

the finest works would have seemed incredible even in 1985. The best 19th century, early 20th century, and some contemporary works, now sell for hundreds of thousands of dollars, the highest auction price being made by Gustave Le Gray's *La Grande Vague, Sète* (1856–9) which was sold for £507,500 (approximately $800,000) at Sotheby's London auction rooms in October 1999.

The era of the million dollar photograph is almost with us. In the not too distant future, a photograph will undoubtedly sell for over $1 million in auction. Indeed, several dealers already have images for sale at that price, and it is a generally known fact that, in 1999, the Pace/MacGill Gallery in New York sold a print of Man Ray's iconic modernist image, *Glass Tears* (*c.*1930), to the collector John Pritzker, for over $1 million.

Perhaps even more astonishing is the recent rise in prices for contemporary photography, much of it for colour photographs whose longevity against fading still remains distinctly unproven. A print by the contemporary German photographer, Andreas Gursky – *Montparnasse* – fetched an unprecedented $600,000 at a Christie's New York contemporary art auction in November 2001. This continued the trend begun as far back as December 1995, when all 69 prints in Cindy Sherman's *Untitled Film Stills* series were sold to the Museum of Modern Art for a sum rumoured to breach the fabled million dollar mark.

Where does that leave someone with a modest disposable income who might be thinking of collecting photography? In the 1970s and 80s photography became a refuge for some collectors because 20th-century painting, drawing, and sculpture had become so expensive; but given such prices this hardly seems feasible now. However, more than any other area of the visual arts, photography still offers the opportunity to collect well without necessarily investing

enormous sums of money. Stunning, important topographical images from the 19th century, produced in large numbers, or unique, anonymous daguerreotypes – images that might compare with any in the medium's history – can be obtained for under $500 or $600. And even rare significant images by major 19th-century photographers can be found in good if not spectacular condition for between $2,500 and $5,000, as can certain images by major 20th-century photographers. That compares favourably with, say, Picasso or Goya etchings, which are far less rare than fine photographs, or 18th- and 19th-century watercolours by named, but second-rank painters.

A collector doesn't necessarily need to purchase photography as works of art in the traditional sense, that is to say with particular regard to artists' names. Photographs do not only have significance as works of art, they can also be fascinating cultural artefacts or historical documents. And they can fulfil that function while retaining their aura as well-made images or fine prints. A nicely composed image in the form of a well-preserved albumen print by an anonymous 19th-century photographer, can exhibit a beauty and intensity of feeling that might surprise those who think of 19th-century photographs as faded, yellowing, rather pitiable objects. Such a print,

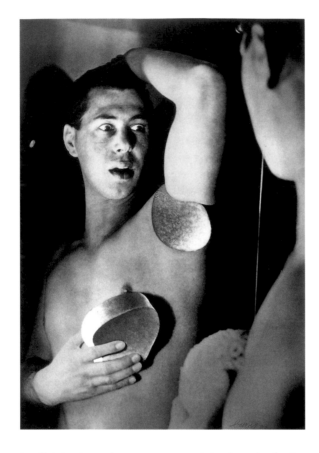

to all intents and purposes an original work of art, need not cost the earth, even today. Indeed, it may not cost as much as a mass produced "art" poster, and intrinsically be worth far more.

Therefore right now, as any dealer will admit, is a good time to begin collecting photographs. To be sure, the earlier one began collecting photography in the last 40 years the better, but as any dealer will also say, it's never too late to start.

There are almost as many reasons to collect photographs as there are potential collectors, but for the majority of serious collectors, the fascinations of the medium are basically twofold. First, despite its detractors, photography is a medium with an artistic history, and perhaps more significantly, a medium with an artistic future that promises to be as fascinating as that of painting. Indeed, for much of its history,

the aesthetic side of photography has been inextricably linked with painting, and nowadays the two are almost indistinguishable in the eyes of contemporary art historians. Some critics have even gone so far as to term photography "the new painting", signifying that the medium has now taken over most of the functions once ascribed to painting alone. When art historians, 50 or a hundred years from now, take a distanced, dispassionate view of who the most influential artists around the turn of the millennium were, much of that list will be populated by photographers.

Secondly, and for some collectors more importantly, photography "takes you there" – it is the documentary medium par excellence. In the art of the very best photographers, such as Eugène Atget, both the aesthetic and the documentary are brilliantly combined to make a compelling body of work. In the 40 years or so of his working life, Atget made a valuable document of Paris around the beginning of the 20th century. But it was more than a visual record; it was also an imaginative chronicling of Paris, filtered through his particular visual sensibility – a document of his existence, his peculiar sight impressions. Not least, Atget's imagery provides us with an aesthetic experience; it's an almost encyclopaedic lesson in how to put a photograph together.

Although photography might be a realist medium, many photographers have used reality merely as a platform for the imagination. With computers, making fantastic photographs today is child's play, but practitioners have been working in a similar manner since the medium's inception – combining images, cutting and pasting, drawing on photographs, creating imaginary tableaux. Herbert Bayer's *Self-Portrait with Mirror* is a great work of the artistic imagination. It's not real, yet relies upon the fact that photography persuades us, if only for a moment, that it is. Likewise,

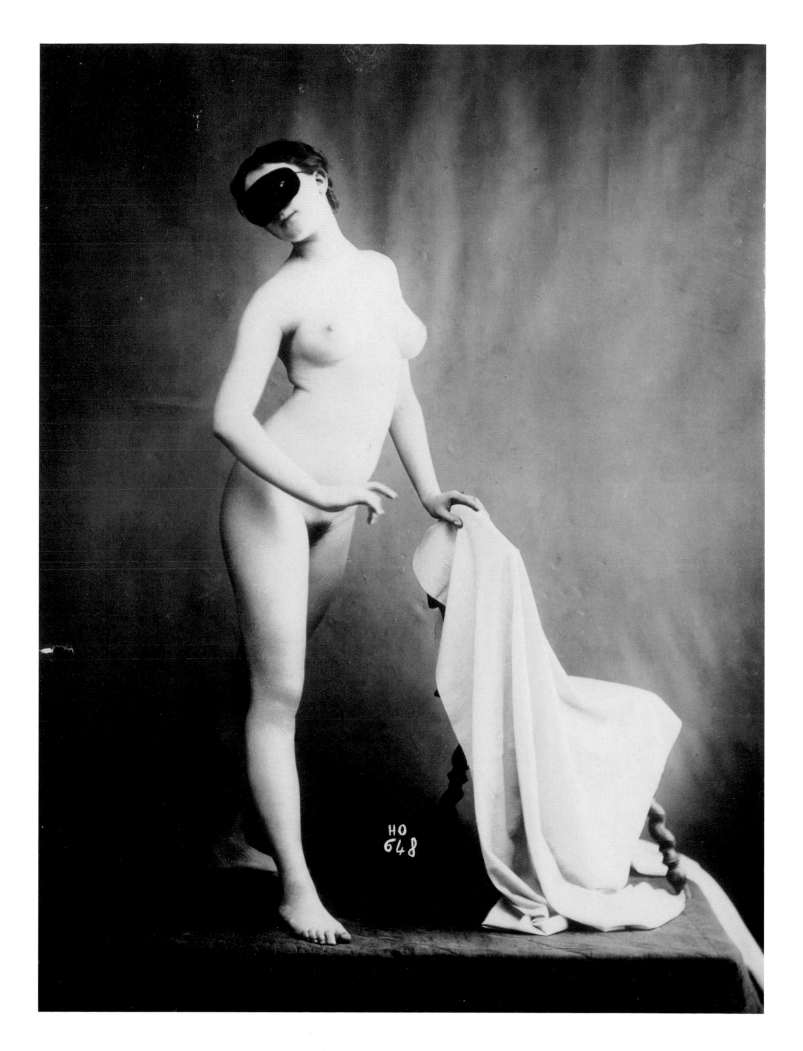

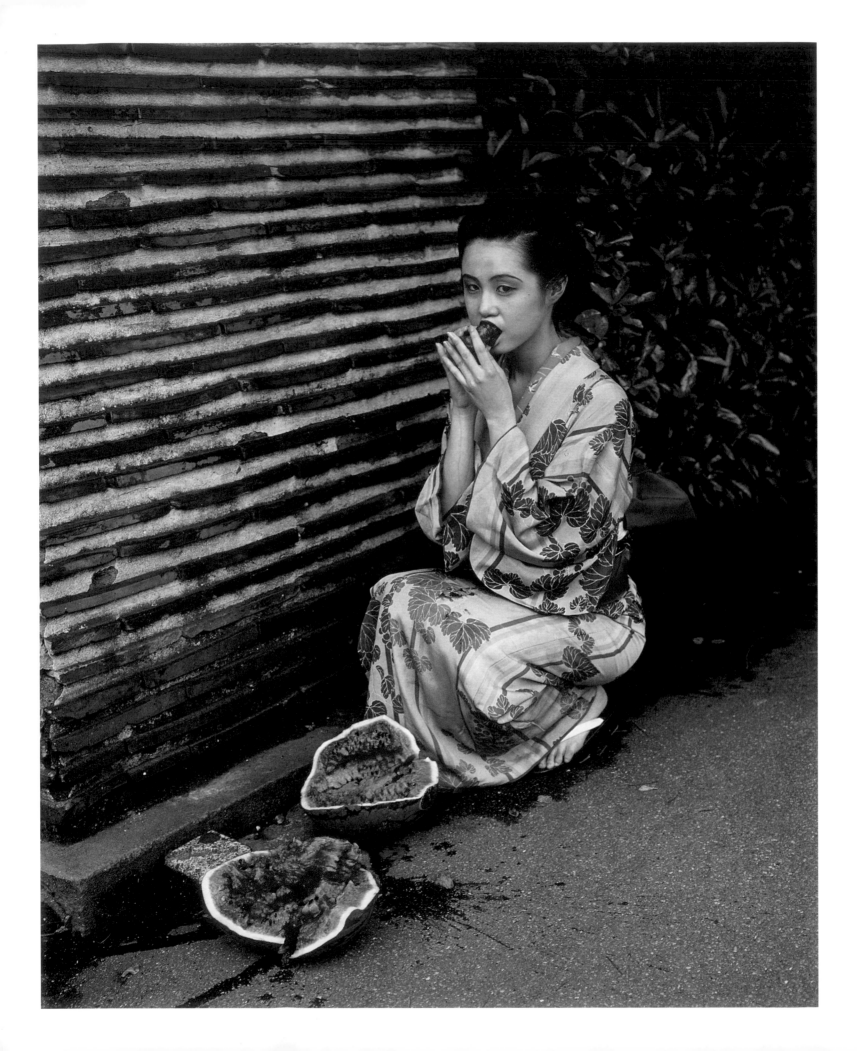

HOWARD GREENBERG
Gallerist, Howard Greenberg Gallery,
New York

" Back in the 1970s there were few collectors and you could buy major photographs for $500 or $600. Now the market is large, and the most desirable photographs – the great masterpieces – are few. I would say the market has reached a point where its annual turnover is more than a hundred million dollars. There isn't just a score of serious collectors out there, but there are thousands of people who buy photography at some level.

In contemporary art photography there's an entirely new market that has grown, particularly in the last ten years, and which functions almost separately from the traditional market for fine photography. The photography is mostly conceptual, exhibited in contemporary art galleries and often large and in colour. Contemporary artists have used photography more than any other medium in the last twenty or so years. It's exhibited and sold in galleries where traditionally, photography was never sold before.

We had a strong and growing market for the entire scope of photography for several years. From the mid 1990s to the present it has broadened and deepened in ways we could not imagine even fifteen years ago. Prices for classic masterpieces as well as highly regarded contemporary works have soared into the six figure range. The million dollar mark has even been passed. And in today's more uncertain economy, interest and prices are holding

One can find quality at any price. But there are different kinds of quality. There's print quality, but there's also photographer quality, and dealer quality. The collector should search out the quality in each area: the best print, the best artist, the best dealer. For example, if you go to a neighbourhood photo fair, search out who is best locally, whose prints maybe cost only $200. Then trust your eye and if it's great, buy it. "

Joel-Peter Witkin's macabre fantasies are brought to life, so to speak, by the fact many of his images involve photographing actual corpses before altering the imagery with various hand-worked processes. Photographic art can vary all the way from the most fantastic, unreal imagery to near abstraction through to plainsong documentary. The collector, depending on his or her interests, can collect the real or the unreal, by subject or by artist, or every combination in between. There is an almost unlimited variety of interest, ranging from the daguerreotypes and calotypes of the 1840s and 50s to the large glossy colour photographs of Cindy Sherman and Andreas Gursky; from exquisitely crafted exhibition prints to creased, coffee-stained "press" prints made for

MANUEL ALVAREZ BRAVO
En El Templo del Tigre Rojo 1949
Silver gelatin print
Courtesy Colette Bravo
Alvarez Bravo is Mexico's greatest
photographer and remains one of the
most reasonably priced first-generation
modernists.

newspaper reproduction. You can concentrate on certain photographers, a particular genre of photography, singular techniques, or particular subjects. Fine photographs are available, no matter what your financial resources. "Quality can be found at all price levels," says the leading New York dealer, Howard Greenberg. And quality varies all the way from the fascination of anonymous snapshots and family portraits that can be picked up for a few dollars at flea markets, to genres like war, news, sports, or fashion photography, through to the established masters and masterpieces.

Photography is very much a fashionable medium, but that does not mean its popularity will be short-lived. As the late French collector, Roger Thérond, remarked in 1998: "Photography is perhaps one of the richest arts. It's a new frontier to

be discovered, and tamed." Collecting photography therefore is more of an adventure than collecting the more traditional visual arts. Many of today's most exciting, young, avant-garde artists are making camera-based images. The collector of contemporary photography has the chance to buy in on the ground floor of an artistic career that may eventually hit the heights. John Bennette, for example, is a New York collector of contemporary photographs whose limit is around $1,000 for a work. Yet by assiduous looking and reading, and astute buying, he has built a notable collection of contemporary photo artists who have progressed to become established names in the gallery world. His collection is worth much more than he paid for it, but his aim in putting it together was not financial gain. It was because he is interested in photography and photographers and gets great joy, not just from spotting a winner, but from living with such superb prints.

Photography's canon – its monument of achievement, its hierarchy of greats and not-so-greats – is not as fixed as that of painting or sculpture. The broad acceptance of photography is only three or four decades old after all. Figures of major importance have been discovered in that period, significant bodies of work have come to light, and new areas of photographic practice have received the attention of collectors. Michael Wilson, one of photography's pre-eminent private collectors of historical photography, echoes Roger Thérond's sentiments: "Even today, there are plenty of areas of photography still to be examined." For example, anonymous, or vernacular photography as it's known, has become a hot collecting area recently, and collectors who may pay thousands of dollars f or an image one week, are just as happy to find one for a few dollars the next, and will cherish it equally, perhaps even more so. It's a vast area, as broad as photography itself, and appeals to

those collectors who enjoy the chase and who appreciate the images themselves rather than their potential investment value.

The work of many known photographers is also under continual reassessment, and their status and value in the marketplace adjusted accordingly. Some photographers who fetched high prices at the beginning of the current photographic boom have dropped back, while others – certain calotypists and early modernists for instance – have been upwardly mobile in market terms. The market for fine photographs is a somewhat unpredictable one. It is perhaps not as volatile as the early 1990s, but there are still discoveries to be made, which creates a certain amount of excitement. And of course, where there's excitement there's risk. The photography market is not nearly so "played out" as that for paintings and drawings, where the major pieces are mostly all in museums, with paintings of the first rank appearing in auction only on occasion. Nevertheless, the supply of the great 19th-century photographic works – the finest images by the major photographers in the best condition – is inevitably a dwindling resource. The same applies to classic works of the modernist period between the two World Wars of the 20th century, when photographers tended to make a few prime prints for exhibition, and each print was individually interpreted.

The relative rarity of the major photographic prints is perhaps one reason why the market has broadened considerably. At the same time, photography collectors themselves have become increasingly sophisticated, and where once they might have plumped for the big established names, are now much more willing to trust their eyes and go for the startling image, no matter the author. As they know, the muse can strike anyone, and that's one of the exciting things about photography. A second-rate painter is unlikely to produce a first-rate work, but anyone with a camera in their hands can get lucky and take an amazing photograph. That fact does not denigrate the medium, as some may think, or negate the talents of those photographers who have laboured long and hard to produce great bodies of work. It simply means that individual works taken by "anonymous" or "photographer unknown" can sit proudly in a collection among the greats – handing out their own valuable lessons to more self-conscious practitioners and giving much pleasure to collectors.

The first question, besides "is it art?", asked by anyone unfamiliar with the world of photographic collecting is, "why pay a great deal of money for a print when any number can be made from the negative?" While this is a fair point, it should be noted that, as the success of the market proves, such fears are largely groundless. The unlimited making of prints from one negative is a theoretical possibility but not logistically feasible in practice, and photographic prints actually tend to exist

JOEL-PETER WITKIN
Interrupted Reading 1999
Silver gelatin print
Courtesy Ricco/Maresca Gallery, New York
Witkin's work is controversial, but his magnificent toned and hand-worked prints, which are unique, make him a leading, and one of the most collectable, makers of photographic tableaux.

in smaller numbers than in the limited editions of traditional prints. However, the very fact that uncertainty exists – were two or 200 prints made of a certain image? – has led dealers to place much greater emphasis on a print's provenance, that is, its origins and ownership history. In the market for contemporary work, as we'll see later, there is a definite trend towards producing strictly limited runs of an image and then "retiring" the negative.

Museums and the private collectors involved at the top of the market tend to concentrate on buying vintage prints – prints made close to the time of the making of the negative. For those who cannot afford a $200,000 Le Gray, however, there are many other kinds of photographs available, and by major names too, within the means of almost anyone. Some collectors may have a photographic collection of just one image, but it's a favourite Cartier-Bresson or something of that order. Not cheap, and probably involving the sacrifice of a vacation or two, but well worth it, and surely far better than having a few overpriced posters on the wall.

The above kind of collector, rather than the "major players", is the person for whom this book is written. *Collecting Photography* is intended to encourage the many potential collectors who are

thinking of starting a collection or who have already dipped a tentative toe in the water. The photographic market has a broader base than many people realize, and it is this base, available to those with modest means, which we propose to encourage.

This volume should be considered an introductory course in the art of collecting photography. We'll use the term art, as collecting involves the heart as much as the brain and is certainly no science. However, the book is only an introduction to this fascinating world, a primer for further study and learning, for the best collectors are always learning something new about the medium.

We will begin with a brief consideration of the art of photography. Then we'll discuss the essentials – what to collect, where and how to collect it, and (as far as is practicable in a fast-moving market) how much to pay for it. We will also provide basic information on how to care for and display those precious prints once they have been purchased, as well as a glossary of the many technical terms used in photography and by dealers. And we have illustrated the text with images chosen from different periods, mainly but not all by photographers well known to collectors, at vastly different prices, but all exhibiting the quality of photographic excellence.

At all times we will try to examine the issues involved in photography collecting, and point out the pitfalls. In fact, there are no more pitfalls involved than in any other area of the art market – any area where value is perceived rather than actually measured is risky – but there are quite a number of things that worry potential collectors, and with a little knowledge these worries can be eliminated.

The terrible events of 11 September 2001 have promoted a great deal of uncertainty in the world, which will undoubtedly take some time to

SUSAN LIPPER
Untitled 1991
Silver gelatin (Polaroid) print
Courtesy the artist
Lipper is a contemporary American artist whose work slides between the apparently documentary and the intensely personal.

ANDREAS GURSKY
Montparnasse 1994
Type C colour print
Courtesy Matthew Marks Gallery, New York
The contemporary market leader. Gursky
has continued to set auction records and
has been the first great market success of
the 21st century.

dissipate. At the time of writing, it seems that much of the world is holding its breath and crossing its fingers, but as the $600,000 Gursky and other auction results indicate, the current collector fascination with photography seems as strong as ever. Photography, as the Atlanta dealer Jane Jackson said recently, "has become such a hot market that, in another ten years, the prices people are paying now are going to seem pretty low".

The issues surrounding both the art of photography and the collecting of photographs are complex, often contradictory at times, but that is just part of the medium's fascination. So, while exercising all due caution, get in there. Photography is not just a major art form of the 19th, 20th, and 21st centuries, it is also an eternally fascinating cultural time capsule, a repository for our collective memories. Over the last three decades a solid foundation for the collecting of photographs has been established not only by the museums and private collectors, but by the increasing interest in the medium on the part of scholars, both as an art form and as a communication medium of vital importance – a primary system for garnering knowledge. In other words, to collect photography is not just to collect an art form. As Pierre Apraxine, curator of the renowned Gilman Photographic Collection in New York, rightly says, "to collect photography is to collect the world".

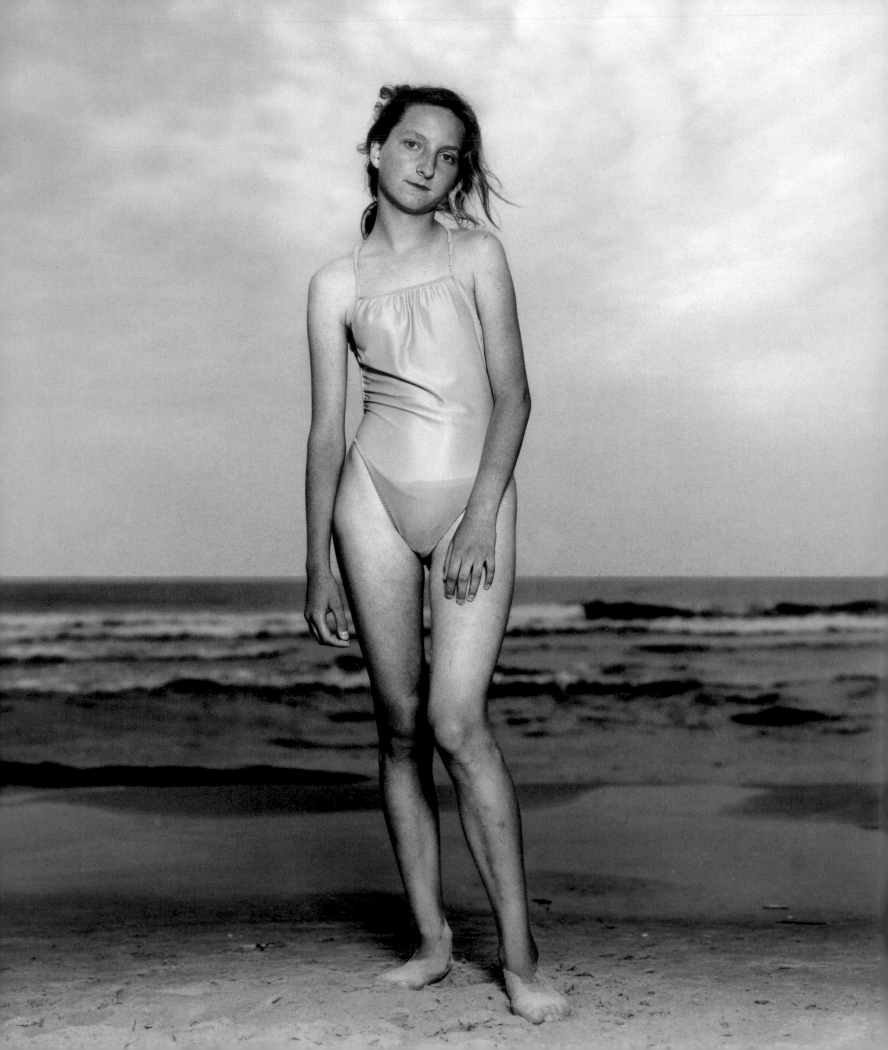

The Art of Photography

Let us assume that the majority of potential collectors have at least some interest in the topic of photography as an art form. For despite photography's many functional, frequently mundane, yet vitally important social manifestations, collecting photography is not like collecting bus tickets, playbills, theatre programmes, stamps, or other kinds of fascinating historical ephemera that attract collectors. Some photographic collectables do have more of a relationship with this kind of social history than with high art – but with one crucial difference. Even if photo collectors are concerned primarily with the subject matter of an image, most will still exercise some aesthetic judgment in adding it to their collection. The idea of what constitutes a good photograph will factor somewhere in their mind. If a particular collector is interested, say, in photographs of horses, he or she will still have a preference for the good rather than the mundane horse pictures – a preference that will be determined by the quality of the picture as opposed to the quality of the horse. After all, no matter the reason why the photographer took the picture, most practitioners would be trying to make it a good rather than a bad picture.

When dealing with visual images, you cannot escape aesthetics. As soon as you raise a camera to your eye, you begin composing, determining the edges of the frame, the shapes within it, and the lighting, then deciding when to click the shutter. Intuitive or not, unconscious or not, these are aesthetic decisions. And as soon as you start to collect photographs, you make such decisions: which item to acquire, the balance of the collection as a whole, how to store and display it, and so on. Indeed, the formation of a coherent, interesting collection – a collection with a meaning beyond the purely personal or the mere material fact of its existence – can be said to be a creative act in its own right.

As we stated in the Introduction, photography has always had an equivocal, paradoxical, tangled relationship with art, and certain anomalies remain – the stubborn residue of the subliminal feeling that photography is not quite a fully fledged art. Despite the strides made in the last 40 years, there seems to be an unspoken class distinction between photographs made by photographers and photographs made by artists, which are not usually called photographs but "pieces" or "works". And however unspoken, this distinction has its material effects.

Two largely separate markets developed during the 1990s. Major contemporary photographic artists, such as Robert Adams or Lee Friedlander, because they are perceived as "photographers", emanating from the photographic tradition, do not command the prices of figures such as Thomas Struth or Cindy Sherman who, a mere generation or half-a-generation later, are perceived as artists, coming from the contemporary art tradition. Thus a considered value judgment – and price differential – remains between photographs and such photographic "works", although this is diminishing greatly, and it seems certain that

W. M. HUNT
Collector and Gallerist, Ricco/Maresca
Gallery, New York

" Photography is unlike any other contemporary art form. Everyone in the 21st century, at least in the Western world, has the experience of having looked at millions of photographs. We see them all the time, and we know what a good photograph is. We are all experts.

The way to collect is to buy a photograph and take it home. Look, react, and commit.

If you're burdened with worries about the photograph's provenance, the photograph's "greatness", the photograph's price, etc., you may be missing the point. Pursue the experience that's pleasurable. When you see an image that thrills you, you must have that piece in your life. Buy it, take it home, hang it on the wall, and live with it.

I've come to understand my collection as a manifestation of my unconscious. Buying photographs has led me on an amazingly personal journey and, curiously enough, it has been a tool for gaining an even stronger sense of myself. It is a completely symbiotic relationship: as I have grown, so has the collection, and vice versa. **"**

the distinctions will eventually disappear and the two markets merge into one.

Some photographers have sought to "legitimize" photography in fine art terms. The traditional objection to photography – that it was merely mechanical – led certain photographers to add a craft element to their work, by utilizing complex methods of printing, or making prints that necessitated a certain degree of manual manipulation. Others sought to imitate painting by concocting elaborate tableaux based on traditional fine art iconography, producing their photographs in a studio, like film-makers directing a movie. Others drew or painted on their negatives and prints, or presented their work in elaborate mounts and frames, and organized salon exhibitions along the lines of their painterly colleagues.

The mechanical objection has been removed by contemporary art theory that argues that art is not so much a case of exploiting the physical link between hand and eye, but more a matter of conceiving an image in the brain and finding some way of expressing it, no matter how. Nevertheless, the various strategies outlined above, used to serve the cause of artistic legitimacy, remain part and parcel of the medium today. They are still symptomatic to a certain extent of the slight inferiority complex some photographers feel towards painting, a feeling which is compounded by those who believe that only photography by so-called "artists" has any creative legitimacy.

However, many photographers have condemned this, and regard mixed media techniques and overt artistic pretensions as producing neither good painting nor good photography. For photographic purists, the

JOHN BEASLEY GREENE
*Temple du Dandour c.*1854
Salt print (Blanquart-Evrard process) from a
waxed paper negative
Private collection
Greene's spare, individual style makes him
highly sought after by collectors of early
photographs of the Middle East.

medium is simply about seeing – the "flame of recognition", as Edward Weston put it – where a coherent image is plucked from the visual chaos before the photographer in a five-hundredth of a second or even less, and fixed for all time. The skill of the photographer is akin to that of a hunter, stalking his quarry and seizing the moment to catch it, to "shoot" the picture. Henri Cartier-Bresson famously termed it the "decisive moment", by which he meant not the moment of peak action – though it often coincided with it if the subject matter was moving and fluid – but the moment at which every element in the picture came together to make the visual balance required of a memorable, formally coherent image. Everyone who picks up a camera – from the casual snapshooter to the seasoned, serious professional – involves themselves in the art of photography at this basic level.

Whatever approach a photographer chooses to take, we need a definition of photographic art that focuses not so much upon the means, or even the intentions, but upon the result. Photography itself is no more nor less an art than painting. It is merely a method, a technique, a means of making an image – as is painting. Painting by

itself is not an art. Some painters produce art; many do not. Some painters deserve to be declared artists; many do not. "Artist" is not a job description, to be written in the occupation box of one's passport – despite the fact that many now seem to use the term in this meaningless way. It is rather, or should be, a term of approbation granted by an audience to those whose work is of a subtlety, complexity, and depth to warrant the distinction. It could be argued that some photographers are artists, producing art, while many are not. Indeed, it is not always those who have set out to produce art who necessarily succeed. In photography, honesty of purpose can frequently outweigh pretension.

Art, then, by this definition, is clearly in the eye of the beholder. This would mean that every single individual in the world has their own view of what constitutes art, which in a sense is true. We all know what we like, and which image "speaks" to us more than another. Yet it is also true that what we know and what we like does not lie within us like some immutable truth, nor is it plucked out of thin air. The sum total of our knowledge, our cultural likes and dislikes, are formulated in large part by received opinion. We are told that Rembrandt is the greatest painter of all time, and we can choose either to agree or disagree with that judgment. Nevertheless, we cannot form our own judgment on Rembrandt without taking – willingly or unwillingly, knowingly or unknowingly – the collective judgment of others into account.

The matter of evaluating every aspect of our cultural heritage has become a vast industry with which anyone with the slightest pretension to cultural life comes into daily contact. It consists of a huge army of critics, academics, curators, historians, dealers, and practitioners (not forgetting the actual producers) who

ALVIN LANGDON COBURN
Victoria Embankment 1905
Hand-pulled photogravure
Private collection
Coburn made expensive platinum prints, but
his preferred medium was photogravure, as
in this plate from his book *London* (1909).

interpret art on our behalf, who decide who and what is to be exhibited, written about, and sold to collectors, who evaluate the pecking order in the canon of great artists; who basically decide what's what.

Indeed, this book is part of the process. You have bought it in order to buy into the repository of knowledge represented by the "art knowledge industry". This volume exists, some might say, to "tell you what to think". We would rather propose that it exists to give you a base from which to acquire knowledge; to inform you about what others think about photography, to be sure, but also to enable you to think for yourself about photography and whether it is an art or not (if indeed that is an issue with you) as well as which kinds of photographs you think you might want to buy and collect.

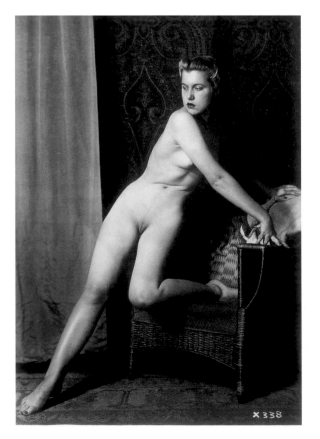

Some postmodern photo theorists have been extremely critical of the whole art industry. They have lambasted the idea of the art museum and the art market, seeing it as some kind of capitalist conspiracy whereby art has become the new religion, that is to say a diversion to keep us in our place – the new "opium of the masses" – and the gallery system just another cunning way to relieve the gullible of their hard-earned cash. Such arguments warrant a much more detailed examination than we have space for in this volume, but let us make just one or two observations. First, all this contrary and nonconformist opinion is itself part of the whole art knowledge industry and art market edifice, which is no monolith carved out with universal truths but a constantly changing sandbank, and moreover one that is too full of contradictions to be a conspiracy. Experts disagree and argue, the status of photography being a case in point. Nevertheless, their expertise stems from hard work and learning. They should be read or listened to with respect, but with all due caution. Though it comes down to a matter of opinion in the end, some opinions are more informed and worth more than others. The general view of scholars – which includes the contrary opinions – cannot be ignored. However, the same rule applies to buying knowledge as applies to acquiring works of art: caveat emptor! Always be open minded yet sceptical. Trust your own judgment after listening to what others have to say.

Nevertheless, knowledge of the medium's history, its philosophical parameters, its most renowned practitioners, and the photographic art market is essential if you are to make a success of collecting photographic images. But with a little work – and hopefully the aid of this book – this knowledge can be attained fairly quickly. It's worth remembering that no one knows everything, and to everything there is a contrary view.

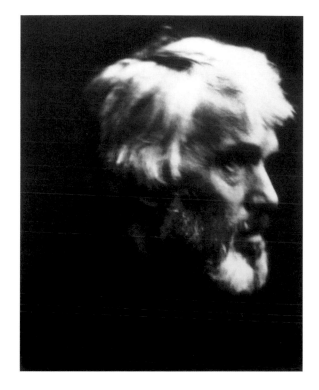

Even experts are frequently surprised, mistaken, and misled. Yet one thing remains clear: the more you look at photographs and think about them, comparing them with others you've seen and liked, or disliked, the more you will be equipped to buy wisely and well.

The Art of the Photographer

As we've intimated, the issues surrounding the concept of photography as an art are complex and convoluted. But let us ask a fundamental question: what is good photography? This is a huge theme with no clear answer, but we can nonetheless locate a few pointers with the help of one of the most enthusiastic of photographic collectors, the late Sam Wagstaff, from part of a previously unpublished interview he gave to us in 1979. Wagstaff had a clear idea of what enchanted him about photography. He had no truck with the then existent canon of great photographers, but was drawn only to images that spoke to him in a particular way: "I'm a collector of extraordinary photography, whether by 'names' or not. I'm interested in the world revealed in a photograph and what lies behind and beyond that world, both in the mind of the photographer and in the unconscious surrealism that is probably photography's most characteristic quality."

Wagstaff begins, rightly, with the world, because by and large the art of photography is the art of the real. The camera transcribes reality, the actual, more accurately than any other visual medium. A Rembrandt self-portrait, for instance, no matter how faithfully observed and transcribed, is an interpretation, an approximation. It is a document only by proxy. Julia Margaret Cameron's portrait of a blurred, seeming impassioned Thomas Carlyle, no matter how brilliantly interpreted, is a document, a trace image of the distinguished writer. Mrs Cameron shows us, even though the image is blurred, how Carlyle looked at a particular moment in the 1860s. No painting, not even by Rembrandt, can achieve this – an actual physical trace of Carlyle, rather than a dazzling amalgam of painted brush strokes, transferred on to a sheet of paper.

This serves to remind us that photography is essentially a documentary medium. As the distinguished American fashion and portrait photographer, Richard Avedon once said: "The limitation and the grandeur of photography is that you are forever linked at the hip to the subject." Although photography presents us with an apparently transparent, unmediated, extremely persuasive view of actuality, this of course is not so. It is a transcription of a particular kind, nominally real but also abstract. A photographic print describes three dimensions on a flat piece of paper. It is still, frozen, whereas the world is constantly on the move. It may be in black and

PIERRE APRAXINE
Curator, Gilman Paper Company
Collection, New York

❝ One of my greatest satisfactions in assembling the Gilman collection was the opportunity it gave me to explore my interest in history, observing the way in which the photograph intersects with and reflects the various cultural, political, social, scientific, etc, preoccupations of its time. For example, to understand the highly personal photographs of the Countess de Castiglione, of which Gilman has quite a collection, I had to become familiar with the political history of the Italian Risorgimento and the French Second Empire. I also had to become attuned to the social rituals of the time, the etiquette of the court, the characters of the personalities involved, the novels people read, the plays and operas they saw, and so on. In a way, I had to live the particular period in which the photographs were created. I experienced some of the thrills of a seasoned biographer.

Collecting is always a creative act. One can collect with imagination, or simply follow whatever has already been done. With the Gilman collection, Howard Gilman and I let our imaginations and curiosity be our guide. If we wanted to create such a collection today, we would not be able to do it in the same way, as many of the pictures are simply not available anymore. It would have to be quite a different collection. I do not know if one could aim, today, to achieve the same encyclopedic character that distinguishes the Gilman collection.

My advice to a new collector would be, first, to look at photographs past and present, but also at other things too – contemporary art, African art, Oriental carpets, neo-classical sculpture, whatever. You must find out why some of these works are more important than others, and what exactly it is that makes them important. That understanding can be applied to photography to great advantage. The second consideration would be to find a good dealer, one who is as responsible to the material as he is to his own well-being. A responsible dealer who knows and loves his material will be able to communicate his passion to his client. You will be acquiring not only the print, but something of the dealer's knowledge too. ❞

GREGORY CREWDSON
Untitled (Penitent Girl) 2001–02
Type C colour print
Courtesy the artist and Luhring
Augustine/White Cube (London)
Crewdson's elaborately choreographed
images have made him a new star in the
photographic art market.

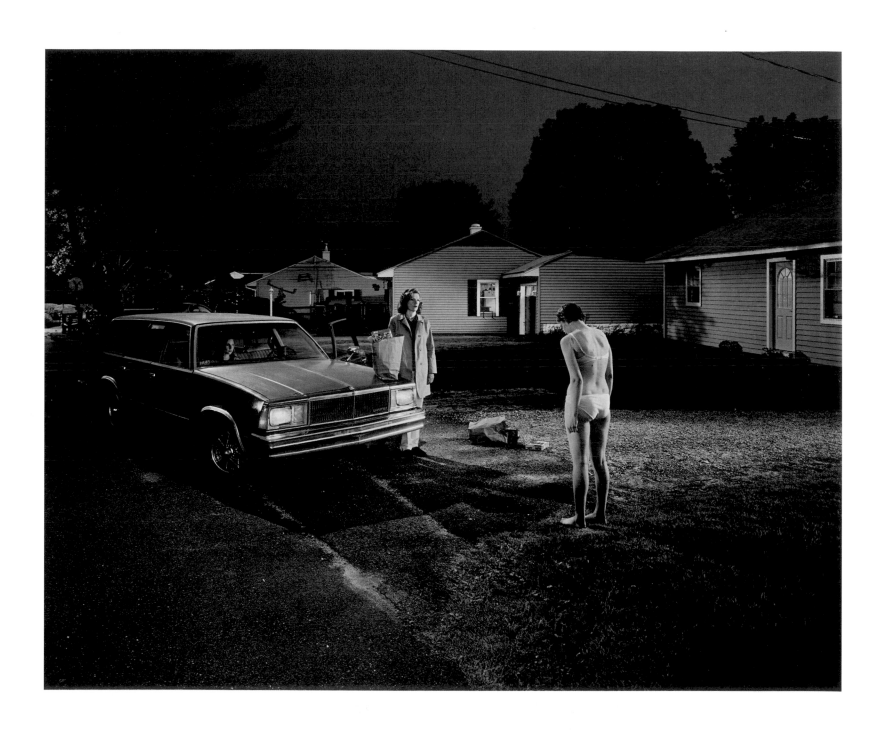

white, whereas we see the world in colour.
The blandest document, therefore, made by
someone with no thought of expressing
themselves through the camera, is nevertheless
an image, a mediation, but an image trying to
pass itself off as a mere transcription.

This is where the photographer enters.
Photographers make a "simple" record of what's
in front of them, trying to make it as direct and
as seamlessly plausible as possible, but in effect
carrying out a tricky juggling act. Much of the
art of photography might be said to reside in the
area where reality becomes an image, but an
image of reality. It is what Wagstaff means when
he talks about what lies "behind and beyond"
the world depicted in the photograph. The
photograph creates its own world – it's never a
pure representation, but nevertheless refers
back constantly to actuality. It is fascinating to
see how many of the best photographs slip
between objectivity and subjectivity, how the
personality of the photographer is hidden one
moment, revealed the next. As Edward Weston
put it, referring to his renowned image *Pepper
No. 30*, his aim was to photograph "a pepper –
but more than a pepper".

In order to reveal the world as it is, yet also
make more of it – at one and the same time –
photographers have controls at their command,
choices to make. Composition, choice of
viewpoint, lighting, are much the same controls
as painters have, though photographers cannot
physically alter things (this has now changed
drastically since the advent of computers,
possibly not for the best in the opinion of many).
Timing – the decision when to press the shutter –
is also crucial, and is one thing that is unique
to photography. We are grateful for any number
of Cartier-Bresson "decisive moments", but
we should also celebrate the fact that, in a
more considered and leisurely fashion, Julia

Margaret Cameron exposed her negative
of Thomas Carlyle when she did, and praise
countless other such decisions throughout
the medium's history.

These choices, of course, are made prior to
exposure. But photography is a two-step process:
the picture is taken, then it is printed. Once the
negative has been exposed and developed, a
print is usually made. Some photographers do
not attend to this step themselves; instead they
give the negative to a laboratory and a nameless
technician to print it, or have it scanned into a
computer and printed out by machine. But other
photographers can be said to be printmakers in
the best sense, and will only trust themselves to
interpret their negatives. In the darkroom, choice
of printing papers, printing, and toning techniques
all contribute to the final result, and a photograph
can sometimes end up at a place seemingly far
away from its beginning as a simple, apparently
mechanical transcription of what was before the
camera lens.

The best photographs, then, are made as
much with the photographer's eyes and brain,
sometimes hands, as well as with cameras and
lenses. Photography is a primarily cerebral art,
an art of selection. If the painter starts with a
blank canvas, or the conceptualist with an idea,
the photographer begins with a full canvas – the

SHOMEI TOMATSU
Melted Beer Bottle After the Atomic
Explosion, 1945 Nagasaki 1961
Silver gelatin print
Courtesy the artist
Tomatsu's reputation as one of the greatest
Japanese photographers has meant a
recent rise in his print prices as his work
becomes better known to Western
collectors.

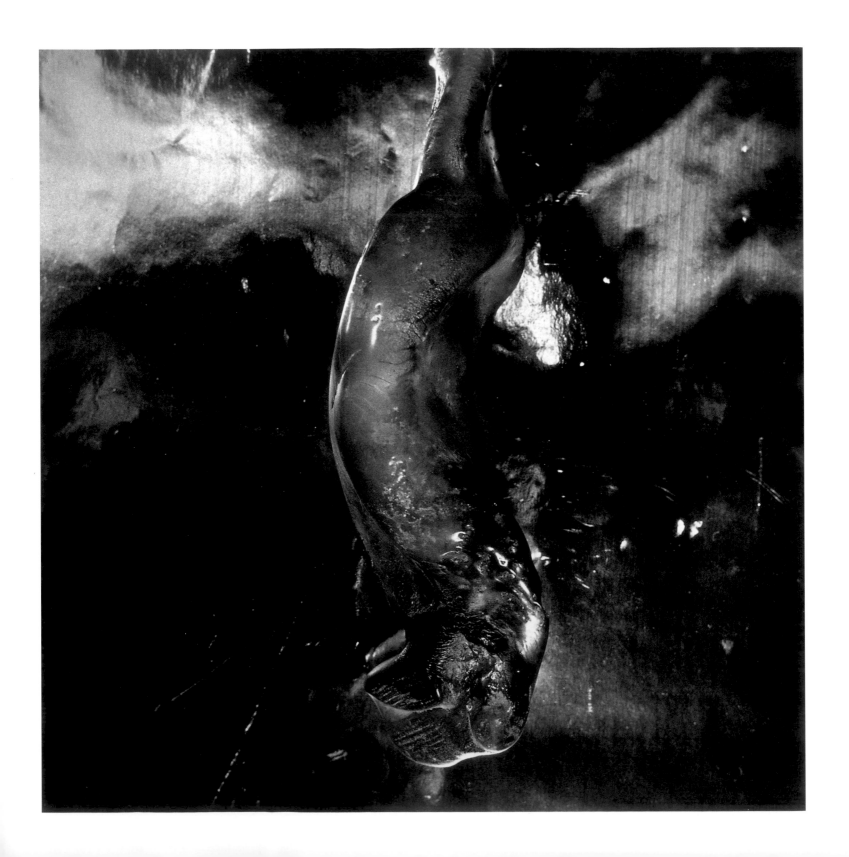

world – and extrapolates from it. It is no less an art, indeed in many ways it is arguably far harder, because everything has already been photographed.

In looking for the best in photography, for a photograph we might want to add to our collection, we are looking, as in any visual art, for an image which resonates, which speaks to us, which tells an old tale in a new way. It may be a perfect composition, a superb placing of objects within the frame. It might be a perfect "decisive moment", where a complex scene is brought into spatial and temporal harmony, or a figure caught with a telling gesture. It might just be the way the light impinges on the scene. It might be a technically stunning and expressively made print. It might be a subtly different view of familiar and well-loved subject matter. It might be a combination of all these things. You will know the image that speaks particularly to you when you see it. As the collector Werner Bokelberg states: "The quality that links the photographs I've collected is originality. I wanted to find the particular image by the particular photographer who saw something in a certain way for the first time."

Indeed, as we've noted, anyone in the right place at the right time can take a memorable and striking photograph, one to rank with other celebrated works in the medium. In certain minds this demeans photography, because it seems to suggest that it's all a matter of luck. Someone once pointed this out to Edward Steichen when he was curator of photographs at the Museum of Modern Art in New York. "Ah yes," he replied, "and isn't it amazing how often the great photographers get lucky."

While it is possible to make a significant collection of photographs by just one author who "got lucky" – an "anonymous" or "photographer unknown" – this does not, and has not negated the work of the great photographers. The English photographer Martin Parr collects old postcards – the duller and more prosaic the better – which he has published in a series of books entitled *Boring Postcards*. The collection of the Chicago lawyer Arnold Crane, built up in the 1960s and 70s, contained splendid examples of the work of many of the most significant 19th- and 20th-century figures, but was also known for many images by anonymous photographers that Crane, exactly like Sam Wagstaff, cherished as much as his undisputed pieces by master photographers. In 2000, the New York collector Thomas Walther held an extremely successful exhibition of the anonymous photographs in his highly regarded collection, published as *Other Pictures*. This "collection within a collection" of vernacular photography included everything from portraits of animals to crime photographs. As Walther states: "I've never looked for masterpieces per se. I focus exclusively and intently on the image itself. It has to speak to me; it has to be evocative."

For Sam Wagstaff the key to the matter was obsession. It was not so much a question of self-conscious artistry for him but a matter of intense personal engagement with the subject. This is the reason why many sophisticated collectors, like Parr, Walther, Crane, and Wagstaff, are drawn to anonymous snapshots and plain vernacular photography. Despite their gaucherie, their compositional and technical failings, a snapshooter's or a modest journeyman's direct, intuitive feelings for the subject can resonate vividly, often in unexpected and certainly unintended ways. As Wagstaff explains, a photographer's passion for a particular subject can often be discerned in his or her resultant imagery: ". . . out there somewhere is a photographer who is possibly – probably – a shoe fetishist, but who is the best photographer of

THOMAS WESKI
Chief Curator, Museum Ludwig, Cologne

❝ In terms of the essential qualities of the art of photography, I can only talk about what I feel. I am interested in photographs which do not imitate other artistic techniques and which accept their own limits and limitations. Therefore I am moved most by those photographers who make images about a particular subject, as opposed to those who make images with a particular subject matter. There is a certain kind of authenticity inherent in this "pure" photography which produces images that seem to be drawn directly from life, almost without the aid of a photographer. And at the same time, such photographers are never bigger or more perfect than the reality they describe. This is the kind of photography that fascinates me in the long run. **❞**

women's shoes. The same with photographers who are into mountains, or flowers, or guys in leather. Whatever. Or even clouds. The largely unknown English photographer from the 1860s, Colonel Stuart Wortley, was a great photographer of clouds, far better in my opinion than Stieglitz. Like Wortley and his clouds, I just look for the work where the photographer has demonstrated a real, intense, and passionate relationship with his subject. It will usually – always – show through in the work."

This brings us to our final point on photographic art as essentially a serial art. The great photographers make many striking images, and moreover, they order them into a coherent, cogent body of work, an oeuvre. By gathering together, sequencing, and publishing photographs by many different photographers, Martin Parr is involved in the same process as with the negatives he shoots himself, creating a broader photographic work, of which he could be termed the creator, or auteur.

For the great photographers who have "got lucky" time and time again, the same applies. Their artistic "voice", style, or point of view will be there in every frame they shoot to one degree or another. However, it is over a whole body of

work, or a series, that their individuality becomes really apparent. When photographs are placed together in a sequence their meanings are multiplied as they resonate and play off each other. Any one of Parr's postcards, taken singly, might well be considered boring. Yet seen in sequence, they are anything but, and together they build up a fascinating picture of the kinds of buildings and cultural artefacts that engage Parr's interest. The sum is most definitely greater than the parts – as with, to take another example, Henri Cartier-Bresson's own "decisive moments" collected together in book or exhibition form, even though each work is considered perfect by itself. This is not to suggest for a moment that a photographic postcard is worth a Cartier-Bresson print, only that it may have something of interest to reveal, especially in conjunction with similar images.

Nor does this imply that that the whole idea of collecting a single photographic print (all that most of us can afford at any one time) negates the true nature of the art. Every photographer of ambition, whether working in series or not, strives to make every image a memorable one. And any photograph worth its salt will have an individual "stand-alone" quality as well as a place

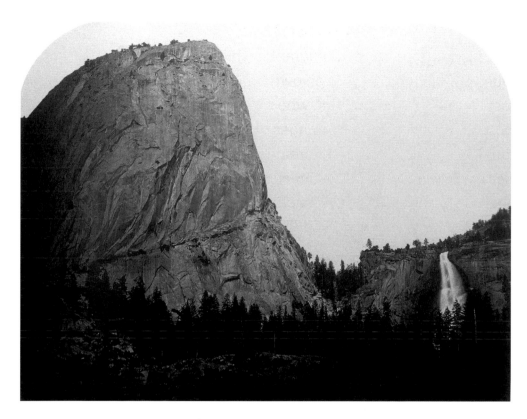

in the wider context of the photographer's body of work. The greater the photographer, the greater the stand-alone quality, and the more often it will occur in the total body of work. Walker Evans's book *American Photographs* (1938) is one of the finest photographic books, a significant and influential work of art in its own right (which is why you would have to pay some $500 or more for a first edition copy). But it is composed of some wonderful single images, some of the most memorable of this century, any one of which would grace a collection (and which would be a snip at $15,000). After all, many painters – from Fra Angelico to Monet to Picasso – also worked in series, without negating the worth of their single images. With photography, one can have the best of both worlds. A collector could acquire a couple of Evans prints, plus a copy of the book, and still have change from $30,000.

The purchase of any photograph to add to

a collection is a totally subjective and intuitive act, even if the collector thinks he or she is doing it simply to make an investment. Prospective buyers make little tests inside their heads, comparing the image with others, gauging the print quality, the image's provenance, and so on. The following two examples, or tests, are totally subjective, but written by two authorities on the medium, both as practitioners and thinkers on photography:

The American landscape photographer Robert Adams said (and to paraphrase) that a photograph can exhibit three verities – topography, biography, and metaphor. Any one of these taken by itself is one thing, two or three together begins to add up to a complex, satisfying work of art. Adams might have added history, or psychology, to his list, but the test is this: when you look at a photograph, ask yourself, at what levels is it operating? Does it say something about the photographer as well as its subject? Are there psychological, metaphorical, or social resonances in the image? With a bit of practice and experience of looking, and perhaps a little guidance, you will soon discover that some images do operate at these different levels, and are perhaps more complex, less obvious and ultimately more satisfying than others. It's like getting to know a piece of music over time. Sometimes the most immediate or obvious is not the piece one comes to cherish most deeply. As Sam Wagstaff has put it, the kind of photography that interested him most was, "any kind that challenges my perception of what I previously thought photography to be". Thomas Walther states that he looks for "the images that went against the grain". Michael Wilson even advises collectors to begin with images "they don't like".

Another observation comes from John Szarkowski, the influential former curator at New York's Museum of Modern Art, which reiterates in

a different way the comments of both Wagstaff and Walther; and the point bears constant reiteration, because the more you look at photographs, the truer it becomes. Writing about the New Orleans photographer, E. J. Bellocq, a little-known commercial photographer who made a puzzling yet profound series of nudes and portraits of Storyville prostitutes in 1912, Szarkowski stated: "A skilful photographer can photograph anything well. To do better than that he must photograph what he loves. Some love geometry; some love sunlight on mountains; some love the streets of their city. Bellocq apparently loved women, with the undiscriminating constancy of a genius."

It goes without saying that for love, one might substitute "hate" or "anger", or any deeply felt emotion. But the point is, when looking for a photograph to buy, look for the photographers who feel emotion for their subject, whatever it is. In order to attain a level of photographic connoisseurship, where you can begin to discriminate between photographs, photographers, or prints, just follow the advice of many of our interviewees, like the New York collector, Sondra Gilman Gonzalez-Falla. "Look. Look. Look," she emphasizes. The more you look at pictures, the more you'll learn about them, as long as you think intelligently about what you are perceiving. Start with those who are regarded generally as the best photographers, and always – compare, compare, compare. It will gradually become clear. Buy some of the standard histories of photography, visit museum exhibitions and photographic galleries, ask questions of dealers,

and above all, ask questions of yourself: What makes this picture better than that one? What was the photographer trying to say here? What is the image saying, irrespective of the photographer's intentions? Does this photograph's power derive from the subject or the photographer's interpretation – or both?

Another useful tool for honing one's critical eye is the notion developed by the French theorist and literary critic, Roland Barthes. Barthes was fascinated by photography, and in his book on the subject, *Camera Lucida*, developed his theory of the "punctum" in a photograph, which comes from the Latin word "to prick, puncture, or wound". For Barthes, the punctum of a picture is the feature in it that "pricks" or "wounds" the viewer. It can be all sorts of things, either within the control of the photograph or outside of it; the little thing that makes you catch your breath.

Of course, there are no absolutes and it's all a matter of personal taste. Barthes' concept hardly sounds like good critical practice, but be assured, it is utilized by the art professional much more than might be supposed. For even the most experienced professionals, an emotional response is a more accurate guide than a purely intellectual one, though one's considered, intellectual response is also important. But first of all, look for the pictures that hit you in the guts, that "go against the grain", because that is where the art of photography most properly resides. As Sam Wagstaff argued: "You can't collect with someone else's eye. It's about putting your own stake in the ground... It's about yourself."

Building a Collection

ELLIOTT ERWITT
New York, 1969
Silver gelatin print
Courtesy Magnum Photos
Elliott Erwitt is a classic humanist
documentary – and one of the few
genuinely humorous – photographers,
highly popular with collectors.

PHOTOGRAPHER UNKNOWN
Lana Turner 1941
Silver gelatin print
Private collection
Vintage Hollywood star portraits
generally show great skill in technique
and lighting. Examples can still be found
for modest sums.

You've been looking carefully at photographs for a while – maybe years – in books and magazines, museums and galleries, and now you feel you might want to start collecting these objects of fascination. What do you do? Initially, as you contemplate plunging into buying that first photograph, it's important not to worry too much about it. After all, you have presumably decided to begin collecting photography because you have a passion for it, so at the beginning do exactly what we've suggested – plunge in. Make one or two purchases on one simple basis only: you know you like these images, and want to have them on your walls. Dive into the shallow end, but watch out that you don't bang your head; so set yourself a reasonable financial limit.

Every addition to a collection should be on the basis that the image "speaks" to you in some profound way, but other considerations soon intrude. However, wait until you've acquired maybe ten or 20 images before you worry about the shape of your collection, or its quality, or investment potential, and hold off a little before you shell out a couple of hundred thousand for that first Le Gray or Man Ray, unless you really can't live without it.

Once you start to acquire photographs and live with them a little, you'll begin to understand more about your particular slant on photography – and every individual has a different slant on this contradictory medium. A good photography collection is an organic thing – it grows with you, and like you it changes as it grows. Obviously, financial constraints will dictate to a large extent the type of collection you might want to build up. But a limited budget is no deterrent to collecting well.

New York dealer Howard Greenberg believes that while it's good to plunge in, neophyte collectors should do their basic homework

before making that momentous first purchase. He recommends studying the medium's history in all its aspects, visiting museums and galleries wherever possible, looking closely at prints, talking to dealers, and above all, trying to get some prints in your hands. Physically holding a print and studying it at close quarters is a vital part of learning to live with a possible purchase and adding it to one's collection. But be careful: it's only when you hold a print in your hand that you begin to find out how seductive an object a photograph can be and how obsessive photographic collecting can become.

One question many new collectors ask is, "is collecting photography a good investment?" While it's worth repeating the words of the Parisian dealer, Gerard Lévy, who said that "it's nicer to have an image on the wall than a hundred dollar banknote", all collectors will worry at some point about the hard-earned sums of money they

are exchanging for what – in a material sense – are only pieces of chemically stained paper. We will consider the question of photography as an investment in due course, but when beginning to collect there is one lesson you should heed, an aphorism you will see repeated throughout this book. The primary rule about collecting, whether as an investment or not, is always go for quality. Buy the best you can afford.

However, the best is not necessarily the highest priced. Price can be an indicator of a lot of things besides simply aesthetic quality, including scarcity, fashion, and brand name. Put simply, the best, to you, is what you yourself fall in love with. As a collector, you have to discover this. Then, you have to learn how to add slightly more objective criteria to your intuition, as well as how to distinguish real quality from the not-so-good, and refine your judgments as you become more experienced.

Unless you are collecting strictly as an investor, don't be afraid to buck fashionable trends. No matter what you are collecting – maybe even conventionally commercial photographs made for mail-order catalogues – some will have a certain quality and stand out from the crowd. Always, always, let the image

guide you. A mediocre Stieglitz or Weston – and there are plenty of mediocre Stieglitzes and Westons – is as mediocre as an indifferent John Doe; and this is not necessarily reflected in the price. You can pay a lot of money for a signature as opposed to an image; but you can find wonderful pictures by disregarded photographers for very little money.

In the beginning, it's perhaps better for a collector to start gently. You might feel safer with a good established name. While established photographers tend to be pricey, there are works such as posthumous and "popular" editions, and so on – such as Ansel Adams Studio reprints for $150 – which nevertheless will give far more of an insight into a master's work than a poster, and will suffice until you save up for that vintage print. Alternatively, you could buy a picture by a young photographer at the beginning of his or her career, or a more established mid-career photographer at a slightly higher price. If you feel a little more adventurous, plump for a good 19th-century topographical photograph, or a 20th-century "vernacular" photograph by "photographer unknown". These can be found anywhere from flea markets, priced at $10 to $30, to photo fairs, and the top galleries, where you might pay something like $250. The field is vast, a lot of it is unexplored, and there are great photographs out there to suit all pockets.

Methods of Collecting

One of the most important questions new collectors should ask themselves is what are the collection's parameters going to be? Although one shouldn't become too hung up about this, especially at the beginning, true collectors might be distinguished from those who simply accumulate photographs at random by the fact that their collection has limits – a theme if you like. No one, not even the Getty, can collect every-

MAXIME DU CAMP
*Jerusalem c.*1851
Salt print (Blanquart-Evrard process) from a waxed paper negative
Courtesy Basil Hyman
Du Camp made the first photographic travel book: *Egypte, Nubie, Palestine et Syrie* (1852). Prints from the volume, usually found in superb condition, have been rising rapidly in value recently.

thing, especially where such a ubiquitous medium as photography is concerned. Some kind of focus should be given to every collecting activity. It gives it a purpose, makes it more interesting (to both collector and potential viewers of the collection), and eventually more rewarding, in both a spiritual and material sense.

There are as many ways to structure a photography collection as there are collectors. In a guide he has compiled for his collector clients, the leading Swiss dealer, Kaspar Fleischmann,

has divided collecting into a number of major categories, similar to those that follow. They are closely interconnected and can overlap, but are useful as both a broad and specific guide and are fairly self evident. We have designated them as follows: by subject; genre; process; school or historical period; quality; photographer; and other.

Subject Many collectors define their collection by subject. For example, a collector might decide to collect only photographs of naked bodies, celebrated people, or flowers – certainly three of

JEM SOUTHAM
Rye Harbour, River Rother, 1 April 1999
Type C colour print
Courtesy Herschel Contemporary Art and
The Photographers' Gallery, London
Southam is an increasingly well-regarded
English landscape photographer.

JEM SOUTHAM
Rye Harbour, River Rother, 1 April 1999

KASPAR FLEISCHMANN
Dealer, Zürich

❝ My advice to any new collector would be to collect from the heart and go for the best. Go for masterprints and your own eye will shape the collection. If you have a topic in mind, like a theme or a time-period, you are automatically setting the collection's parameters. I would also advise buying only vintage for images up to about 1950. Thereafter, make sure the print is limited in number and signed, or part of a numbered edition. And, again, the top priority is to buy quality.

My guess is that, in the next few years, the hottest area in collecting photography will be images from 1920–1930 and from the second half of the 19th century. Contemporary photography will also be desirable, as long it's based on fine technique and archivally stable procedures, combined with an integrity of ideas. **❞**

the most popular subject categories. Another might specialize in photographs of waterfalls, trees, or clouds, images of Egypt, Japan, or India. The New York collector, Henry Buhl, for example, has over 2,500 photographs featuring hands, and W. M. Hunt's collection revolves around eyes, the windows of the soul.

The idea of a subject collection is that, if one wishes, images from every period can be collected, maintaining a strong focus yet creating a lively collection which illustrates how different photographers from different periods, with differing styles and approaches, have dealt with a common theme. It is also a good approach for the collector who might be interested in something other than simply photography as an art medium, and is an instinctive, though not unsophisticated way of structuring a collection. For instance, to someone interested in Egyptology as well as photography, a collection of photographs of Egypt would be a natural way of extending both interests. Such an approach, after all, led to the creation of many of the finest photographs, taken as passionate documents and not made as self-conscious works of art.

Often a collector begins by collecting a particular subject because it is of primary interest, but then, as he or she becomes gripped by the medium of photography, will broaden the focus to encompass other facets of photographic collecting, perhaps becoming interested in specific periods or photographers, or in certain techniques.

Genre Collecting by genre is an extension of collecting by subject. A photographic genre is a category encompassing both subject matter and a particular approach to the medium – usually a functional rather than an aesthetic approach, although any consideration of the medium involves aesthetic issues. However, topographical photography, photojournalism, sports, or fashion photography might be considered genres, whereas categories such as pictorialism or surrealist photography are historical schools or aesthetic movements. In genres like the nude, portraiture, fashion, or landscape photography, aesthetic values become important considerations – at least at the higher, and perhaps more pretentious levels – while in the more functional genres, such as the snapshot, newspaper photography,

GEORGE WASHINGTON WILSON
Stereocards *c.*1870s
Albumen prints from collodion negatives
Private collection
Stereocards from the 1860s and 70s can be
found for an average of $10–$15, though
examples by well-known photographers in
good condition are considerably more.

erotic, archaeological, or scientific photography,
a lucid transcription of the subject is the primary
aim. The leading collector Michael Wilson
concentrates on 19th-century travel photographs,
although that is one (albeit major) aspect of a very
large collection, which focuses upon every aspect
of the medium – aesthetic, cultural, and historical.

The more functional genres are a good source
of imagery for collectors with keen eyes, for
such imagery can be found at keen prices. For
example, press photographs from the 1930s to
the 60s, many of them striking images, can still
be found for $10–$50, even though vernacular or
snapshot photography has become a popular area
for some of today's top collectors, and the more
spectacular examples are beginning to be priced
in the hundreds.

Process There are many different kinds of
photographic processes, producing very different
kinds of images, and a collection concentrating
upon these is a worthwhile endeavour for those
particularly interested in the technical as well
as the aesthetic history of the medium. Some

techniques have been associated with a particular
period, such as the daguerreotype, while others
have gone out of fashion and resurfaced at
different times throughout photographic history,
such as the cyanotype. A technical collection may
range from the silver processes to the non-silver
processes, from painstakingly made individual
prints by the photographers themselves to the
photo-mechanical techniques such as the
woodburytype or photogravure, where uniform
reproducibility was the keynote. For example,
Brian May, the guitarist of the rock group Queen,
is a passionate and knowledgeable collector of
stereographs of the 1850s.

A collection illustrating different processes
may be thought of as primarily technical, but
almost any collector is also delving into the
aesthetic development of photography and
making preferential visual choices. It is fasci-
nating, for instance, to see how different prints
from the same negative, using different methods
or even changing the size, affects our perception
and reading of an image.

School or historical period For those inter-
ested particularly in the aesthetic development
of photography, or the link between photography
and other art forms, the stylistic collection might
be appropriate. A collector might be interested
in pictorialism, or photography from the Bauhaus
period, or a particular photographic era, such as
the 1850s and 60s, or the period between the
two World Wars, or strictly contemporary trends.
Another might be interested in specific aesthetic
approaches, such as photo-collage, "straight"
photography, or photographs of tableaux that were
"fabricated to be photographed". Some collectors
have even concentrated upon acquiring images
made in a single year because certain aspects
of that year – photographic or otherwise – were
of significance to them.

Such a collecting approach tends to go hand in

WALKER EVANS
Negro Barber Shop Interior, Atlanta,
Georgia 1936
Silver gelatin print
Private collection
Evans's print prices have perhaps been low
in comparison to his reputation, but recently
they have caught up rapidly, and the best
vintage prints are both rare and expensive.

hand with a keen interest in other visual media, and the relationship between photography and art. The stylistic collection is often part of a wider collection containing related examples of work in other visual media. Thus it would be natural for collectors of, say, surrealist paintings to have also photographs in their collection. Conversely, collectors of surrealist photography may well expand their collection by acquiring the periodicals and printed ephemera in which the images appeared, plus artists' bookworks, original prints made by traditional techniques, collages, objects, and even paintings.

Quality This might be said to be the sophisticated version of the random approach, where the collector is interested in cutting across considerations of period, style, process, or artist; yet this approach is anything but random. Here, the primary criterion is quality, photo-collecting for the visual connoisseur, the aesthete, the finest prints of the finest images by the finest photographers in the finest condition – in short, the masterworks of photography. This approach means collecting the important, the classic photographs in their best possible manifestation. It means, almost by definition but not quite, buying only vintage prints, and if not concentrating solely upon vintage, acquiring a certain level of connoisseurship in being able to recognize the finest print as opposed to the lesser.

Needless to say, the fine vintage print, like fine wine, tends to be a rare beast, so if you are intending to form a collection based around photographic masterworks, it is necessary to have a certain depth to your pockets. But remember also that the photograph bought from a student at a college degree show is automatically a vintage print, and if the photographer goes on to greater things, you might actually have a masterwork on your hands after a decade or so. A fine collection of potential "masterworks" could

be put together for a minimum outlay by eagle-eyed collectors at college shows, print fairs, and debut exhibitions. Anyone buying the work of Struth, Gursky, or Ruff in the early 1980s would not have done badly.

Photographer Some collectors are interested in the work of one or several photographers, and confine their collecting activity to acquiring all the work they can by their favourite, in effect building up a survey of their chosen photographer's career. Often, this can mean a great commitment to the artist by the collector, and can result in their collection becoming a valuable resource, where the collector becomes an authority on the subject of his or her collection, especially if the works themselves are augmented with documentary material about the photographer, such as exhibition reviews, catalogues, and monographs.

If a collector is particularly interested in a young photographer at the start of his or her career, collecting their work also becomes an indirect way of sponsoring them and encouraging their future development in the medium. There are instances of established photographers collecting the work of younger colleagues in bulk. Discerning collectors – putting their money where their eyes are – obtain the work at a bulk discount, and younger photographers get a boost, not just in prestige, but in hard cash, so both parties are satisfied.

Other Obviously, collections can be made which combine two or more of the approaches indicated above. A collector might concentrate on the finest non-silver prints made by leading Pictorialists, for example. There are also different areas of photographic collecting, equally viable, which do not focus primarily upon the photographic print, and can be grouped under the term "photographic ephemera". For example, in the 19th century there was a vogue for incorporating small portrait photographs into jewellery. Some

MANFRED HEITING
Collector, Amsterdam

❝ As a graphic designer in the 1960s, photography was a daily element of my work. In 1966 while I was working at Polaroid in Cambridge, Massachusetts, I met Ansel Adams, and was privileged to work with his photographs. He taught me to respect and appreciate the original print, which later became the guiding principle in my collecting.

I believe it is still possible to put together an exemplary collection. In a way it might even be easier today since so much material is still in private hands, and will become more available because of the general attention the field is getting. The only snag is that it requires considerably more money than I ever had. But the fact that we now have more knowledge about the medium's history, photographers' work, the possible condition and value of a print – not to mention the communicative value of the Internet – enhances the possibilities on every level.

My advice to a new collector would be learn to see what you like. Study a handful of history books and critical essays, go to exhibitions, galleries, and auctions. Do not buy with your ears, but enjoy. Thematic collections are the easiest and most rewarding ones to form today. **❞**

collectors collect the bakelite cases made for daguerreotypes or ambrotypes in America which are known as union cases. There is also a large and flourishing market in collectable cameras and photographic equipment, though that is outside the scope of this book.

In addition, there is another approach to photographic collecting which acknowledges the primacy of the photographic print yet does not concern itself directly with collecting photographs as art objects. Some collectors are interested in the various manifestations of photography as a mass medium, collecting things like photographic postcards, or newspapers and magazines containing significant photographic images. The most interesting and currently active field of this kind is probably the collecting of photographic books, which has become no second-best option to the collecting of original prints. Of course, to collect early 19th-century photobooks is to collect original prints, since the first photographic books were illustrated with pasted-in original prints, in tiny editions which now make them rare and valuable (and natural candidates for breaking up and resale as individual prints). However, as mechanical reproduction methods were devised, photographically illustrated books were published in larger and therefore cheaper editions. Nevertheless, mechanically reproduced photographic books have often been significant factors in the development of the medium and attract serious collectors, particularly when they go out of print. It has been argued that the photobook is not only an autonomous artwork in its own right – as opposed to the photographic print – but that it is perhaps the medium's natural home, being a vital link between photography the gallery art and photography the mass medium. Certainly, there

is a collecting vogue and a strong market for the photobook, and some – in their first editions – now command prices commensurate with prints, even books printed as recently as the 1960s and 70s.

To give an example, certain Japanese photo-books of the 1960s and 70s, printed in small editions on cheap paper, and sold cheaply at the time, can fetch up to $10,000, or even more. Rarity value is involved here, but even not-so-rare, yet classic American books from the 70s, such as Robert Adams's *The New West* or William Eggleston's *Guide*, can retail for well over $1,000. But remember that (exactly like prints) top prices for books are dependent on tip-top condition. Only books in excellent condition, complete (that is, with dustjacket and so on), will make the best prices.

Collecting Photography as an Investment
The subject of collecting photography as an investment is one dealers or collectors might be ambivalent about to one degree or another. Any dealer in photography will automatically warn clients that it is dangerous to collect photographs purely as a financial investment, reminding them that the value of their holdings might go down as

well as up. Dealers will advise them to buy only what they like, without any thought of financial gain. Yet at the same time they will enthusiastically "talk the market up" to that same client, pointing out how much photographs have increased in value in real terms, outperforming the stock market or other areas of the art market.

The truth is, they are perfectly correct on both counts. Buying photographs solely as an investment is riskier than putting your money in the bank or buying government bonds, but surely no more so than investing in any other kind of art now that the photography art market has become so well established. Some individuals and corporations, particularly those in on the beginnings of the market in the 1970s, or even earlier, when there was virtually no market, have done extremely well out of photography, but almost certainly there will also be those who haven't.

Many collectors will say that they collect photography only because they love the medium, and this statement will be perfectly true, yet a little disingenuous. An interest in the price movements in the photographic market is surely mandatory for any serious collector, if only in consideration of the sums he or she might need to finance future collecting activity. And no matter how purist or disapproving collectors might be about the machinations of the art market, none of them are pleased if any prints they have acquired – using their own judgment and eye – actually decrease in value, or struggle to keep pace with inflation. A rise or fall in the value of their holdings, after all, is one way of judging their success as collectors, of confirming their taste. Even if they never intend to realize their collection's value in monetary terms; even if market movements come a poor second to higher philosophical values and simple aesthetic pleasures, most collectors usually have a shrewd idea of current prices fetched by their favourite images or photographers. Almost without exception, every collector is also an investor, at one level or another.

So if you are considering collecting photography, whether primarily as an investment or not, you should certainly consider how photography has done over the last 30 years or so compared to other things upon which you might spend your disposable income. People in the market – collectors, dealers, curators – generally have their own individual criteria to form their judgment. Some monitor prices of well-known images which are traded frequently, some use the work of certain photographers or groups of photographers. Some evaluate auction prices only, others look at both auctions and gallery prices. Price information can be obtained from various organizations, the Internet guides www.artprice.com or www.gordonsart.com, or the subscription newsletter, *The Photograph Collector*.

Every year, *The Photograph Collector* publishes an annual report entitled "The Photographic Art Market: Auction Prices", which lists the prices realized for every photographic lot sold at auction in the previous 12 months. In that yearbook is the TPC Comparative Auction Index, which works as follows: the staff of the newsletter choose a list of

25 representative photographic images (or comparable images) which, because of their aesthetic or historical importance, are likely to recur at fairly regular intervals at auction – market leader images such as a Le Gray seascape or Ansel Adams's talismanic *Moonrise, Hernandez*. This basket of typical market indicators is averaged, then measured against the Dow Jones Index, which of course does exactly the same thing with a basket of popular stocks.

Using this reasonably objective method, *The Photograph Collector* reports that beginning from an equalized base level in 1975 – when the photographic market was just beginning to take off – the Dow Jones has had a percentage rise of 1,780, while the basket of photographic collectables has enjoyed a dollar value increase of some 2,400 percent. This is extremely positive, though as any seasoned investor knows, these kind of statistics need interpretation and analysis, a reading of the subtext hidden in the figures. *The Photograph Collector* surveys cover the years when the market rose from virtually ground zero to the heights it occupies today. Whether such percentages will be sustained in the future remains to be seen.

However, overall the prognosis would seem to be reasonably favourable. Actual prices notwithstanding, in the period covered by *The Photograph Collector* surveys, the number of dealers selling both vintage and contemporary photography has increased from under one hundred to over a thousand. The number of museums seriously collecting photography has increased more than tenfold, until no museum that calls itself an art museum can afford to ignore photography. In other words, there are enough serious vested interests involved in the whole business of photography collecting to ensure the probable continuing health of the photo market, despite the economic "downturns" that will occur

inevitably over the years.

The rules regarding the acquisition of photographs as an investment are pretty much the same as those governing collecting for oneself. The late Harry Lunn Jr., the doyen of dealers, put it in a nutshell, and any collector following his advice cannot go far wrong: "Like any other field the investment advice and the aesthetic practice are the same: try to identify the finest examples by the best artists in the finest possible condition."

Lunn's "finest examples by the best artists" confirms a truism about any kind of art investment. The big players make the most money, because the works perceived by the majority to be the finest (and therefore the most expensive) both sell more readily and maintain their value in the inevitable "blips" that the

SAM TAYLOR-WOOD
Self-Portrait in a Single Breasted Suit with Hare 2001
Type C colour print
Courtesy Jay Jopling/White Cube, London
A leading British artist, Taylor-Wood has made a substantial body of photographic work as well as video. This is her controversial self-portrait following major surgery.

market undergoes from time to time. Percentage rises being equal, if the percentage rise is say, ten percent in a year, the owner of the $500 print by Francis Frith makes $50, while the owner of the $500,000 Le Gray makes $50,000. Even allowing for such out-of-pocket expenses as insurance and other sundries, the difference is obvious.

Having a thousand Friths or equivalent is not likely to be as profitable in investment terms as owning the single Le Gray, for realizing the gain is undoubtedly going to be more difficult. Selling one thousand cheap prints is probably going to be harder than selling one, highly desirable masterpiece, even given the fact that there are likely to be fewer takers at $500,000 for the one image. In the event that a single buyer were willing to take all thousand prints off your hands, a sizeable discount would surely be necessary to secure such a bulk sale. The Le Gray, in short, tends to win out at every turn.

In practice, anyone collecting seriously for investment would assemble a "portfolio" of images as one would a portfolio of stocks, and stick with the safe, top of the market performers only. Or perhaps a collector could allocate purchases between different areas of the market, taking care to ensure a good balance between expensive masterpieces by the best-known artists, and good, solid middle-of-the-road performers in the form of established but lesser regarded talents, and, possibly, as yet disregarded photographers who may hit the heights in the future and provide a high return for a modest gamble.

The main difference between buying for financial gain and collecting for aesthetic pleasure lies in the elimination of subjectivity. In other words, investor-collectors become more interested in whether a piece will bring in a good return on their investment rather than whether they actually like it. In practice, one ought to be able to find enough buys around to satisfy both criteria, but

when purchasing for investment, the return is the primary, if not the sole criterion, and sentiment must be firmly shown the door.

Therefore investor-collectors are of necessity somewhat conservative. Investment is a herd activity. Where the majority (the market) leads, the rest follow. So if acquiring an image by whatever photographer for investment, go for an established image by that photographer rather than the relatively unknown or "oddball" image. Even if you are sure of your taste, that does not mean to say the market will be. The most popular and valued images in market terms are those that appear most often in print, especially in the history books. To be sure, today's unknown image may be tomorrow's certainty if the market takes to it, and you will have made a killing by taking a flier. But in order consistently to buck prevailing market trends and "make" the market rather than simply follow it, you have to be one of two things: a genius with an acute instinct not only for photographic worth but the next market trend; or you must have "clout" in the market, being either a major player in financial terms or with enough perceived authority to persuade others to follow where you lead.

But it's not easy. For example, when the Irish dealer Sean Sexton found a cache of prints at a market stall, by a hitherto unknown Edwardian photographer, Charles Jones, he instantly recognized a photographer of true originality and suspected he had a real "find" on his hands. Jones' still lives of fruit, flowers, and vegetables now retail for upwards of $2,000 a print, but it took Sexton years of perspicacity to build the market value up to that kind of level. This confirms that unless you acquire a tremendous bargain from out of the blue, or suddenly chance upon tomorrow's big trend today, photography as an investment is usually a medium- to long-term venture.

Guidelines for Investor-Collectors

The following guidelines are useful tips for any collector, but are mandatory for investor-collectors. Never forget that buying photography, or any kind of art, is not an empirical science. However, the more knowledge you arm yourself with, the better your "intuitive" choices are likely to be.

Buy the best you can afford This is the golden rule. For investor-collectors, this means avoiding non-vintage prints unless there is a very good reason for doing so, and refusing to be seduced by less than first-rate material. Large editions, late prints, and so on – unless there are clear extenuating circumstances – will not tend to be good investments.

Pay particular attention to condition The other self-evident rule. The physical condition of prints – lack of scuff marks, surface abrasions, tears, etc – is a highly significant factor in determining the potential investment value of a photograph, or any other kind of photographic collectable, such as photobooks.

Check an image's provenance Look for signatures, stamps, etc, and any other evidence of provenance – the origins and ownership history of a print. Quiz the seller about the history of a

MARTIN PARR
Photographer, Bristol, UK

❝ I collect photography books because I'm a photographer and I need to inform myself about what's going on in the world photographically. Books have taught me more about photography and photographers than anything else I can think of. I like the idea that you have a book which is a time capsule of ideas as well as just the images inside it. I'm also sometimes attracted to the idea of production values and the tactile aspect of a book.

A book is where you combine great images with beautiful production. The production doesn't actually have to be lavish – it can be very crude, or badly printed even, and still work. Roy DeCarava's *The Sweet Flypaper Of Life* is a good example of a very small book where the printing and everything seem to be in harmony with the ideas and it becomes a very beautiful object. I also like the idea that these books can travel the world and educate other photographers. Certain books have certain influences. The relationship between, say, Japan and Europe and America is fascinating, and very much dependent on books travelling between these territories. This is what makes me excited by the idea of the book.

I also collect prints, generally connected with photography books. Sometimes where there's a book I particularly like, I try to buy the book dummy. In addition I collect political ephemera, wallpaper, many things – I'm an obsessive collector. It's a big problem because I'm finding it difficult to store everything, so I'm drowning in books at home. I also collect postcards, but at least they're easier to store. ❞

potential purchase. Full provenance, backed by proper documentary evidence, is becoming an increasingly vital factor in the photographic investment market.

Avoid restored prints Avoid images that have been heavily restored, or worse, 19th-century prints that have been chemically "intensified" to restore their colour and tone. The market does not regard them as original. Be suspicious of vintage material that seems "too good to be true" if there is no proper provenance.

Consider subject matter Subject matter can influence potential investment value; if it is too harsh, the potential resale market may not be as wide. In 1915–17, Paul Strand made two pictures that are equally important in the development of modernist photography – *Blind Woman* and *Wall Street*. Both are iconic images, and are mandatory purchases for any self-respecting museum collection, but it is evident that *Wall Street* appeals more to the private collecting market. Photography captures the raw facts, but some facts may be too raw for the average collector and the home,

PAUL STRAND
Wall Street, New York 1915
Photogravure (from *Camerawork*)
Courtesy Aperture Foundation Inc., Paul
Strand Archive, Millerton, New York
Strand's *Camerawork* gravures are
important and relatively expensive,
because there are so few vintage prints
from the period in other media.

and therefore hinder the broader market appreciation of an image.

Avoid ephemeral market trends This is a tricky one, but the art market, particularly a new market like photography, is subject to fads and fashions. A photographer's work is "in" one minute, then "out" the next. So stick to the tried and tested, the Le Grays and Stieglitzes and Cartier-Bressons, and avoid the latest SoHo or Chelsea sensation unless you are very sure of your judgment. You cannot avoid market fashion to some extent, but be very aware of the phenomenon.

Take the long view Collecting for investment tends to be a medium- or long-term business, unless the lucky investor has happened across pictures at below-market prices. Probably the best

returns have been made by those carefully assembling a coherent collection over a number of years. The disposal of a balanced collection tends to produce added value as the perceived worth of a piece can be enhanced by its bedfellows. Although these sales clearly were exceptional in every way, one can certainly surmise that some lesser lots in the André Jammes sale in 1999 made premium prices because of the company they kept.

Just as in the stock market, people are making and taking quick profits, but this is a high-risk strategy. The more prudent collector-investors are more content to bide their time and enjoy their photographic assets as they quietly accrue in value.

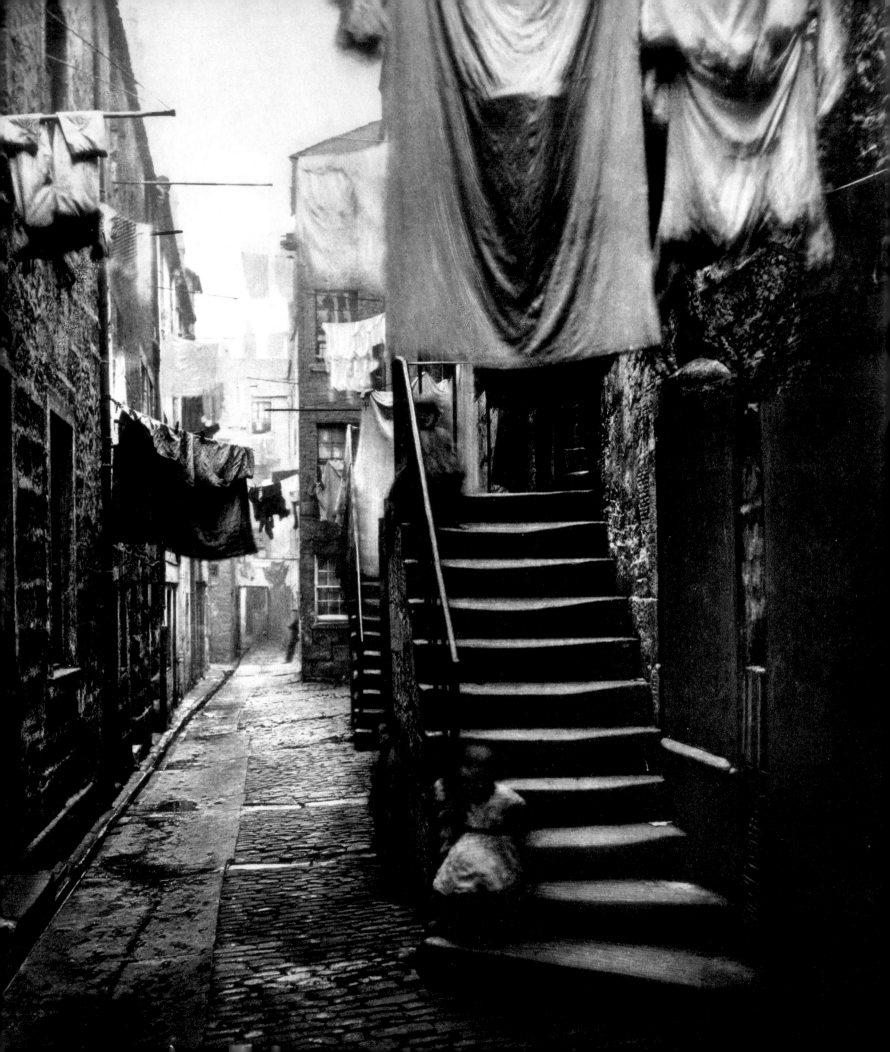

The Photographic Print

Although collecting photography covers a variety of artefacts, the photographic print is undoubtedly the mainstay of the photo collecting market. But as the curator and photo historian Peter Bunnell wrote in 1964: "The universally held characterization of the photographer is that he is an observer, that he possesses a vision. In addition to this tenet, there is the less realized fact that the photographer is also a printmaker – whether working with paper, metal or plastic, whether working in terms of the unique image or in multiples, whether through customary direct techniques, or synthetics, or combinations. Not all of the photographers who possess vision impart equal sensitivity in printmaking." So let us consider the print in some detail, returning first to the question raised in our Introduction: how many prints might there be of an image?

As we have noted, there are generally far fewer prime prints of the average photographic image around than one might suppose. Photographs are fragile things, and many have suffered in the past from the disregard in which the medium was held – either handled carelessly or simply thrown away. Moreover, as many photographers dislike printing, they often employ others to make their prints for them.

Since darkroom work is such a travail, and since the production of new negatives is a relatively simple matter, photographers tend to be frighteningly prolific in the production of new negatives and miserly in their production of prints. Being eager always to print their latest images, most tend to make only a few acceptable prints from a negative before turning with relief to the next. And the term "acceptable" is key, for not every print from a negative is exactly the same.

Having printed a few acceptable prints from a negative in a single darkroom session, a photographer might never return to it. He or she might return to especially successful negatives on only

a few more occasions throughout the course of their career, making a few more prints each time. The result is usually a strictly limited number of first-rate, top-quality prints. The nature of the process ensures naturally that this total is often more limited than people realize, thus would-be collectors should (on the whole) be reassured. Nowadays, prints increasingly tend to be limited by edition, following traditional print market procedure, but that has most probably increased rather than decreased the average number of prints of a particular image. In the case of prints from before the 1970s – when the photographic market began to move and the idea of editions became current – it would be a rare item where more than, say, about 30 fine, exhibition quality examples existed, and often the number is much smaller. For example, there are only about 13 vintage prints of Edward Weston's famous *Pepper No. 30* of 1930 in existence. If another example turned up on the market, it would fetch hundreds of thousands of dollars. There are three authenticated prints of Man Ray's *Glass Tears*, which

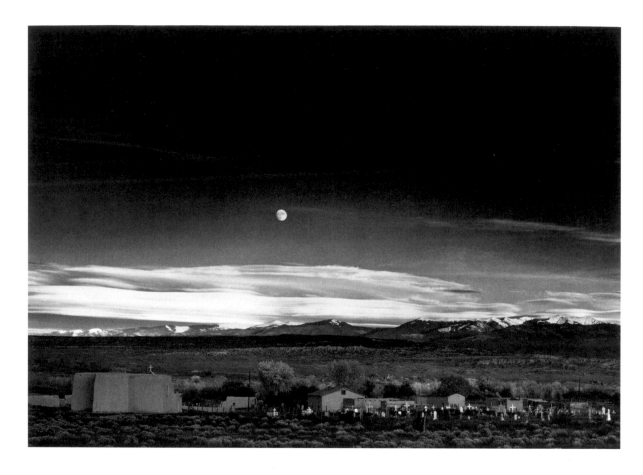

explains why it sold for over a million.

There is also the question of consistency. Photographers intending to publish editions are generally compelled to make larger batches of prints, using the same batch of paper, the same batch of chemicals, the same batch of toner, in order to achieve uniformity. This is a far cry from the older, rather more haphazard methods. Editions surely demand that the variables be eliminated, though in practice this is not always the case, as we will see. However, uniformity presents a problem in the minds of many photographers, especially those, paradoxically, who are concerned with making fine prints rather than any old print. Undoubtedly the most famous and oft-repeated maxim about photographic printing was made by one of the 20th-century's finest printers,

the American landscape photographer, Ansel Adams. "The negative," he said, "is the score, and the making of the print is the performance."

If we adopt Adams's musical analogy, we might question whether total uniformity is always so desirable. After all, a musical piece conducted and played the same way at each performance would quickly pall, for both performers and audience alike. And so would the world of photography if every photographer printed the same way, all exactly the same as each other, and with monotonous regularity, year after year. Adams himself would be termed a classicist in musical terms. He was methodical, correct, controlled. His knowledge of the practical application of photographic science was second to none. His own darkroom was equipped with every advanced

technological aid. If one's life depended upon turning out a large number of perfectly matched prints one would turn to Ansel Adams. Yet he always kept to his own maxim – the negative is the score, the print the performance.

Consider his most famous image, *Moonrise, Hernandez, New Mexico*, taken in 1941. This picture frequently set market records, especially in the late 1970s and early 80s, despite the fact there are around 900 prints of the image in existence. However, that is not to say that *Moonrise* exists in an "edition" of 900, for this implies that all versions of the image are more or less identical. For instance, a large (39 x 59 inches) print fetched the then unheard of price of $71,000 in 1980. But it was one of only 12 printed to that size in 1974. There clearly aren't 900 different *Moonrises*, for Adams made some relatively large "runs" of the print, especially towards the end of his career. But he had been printing this negative since 1941, in any number of "performances", and there are quite distinct variations in size, papers, and approach, plus the rather more unforeseen ravages of time. Some lucky collectors have several copies of this image in their collections, each exhibiting quite different characteristics. In the 2002 exhibition Ansel Adams at 100, curator John Szarkowski selected a number of paired images, each of which had been printed differently, for direct comparison.

The variables both within and outside the photographer's control are almost infinite. The photographer/printmaker is faced with a long chain of choices, any of which may vitally affect the outcome of the print. Much of this fine tuning is far from scientific in nature, but is improvisational, executed at the last second by the intuition of the moment. Moreover, making a photographic print of exhibition quality can involve an inordinate amount of time and frustrating effort, involving the photographer's intuitive feelings

to a large degree. What kind of print best realizes his or her intentions today? A dark print? A light print? A contrasty print, or a less contrasty print? What colour? Should it be printed on warm toned or cool toned paper? On a glossy, matte, or textured surface? What kind of developer should be used? Should the print be toned? And so on. If it's a colour print, what kind of colour balance is the right one? The choices are extremely varied and require not just technical know how but aesthetic judgment.

Making fine prints is not just a performance, it's often a lengthy rehearsal. On average, if the photographer is dealing with an "easy" negative, perhaps the desired print is obtained after two to three attempts; let's say after maybe half-an-hour to an hour. If the negative is difficult, that time could be extended to two, three, even four hours, and half-a-box of paper. That's four hours and perhaps twenty-five sheets of paper to get one print of sufficient quality to sell in a gallery. It's said that Alfred Stieglitz would spend up to a week in the darkroom making the perfect print from a difficult negative.

The whole process, or at least a good part of it, must then be repeated if the photographer wants another exhibition print – more work, with less uncertainty perhaps, although such imponderables such as the strength of the chemicals, how the print is agitated in the developer, etc, can affect the look of two prints exposed for the same amount of time. And then once the prints are fixed, the whole process of toning, washing, and drying is necessary, with more potential variations in the final result. In essence, one can say that no two black-and-white photographic prints are exactly the same, and that might be claimed even for colour, though only the photographer might see the subtle differences in many cases. Only prints made with printing inks by photo-mechanical reproduction, or the new computer-generated

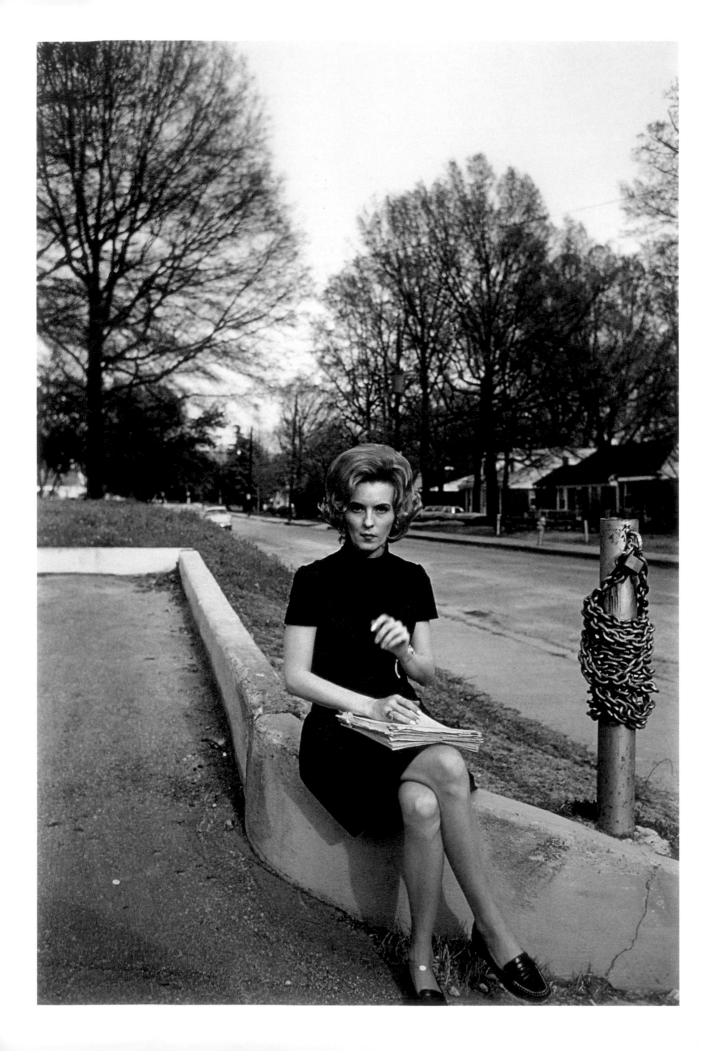

JANET BORDEN
Gallerist, Janet Borden Inc., New York

" I think there's some overlap between vintage and contemporary photography markets, but as with anything, there are collectors and collectors. Vintage collectors are conservative by their very nature, but I prefer the friskier collector, who in general is the collector of contemporary work. Vintage collectors also tend to have a thing about print quality that borders on the fetishistic, whereas collecting contemporary work is much more about buying into the concept. It doesn't make selling any easier – maybe the reverse – but collectors of contemporary photography tend to be that much more open minded.

Editioning is also very important, because collecting is about owning something that is rare, or even unique. Collectors don't only want an original concept; they want to feel that they own a special object. So editioning, and in fairly small editions, has become vital to today's market. Sometimes that's the only thing that will get a collector off the mark.

Today, much of the best and most innovative work is being done in Germany, but the incredible success of the Germans is also due to an incredible market structure at work. It's all marketing, so I think that the Germans will be around for a little while yet. **"**

prints, can be said to be identical. But even there, subtle variations can occur.

In short, in traditional photographic printing the photographer (or printer) inevitably ends up with two categories of print, those pronounced as of exhibition quality and ready to be toned, mounted, and signed, and the others – the "also rans", those of lesser quality. If they are not quite up to exhibition standard, they may be good enough to be designated "work prints" or "press prints". If markedly inferior, they should be consigned immediately to the wastepaper basket, but unfortunately this is not always the case.

Galleries or dealers in photographic prints should, and generally do deal in prints which have been declared to be exhibition or sales quality; that is to say, they should be the best a photographer can make, representing how he or she interprets the negative at that time. Anything else should not be offered by the reputable dealer, unless there are extenuating, clearly defined circumstances, and nor should photographers countenance anything being traded other than their finest prints.

What the photographer has been aiming for, and what the collector should look for, is a print that "sings", to reiterate Ansel Adams's analogy – a print where the tonalities are in harmony with each other and the subject matter and which expresses nothing more nor less than the photographer's intentions; the kind of print that ensures the subject speaks to us in the widest possible way. Balance is another way of looking at it. If some of the print's tonalities seem a little out of kilter with the rest of it, it is probably not the best print, unless this is a deliberate strategy on the

photographer's part. It is as important in photographic education to learn how to dispose print tonalities (or colour balance if printing in colour) as it is to dispose shapes within the picture frame. However, it's all very subjective, and a difficult notion to express in words. It can only be grasped by looking at prints, and comparing prints of the same image with each other, ideally side by side. If the collector looks at as many prints by the same photographer as possible – in museums, in the best photographic galleries – the print that sings the loudest and sweetest will soon be determined. Though as with actual singers, different people will have different ideas and their own preferences. Nevertheless, the more one looks at prints, the better one's eye becomes attuned. Practice makes perfect – for photographer, printer, and collector alike.

What is an Original Print?

Let us consider a number of the caveats that all would-be collectors of photographic prints should be aware of, though this should in no way deter them if they arm themselves with a little knowledge and common sense. We have said that some photographers make their own prints, others have them made by a printer with whom they work quite closely. So what exactly is an original photographic print? Is a print made by the photographer from his or her own negative more original than one printed from the same negative but by a hired printer?

Any print made from a photographer's original negative is an original print. But in photographic collecting, there's original – and there's original. Many collectors insist that only a print made by the photographer is original, and sometimes the market reflects that; but such an insistence is, frankly, impractical. After all, one does not insist on a Picasso etching being printed by Picasso. It all depends on the kind of photograph and the

kind of photographic artist. Many 19th-century prints would not be made by the photographer, a fact that makes them not a whit less sought after. And for many great 20th-century photographers – Henri Cartier-Bresson for example – catching the subject in motion was more important than making a fine print. For Cartier-Bresson, any print that reasonably transcribed what was on the negative was fine, so he had no compunction in entrusting it to a printer. This is true of much work in the documentary/journalistic modes where the photographer is working with a small camera and the essence of the image is established with the clicking of the shutter. Whereas for a would-be photographic artist like Alfred Stieglitz – using a large view camera and showing fine exhibition prints – entrusting his negatives to someone else would have been unthinkable.

The relationship of photographers to printing is a continuum, running from those to whom subject matter is everything and the print unimportant, to those who are essentially printmakers before anything else. Thus what would seem a more realistic definition of an original print is one that emanates directly from the photographer's negative, and carries his or her approval as authentication, or the approval of the artist's estate if it is a posthumous reprinting, though some would argue that posthumous prints are in no way original.

Already, we are beginning to qualify our definition of original, and the anomalies become ever more complicated. What, for instance, do we make of the photographer who makes a copy negative to print from – by making a new negative from an existing print and accepting an inevitable degradation of quality – in order to protect the irreplaceable original? What about computer technology, where the negative itself can now be cloned without a qualitative loss? How do we view the products of the photographer who has

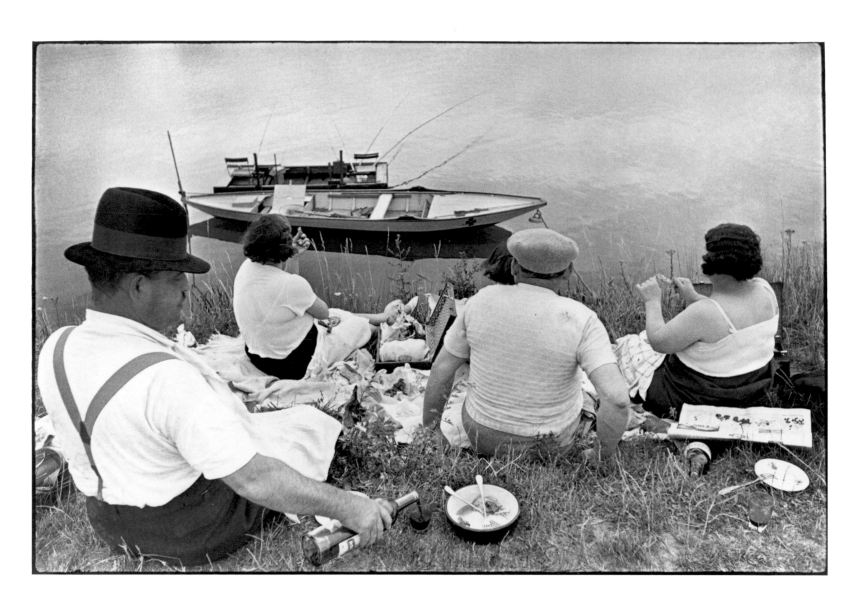

negatives printed not singly – by hand – but in large numbers, by one of the photo-mechanical processes such as photogravure or collotype? Some collectors find it difficult to accept Camerawork gravures as original prints, and likewise the fine heliotype or collotype illustrations found in superior examples of late 19th-century photographically illustrated books. And yet can anyone seriously deny that a mechanically printed image like the early French photographer Charles Nègre's view of Chartres Cathedral is anything other than one of the supreme achievements of photography, and a wholly authentic and masterly realization of its creator's vision? Those eagerly bidding for the magnificent Nègre heliogravures at the 2002 Paris sale of the André Jammes collection certainly thought so.

We might solve these dilemmas by returning always to first principles: what was the photographer's intention, and what is the result, regardless of the photographer's intention?

For example, if making copy negatives and then printing from them is a normal part of the photographer's practice, then prints made in this manner, degraded technically or not, must be accepted as authentic statements by that artist. If not part of the photographer's practice, then such prints must be viewed as non-authentic and a misrepresentation.

If one treats each and every case according to its merits, then the whole question becomes not so much a case of "how original?" but "how good?" Again, putting it a different way and harking back to music, was Beethoven necessarily the best conductor of his own music? He wasn't, if we're to believe much informed contemporary opinion. Similarly, there are many photographers who have

PHILIPPE GARNER
Worldwide Director of Photographs,
Phillips, de Pury and Luxembourg,
London

❝ So much photography is about subject matter. Therefore, my advice for new collectors would be to start from a subject that interests you, something that you have a passion for. Unless you buy with emotion, you'll never put together a collection that satisfies you, and if it doesn't satisfy you, it probably won't make much sense to anybody else.

The simple answer to buying vintage prints is "yes". I know from a personal perspective: I have bought "later printeds" and they languish neglected at the back of a drawer, because I've found that, at the end of the day, they tend to become somewhat sterile objects. There is an intrinsic magic, a rightness, an authenticity, about the print which carries some history with it. There's much discussion about what is meant by vintage because different criteria apply to different photographers. But, broadly speaking, pursue the print that carries some history with it, and that has a resonance as an object. That's likely to be a vintage print. ❞

not realized all they might have from their own negatives. An artist's view of his or her own work is also likely to change over a period. Many photographers vary their printing approach quite widely over the course of a couple of decades or so. Changes too, are forced upon the printer by changes in the types of materials available.

Perhaps the most startling example of a photographer changing his printing style was that of Bill Brandt. Early Brandt prints tend to be small, dark, and soft in their tonalities. Then around 1960, in mid-career, he began to make larger prints, almost pure black and white in their extreme tonal contrasts. These new prints were difficult to achieve, so he made copy negatives of a successful one, and printed from these. So Brandt prints exist in two distinctive forms – the early, soft prints, and the later high-contrast prints, plus variations made from the original negative and those made from copy negatives. Some collectors prefer the soft prints, others the later, contrasty prints.

Collectors soon get to know the characteristics of the work of those photographers who interest them, and buy accordingly. As well as a photographer's actual imagery, the precise details of the process, the original purpose of the print, the size of the edition, and other considerations, may or may not elicit conclusions as to the intrinsic merits of a purchase. If the print as an object is especially important to a collector, he or she will buy only those photographers who print their own work. If not, seeing and not printing will be the priority. After all, the fact that the photographer has sanctioned the print – with a signature or a stamp – is more important than who actually printed it, although potential collectors should be aware that it was not the general practice to sign prints until fairly recently. Some photographers did, others didn't, so, as always, when buying photographs in the end it comes down to a little background knowledge, and what your eyes and your instinct tell you.

Vintage Prints

The question of vintage prints has become as vital to the question of collecting photographs as art as states or pulls have become to the collecting of etchings or lithographs. Vintage is a term which crept into photographic collecting during the 1970s, when the market began to take off, and when senior photographers, suddenly realizing that they had kept maybe one or two prints from one of their classic images taken 20, 30, or 40 years previously, dusted off these old negatives and made new prints to satisfy the current demand. Vintage was coined to distinguish the old, original prints from the recent, and value was established in relation to a print's age.

The term, therefore, refers to prints made around the time of the negative's origination. There is no specified period, but as most photographers print their images within five years, that seems a reasonable guideline. If the photographer prints the negatives again at a later juncture, dealers and curators now tend to refer to them as later printed, or later prints. And if the photographer produces prints even later – to augment the old-age pension perhaps – these are termed modern prints. It has become an increasingly popular market practice these days for a photographer to double-date prints – to indicate the dates of when both negative and print were made on the back of the mount.

In the market, it is vintage prints that generally command the premium prices. As the Swiss dealer Kaspar Fleischmann has written, "serious collectors always make sure their prints are vintage". The veteran collector Arnold Crane was even more adamant: "Run, don't walk, from anything but a vintage work," he urged collectors, "for the vintage work has the unexplainable magic of presence: that actual presence of its master creator."

However, the critic A. D. Coleman has doubts about the whole concept, stating that the word usually functions, "as little more than a fancy substitute for 'early' or 'old'", a marketing concept in which "the use of 'vintage' purposefully connotes both more valuable and better". AIPAD (the Association of International Photography Art Dealers) is also concerned about the term, and has tackled the issue in its latest handbook on collecting. Certainly, Coleman's attitude carries a degree of truth. "Vintage" is undoubtedly a marketing ploy; it is also complicated to define exactly; yet there is much more to it than that, and even AIPAD will find it difficult to eradicate the notion, which has become firmly entrenched. There are several reasons (apart from price and investment value) why the collector should try to buy vintage and why both the market and scholars of photography take the notion seriously.

First, the term vintage at least provides a framework of reference for those who need it, and draws attention to the fact that there are important differences between prints, reinforcing the point that each case should be treated on its merits. It also makes clear that when a collector pays a certain amount of money for a photographic print, he or she is buying an art object. Value in the art market is not just a matter of aesthetic judgment, which is far too loose and subjective a concept for dealers. The age and condition of an object – its "aura", if you like – is important to many collectors, and while aesthetic purists might scoff, there is no doubt that a degree of snobbery and one-upmanship is part of the appeal.

As we have seen in the case of Arnold Crane, many collectors like to feel that they are tuning in as closely as possible to the moment a photograph was created, into the photographer's thought processes and the cultural milieu of which he or she was an integral part. A print made 20 or 30

years after the event does not do this, it just does not have the aura of the vintage print. The "time capsule" element in a photograph is a crucial part of the medium's appeal, and it goes without saying that only a vintage print will reflect this fully. A photographic print from even 20 or 30 years ago will have acquired a patina, a feel about it, even in that short time, which simply cannot be duplicated in a newly minted, modern print.

It might be inferred that vintage reflects the supposition that a photographer's first thoughts on a print are his or her freshest. Some collectors and dealers argue this, but to be set against that notion is the fact that some photographers might improve as printers as they progress in their

careers. With certain photographers, buying vintage is a must. With others the situation is perhaps less clear cut. One important issue regarding vintage prints is the fact that conventional photographic materials have changed over the years. Modern papers cannot match those of yesteryear. The photographic papers of the 1920s were simply richer in silver content than those of the 1960s, and those of the 60s richer than today's papers. It is an indisputable truism that the older the print, the more tonally rich it tends to be, given the variations in cameras, films, and individual printing preferences. As even the sceptical Alan Coleman admits, the first print a photographer makes is part of the image-making process in a

way later prints are not: "The range of papers, chemistry, and darkroom hardware available at the time the negative is made, and the photographer's choices among them, will have a distinct shaping affect on the imagery. And the choices he or she makes from the negative – the initial interpretations – will reflect and embody that decision-making process."

So our advice is, if you are interested in the investment aspect of the photographic print market, even if it's a secondary issue, buy vintage if you possibly can – though not slavishly so if the image is of more interest than the print. If it comes to making a decision between an indifferent vintage print and a stunning one from a later date, think hard and consider why you are collecting photographs.

For example, it is clearly desirable to have an original vintage albumen print from Francis Frith's monumental large-plate Egyptian negatives of 1857. It is, we believe, also desirable to have one of the modern prints marketed by Janet Lehr of New York, struck from the original negatives using substantially the same albumen process. The vintage Frith print in pristine, unfaded condition is obviously a great rarity, a prime photographic treasure, intrinsically and materially, and is well worth the many thousands of dollars you will be asked to pay for it. The badly faded original is quite another matter. Is it really worth the $1,000 or more that would cost? If you cannot afford, or find, a good original, is not a fine modern print, using 19th-century processes, a better bet than a faded vintage print? The answer to that question also determines what kind of photo collector you are. A modern print of a 19th-century image is certainly a useful adjunct to a collection at the very least – even if you have an original – as it can be framed and hung without worrying about it fading. However, if you must have vintage, also be aware that a less than perfect 19th-century print might be the only one available.

Henri Cartier-Bresson is one of the 20th century's greatest photographers and any serious collection must have examples of his work. He made many of his most famous images in the 1930s, but good vintage prints from that era are outweighed by indifferent, carelessly fixed prints, frequently quite small and in not very good condition, for they were often not valued and preserved as they should have been. To be fair to the photographer, making fine exhibition prints was not a priority, and he usually had them printed by others. Later, his prints were made by Pierre Gassmann in Paris, and some collectors consider that examples from the 1950s and 60s (of the 1930s negatives) are amongst the finest realizations of his work. But many of these prints are "press" prints, so other collectors opt for the later 1970s prints, which were made for exhibition and the print market, and so tend to have the great man's signature, boldly written in ink, below the image. Thus for Cartier-Bresson, as with any photographer who has had a long career, the concept of vintage can sometimes be an obfuscation rather than a clarification.

Another example is the work of Diane Arbus. Again, there are few vintage prints, actually made by the photographer, because of her untimely death. At the time of her death, she was making a portfolio edition of her best-known images but completed relatively few. So the Diane Arbus Estate commissioned posthumous editions of her work, printed by a photographer, Neil Selkirk, who had printed for her and who printed exactly as she would have printed them. The estate have issued these prints on to the market, so many images at a time, in editions of 55, over the last 30 years. Although 55 sounds like a large edition, the earliest issues are now generally sold out, so even prints from these editions are now commanding

ANDRE KERTESZ
Distortion No. 40 1933
Silver gelatin print
Courtesy Donation André Kertész,
Patrimoine Photographique, Paris
Vintage Kertész prints are extremely
expensive, but there are many later prints
available at more reasonable prices for the
less affluent collector.

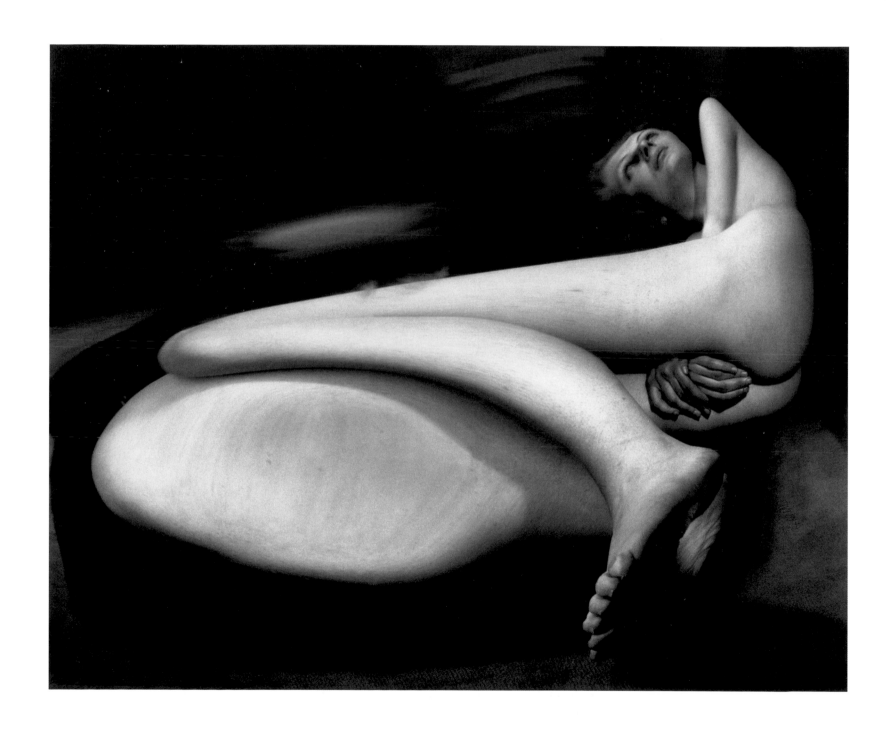

HANS P. KRAUS JR.
Gallerist, Hans P. Kraus, Jr. Inc., New York

" The appeal of collecting 19th-century photographs is fundamentally the same as for 20th-century works, with the added attraction of the rarity of early photographs. There is also a sense of wonder that 19th-century photographs have survived, sometimes in extraordinary condition, as well as an appreciation for photographs produced by pioneers of the medium.

By definition, the supply of early prints is limited. With the increasing interest in 19th-century photographs, the value of many works has risen significantly. At the same time, as a result of this heightened awareness, bodies of work by previously unknown photographers are coming to light and new caches of important photographs continue to be discovered.

The handling issues for showing early photographs are the same as with all fine works of art on paper. They should be framed and glazed with ultra-violet filtering plexiglass and hung away from any bright light source. It is advisable to rotate pictures on and off display at regular intervals. Certain early photogenic drawings and photographs remain unfixed or just stabilized with salt or iodide; these are particularly light-sensitive and should be carefully protected. "

prices from $10,000–$20,000 dollars plus when they come on the market, and authenticated vintage prints are into the hundreds of thousands for the best-known images.

The concept of vintage, therefore, is not only complex, but something of a movable feast, depending often on the prestige of particular photographers and also the way they managed their printmaking over their career. We can only repeat our previous advice: buy vintage if you possibly can, but don't make a fetish of the notion and ignore other kinds of print. As Alan Coleman reminds us: "It is only one of several significant kinds that may be produced from a negative over the course of a photographer's lifetime."

Limited Editions
The following may seem to contradict what we have stated previously about the real numbers of particular photographic prints in existence. But

clearly photographic collecting is full of potential contradictions. We have noted that most prints existed in smaller numbers than if there had been limited editions made from the same negative. We have also stressed the serendipitous nature of much photographic printmaking, the potential variety available to a photographer, the casual nature of the process – the whole idea of the negative being the score and the print the performance.

As there was hardly a market for photographic prints made by contemporary photographers until about 30 years ago, and even then it really applied to only a few figures, the vast majority of photographers got away with being haphazard and casual – in a word, unprofessional. They weren't likely to sell many prints, so they could afford to turn out a few prints here and there, as and when they chose, taking refuge in that famous aphorism of Ansel Adams. However, it has become increasingly clear

that in today's photographic art market, for those photographers who wish to participate successfully in the market, it will be mandatory to produce limited editions of their prints.

For many photographers – let's call them old school without being pejorative – the whole notion of making a limited edition print of an image is anathema. It goes against the grain of the medium, they argue. The essence of photography lies in its infinite reproducibility, the very fact that a large number of prints can be made from a negative, in a profusion of performances, not one the same as the last. Yet this is rather disingenuous. While there has been a historical situation in which such an attitude could prevail, even flourish, we now have the beginnings – and it is still only the beginnings – of a universal photographic art market, and the casual approach is no longer appropriate.

Although one of the great strengths of photography lies in reproducibility, the art market is about the cachet of rarity. If a photographer wishes to make full use of photography's reproducibility potential, the best arena for that is in a publication. Making a print specifically to exhibit on a gallery wall and sell as an original artwork is quite a different business and should be approached accordingly. An essential quality of photography is that it can function both as a mass medium – reproduced infinitely – and as a traditional printmaking medium for artists. It's a pleasurable conceit for photographers to imagine that they can have their cake and eat it in the art market – make any number of prints from a negative yet still charge high prices for a signed original – but it's wrongheaded. The limitless number of prints is a highly theoretical notion, and in practice few photographic prints are ever printed more than ten times. However – and this is the problem for dealers and collectors, as well as photographers – the figure ten could just as easily

be 15 or 20, or, as in the case of Ansel Adams's *Moonrise*, 900. In other words, it's an unknown, on which a collector is being asked to gamble. And collecting is enough of a gamble without that kind of variable.

Collectors are being asked to pay a lot of money for their love of photography. So given the current state of the market, the prices being asked, and the desire for photography to be regarded as respectable in terms of the art market, it would remove some of the current grey areas if all photographers looking to exhibit and sell their prints were to print them in clearly defined and limited editions. Many collectors, especially those of contemporary art photography, naturally want the images in their collections to be as unique (or nearly as unique) as paintings. If photography has become the "new painting", as many critics claim, they have a right to demand this, and indeed will demand it – with their cheque books.

By limited we really mean limited, and finite. An end should be made, for example, to the practice of making editions defined by image size, at least where the size differential is so minimal that the reason for making another edition is simply to release more product on to the market, especially where the image concerned is clearly more saleable than another. But that's one of the problems with any kind of printmaking. Some images are always going to be more desirable than others, and potential bestsellers. Editions might take account of this, but should not exploit it unduly. There are legitimate arguments for both varying the size of a potential "bestseller", and also for making editions at different sizes. Photographers using 8 x 10 inch negatives, for example, often produce contact prints and enlarged editions. Fair enough, but once different editions of a single image defined by print size go beyond, say, three variations, the collector could have legitimate arguments about sharp practice.

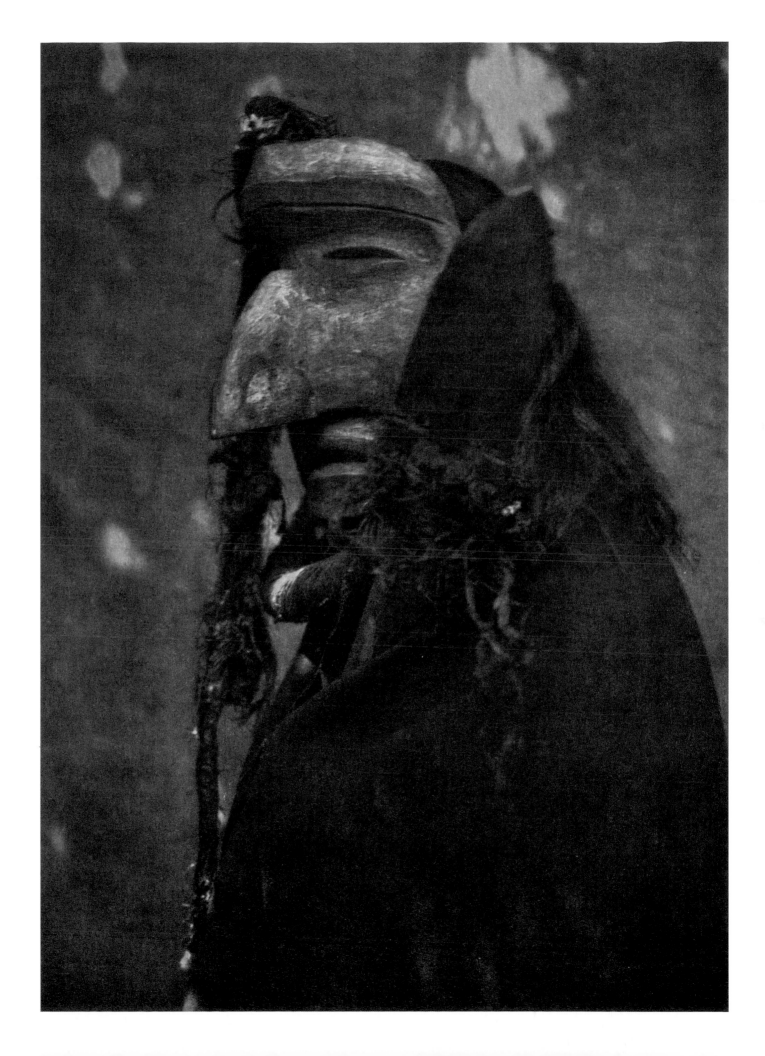

The same applies to employing different papers or printmaking techniques for an image. Today, an edition might be produced using conventional silver-based papers and hand-enlarging techniques, while in five years another might be made utilizing digital technology. There might be an argument for saying that the silver-based edition could be regarded as a de luxe edition, while the digital could be seen as a popular edition and priced and marketed accordingly. It's all a matter of perception allied with market demand.

For those photographers who claim that the serendipitous approach to printmaking will be compromised by editioning, it need not. Editioning could be simply about limiting numbers rather than producing numbers of prints all exactly the same. For example, Joel-Peter Witkin editions his prints, but since they involve a lot of hand work and difficult toning, each one is effectively unique. And some photographers set an edition size and then only make the requisite prints to order. This can mean that in

GARRY WINOGRAND
Centennial Ball, Metropolitan Museum, New York 1969
Silver gelatin print
Courtesy Fraenkel Gallery, San Francisco
Winogrand is another important post-war American photographer of the social landscape whose prints are arguably undervalued.

practice they may only make, say, 30 prints out of an advertised 50. Or print them at different times, resulting in slight differences between batches. So if you are considering buying an editioned print, ask your dealer its size, how many have been actually made, and so on. The bottom line is how many prints of an image are going to be out there.

Another editioning practice is that of the stepped edition – the "steps" being in price hikes as each print of an edition sells out. So if there is an edition of ten offered with a price of $1,000 asked, the first five collectors may pay the $1,000, but then print number six might retail for $1,200, and so on, until print number ten might attract a price of $2,500. It's a practice that rewards a prompt decision on the part of a collector, but can also lead to a certain amount of abuse, particularly if the steps are decided arbitrarily by the dealer rather than carefully set out at the beginning.

In the end, as a collector you have to decide for yourself. After all, an edition of 900 never harmed sales of *Moonrise*. Or did it? And making popular editions of work by pre-eminent artists – 500 or 1,000 using digital printing techniques and retailing for around $400–$500 – brings the work of major figures within the purse of many more people, more than the relative few willing (or able) to pay the many thousands of dollars demanded for prime prints in strictly limited numbers.

It seems inevitable that current trends are pushing photographers towards limited editions, and indeed not just limited editions but much smaller editions than before – five, six, ten at most, with many examples of unique prints. It also seems that there will be less fiddling about in the future with different sizes and differently printed editions. However, it remains to be seen whether large, popular, digitally printed editions will be a factor, probably on the Internet, possibly

not in terrestrial galleries. Certainly a move towards minuscule editions will help to allay the fears of collectors at the top end of the market, and there is no reason why that attitude shouldn't filter down through the whole market, helping lesser-known photographers and nervous new collectors alike.

It's fine to think of photography as a democratic medium, available to all; and in the form of books, posters, digital editions and the like it certainly is. One of the great things about the medium is that far less of the photograph's aesthetic aura is lost in reproduction, whereas a reproduction of a painting is a mere shadow of the original. Yet photography is also a printmaking medium. Not all photographers impart equal care in taking, but the best photographic prints have as much aura as any painting – unique tactile qualities as prints and as art objects.

One further point should be emphasized, which relates to the issue of vintage prints. If all photographers took a systematic, ruthless approach to editioning, the problem of vintage or non-vintage prints would disappear – except in the case of historic prints made in the pre-editioning days. Every new print would automatically become a vintage print, with a clear and uncontroversial provenance, for the whole question is one of provenance and rarity value.

It would seem that the market is becoming convinced that making editions, and small editions at that, is the way to a healthier market, both at the top and at the bottom. A rigorous approach to editioning would mean that collectors will feel they have something more or less unique, and more intrinsically valuable. Photographers will also benefit – they will be able to command higher prices, and they will be forced out to make new pictures.

Digital Photographs

To date, we seem to have been very concerned with the photographic past, to the extent that a good part of the photography collecting market seems as much a part of the antiques trade as the art market. But let us consider a highly contemporary issue, a key question for the photography collectors of the future. What are the implications for collecting and the art market following the recent innovations in digital photography, and more particularly, the inevitable expansion in the production of digitally produced photographic prints?

At a photographic gallery opening consisting largely of digital prints, a collector was heard to mutter "expensive posters" as he contemplated the impressive array of inkjet, iris, and lambda prints on the walls. He was not alone in this kind of perception. At the moment, many collectors are asking the same question about inkjet prints and other digitally produced photographs. Are they indeed merely expensive posters and not original photographs at all, or at the very least photographs that are of little interest to the would-be serious collector?

There are a number of complicated issues at work here. First, we are faced with the perennial bugbear confronting the photography collecting market, that of reconciling what in effect seems to be a mass medium with the business of creating rarity. With conventional photographic printing – especially the creation of fine prints – the unlimited production of identical prints from any negative was a theoretical rather then a serious practical proposition, for numerous reasons which we have discussed. With digital printing techniques, innumerable copies – 50, 500, 5,000 – are available at the touch of a button, each one perfect and absolutely identical to the last. For collectors that fact immediately brings into sharp relief the two primary questions we have previously considered – the numbers issue, and the issue of whether we are dealing with an original print or merely a photo-mechanical reproduction, literally an "expensive poster". However, has the situation regarding photography and the question of value really changed all that much? Is the situation regarding the photographic collectable not simply as it always was? A matter of perception? Of course, in the art market perception is everything, so let's consider the problems of digital in greater detail.

Whatever printing method is utilized to make a print – traditional, digital, or indeed a combination of the two – photographers and galleries will decide whether to print an edition of, say, five and sell them for a premium price to a small coterie of collectors, or print 500 and sell them at modest prices to a wider circle of collectors, or 5,000 and sell them cheaply to a mass market. That has always been the case. Digital just makes it easier and more practical. So perhaps the photographer might decide to do both – a connoisseur's and a popular edition – possibly using traditional printing for the small edition and digital for the large. However, doing that with the same image is always likely to compromise high-end sales, as any collector paying big money wants the cachet of rarity, regardless of the process by which each edition was made. The first consideration for the serious collector or investor-collector, then, is numbers. If a photographer wants to produce elite and popular editions it's probably wiser to do it with different images.

We have seen that, traditionally, some photographers have been interested primarily in the perceptual side of photography – taking the picture – and have left the printing of their images to others. Some have utilized copy negatives or photo-mechanical process as gravure or carbon and managed to make prints both of great beauty and desirability to collectors. Photographers,

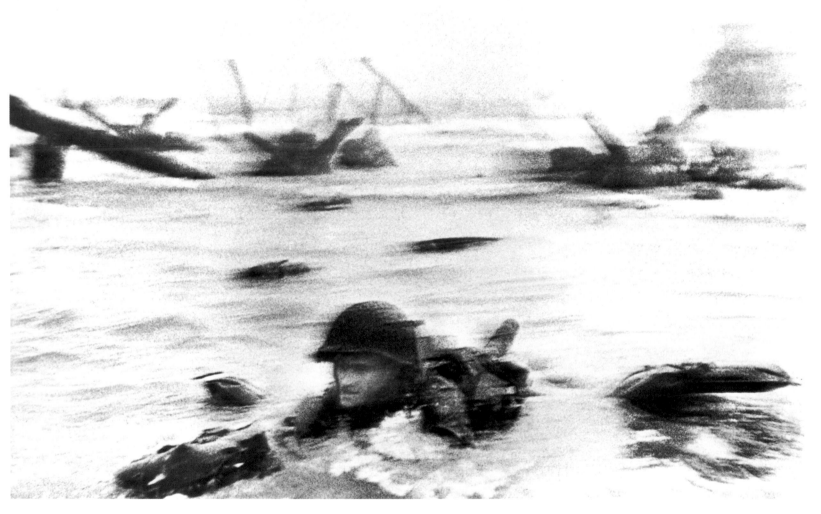

in short, have been involved in printmaking to greater or lesser degrees since the medium's invention. Clearly, some collectors only collect prints made by the photographer or very close associates, but to be a total purist over print authorship would be to limit collecting in practice to far fewer photographers than might be imagined. For those of a broader persuasion, collecting an inkjet print from a scanned negative – if approved and signed by the photographer – is no different from acquiring a beautiful Gassmann laboratory print from a Cartier-Bresson negative.

Many contemporary photographers are professing great interest in digital methods, partly because they take them away from darkroom drudgery, partly because they can see the commercial potential of popular editions, but also because some of the digital processes result in prints of great beauty. Images printed by inkjet seem to "sit" in the paper rather than "float" on the surface in the manner of most modern photo-graphic processes, much more like expensive dye-transfer or platinum prints, or that most ravishing of early processes, salted paper prints. So there are clear aesthetic reasons for choosing colour inkjet

printing over the rather more impersonal surface of type C prints. Choosing digital over conventional printing methods, therefore, might result in a more appropriate realization of a photographer's vision. However, there are technical objections to inkjet printing. The kinds of inks used to make digital prints are extremely susceptible to the action of light and do not conform to archival standards of permanence, although the industry is well aware of this and is striving to improve matters. And for photographers ideologically wary of inkjet – which is a fundamentally different process in that it does not use chemicals or the agency of light – digital information can be printed on to conventional photographic papers, and it is this halfway house that many are turning to, combining the ease and manipulative qualities of digital with more familiar printing techniques.

The technical problems of digital, therefore, have been largely overcome, leaving only a wariness on the part of dealers that the market might be flooded with cheap prints, undermining a sales structure carefully built up over 20 years, and a nagging suspicion on the part of some collectors, and photographers, that the artist is even more removed from the making process. This latter caveat, it might be added, is more likely to affect collectors of traditional photography than those interested in contemporary art photography. Collectors of contemporary art seem quite happy to pay large sums of money for inkjet prints, whereas the more conservative photography collector seems rooted in the hand-crafted, fine print tradition.

It seems clear that many leading photographers will take full advantage of both conventional and digital processes, both the connoisseur and popular markets. The value of their work for museum collections and high-end private collectors – which, after all, is where an artist's reputation is made and sustained – will be controlled by strict editioning and careful assurance regarding image provenance. Their general popularity will be maintained by making their work available to a wider audience in more readily affordable versions.

Digital printing tends to be utilized for the cheaper editions, especially where colour is involved, though this situation is changing as the technology changes and the question of permanence is addressed by the ink and paper companies. Only when several major photographers – in the $10,000 and upwards range – begin to print all, or most of their work, including their "top of the range" editions, using digital processes, will digital printing finally become a fully integrated and unremarkable part of the collecting scene. There are signs that this is at last beginning to happen, and happening very rapidly. Even photographers using traditional cameras and film, and looking to produce silver gelatin or type C colour prints, now happily scan their negatives into a computer, and after manipulating them digitally print them using one of the computer techniques that outputs on to traditional photographic paper. The messy, noxious, wet darkroom is becoming a thing of the past to all but a very few.

Buying and Selling Photographs

Buying Photographs

Once a would-be collector feels ready to make that all-important first purchase, the big question becomes how and where to buy. Fortunately, the number of places where one can buy photographs or photographic collectables is on the increase. More importantly, photography is being brought to those who do not live in the large metropolitan centres of population, courtesy of the Internet. As we have indicated, it's not as easy as one might think to acquire the print of one's dream, as any gallery stock is limited, but nowadays, thanks to modern communications, the world has become the collector's potential gallery.

However, there is a caveat about, say, someone in London buying online from a gallery in California, or bidding on the telephone to a New York auction. He or she is buying sight unseen. It is possible to see an illustration or a scan of the image, but it's difficult to tell the exact colour or condition of any particular print, although both auction houses and dealers endeavour to provide detailed and objective descriptions. However, as most experienced collectors know, if three people are asked to describe the condition of a print, you are likely to get three different answers. With most contemporary work this may not matter very much, but with 19th- and early 20th-century vintage prints, it can become a problem.

Many galleries or dealers selling mail order will send items over a certain value for approval before completing the purchase, although this involves postage and insurance, and the double risk of a two-way journey. And if someone constantly rejected items posted out on approval, the facility would soon be terminated. In the case of auctions, a successful bid is in effect a contract to purchase, so if you bid successfully by telephone and are disappointed when your purchase arrives, you just have to live with it. Therefore, unless you are buying contemporary work, or until you have experience of the market, it is probably better as a new collector to buy from one of the many outlets where you can inspect the goods, hand over your money, and walk away with the item. For any collector the main ways of acquiring a collection (apart from garage sales, flea markets, and thrift stores, which though seemingly unlikely venues shouldn't be ignored) are: from a gallery or dealer; at auction; from a photographer; from a photo fair; from the Internet or an online auction; or from a photographic archive or library.

From a gallery or dealer Visiting a commercial gallery or private dealer who holds images by the photographers in which a collector is interested, or buying from an exhibition is still the most common way of buying photographs. The great advantage of this is in being able to select, at leisure, from the dealer's stock or from the images on the walls, which can be compared readily with the other pictures by the same artist either on display or in the stock drawers. Dealers and galleries are usually able to offer a greater variety of quality material by individual names than is usually available at auction. This enables collectors to plan their purchases carefully, rather than be rushed into hasty buys by the frankly hothouse, though admittedly exciting atmosphere of an auction sale. Much of the work bought at auction ends up as dealer stock anyway, but the ability to select one's purchase in private and without hassle is worth the dealer's mark up. The larger private dealers and galleries always plan their exhibition schedules well in advance, usually over 12 months or more. So if, for example, a gallery announces in the spring that they have scheduled a Cartier-Bresson exhibit for the autumn or winter, the collector has time to set aside spare cash for that long coveted purchase.

Some potential collectors are put off by what they regard as the snobbishness of some galleries, and it's true that some major galleries can seem

JULIE SAUL
Gallerist, Julie Saul Gallery, New York

" Most vintage collectors are hot in pursuit of particular areas, particular works, particular artists, whereas contemporary dealers and collectors are constantly looking for new work, new artists, new ideas. The concept is the thing. Once a market is established for a contemporary artist it becomes somewhat like the vintage market – Cindy Sherman, for example, is now a "classic". But I would say generally that the attitude of contemporary collectors – those who patronise our gallery – is more open minded, and tends also to embrace other media.

I really have grown to like small editions with higher prices. It's a more interesting way to sell, because then everyone moves on to the next body of work. I definitely encourage my artists to make small editions and though it's difficult from an accounting point of view, I like to escalate prices as the edition sells out. It encourages people to make decisions about buying the work.

In terms of digital photography, I was never enormously interested in process, but I feel it's important to understand the possibilities of the medium in order to understand what an artist is about. When digital work first appeared, I was interested to see what it looked like. Now I've seen it perfected and developed and used in a whole variety of ways. I think it's great: it gives the artist or photographer more possibilities for making work. My only concern is that I want some authoritative evidence to convince me that the work is archival, because I feel a responsibility to collectors to sell work that will last. But aside from that, if a medium – whatever it happens to be – produces interesting and beautiful objects, that's fine by me. "

intimidating with their Armani clad staff and immaculate white walls, upon which nothing seems priced at anything less than $20,000. But any gallery or dealer worth his or her salt is just as happy (or almost) to sell a print priced at $500 as one priced at $5,000; a sale is a sale. And as there are more potential customers for the lower priced items, a good gallery or dealer will have photographs to suit all pockets, even if they aren't immediately on show. No gallery or dealer has everything, but along with the work displayed, they are selling knowledge and expertise. If a dealer doesn't have something in which a buyer is particularly interested, it's his or her job to know someone who does, and should be able to arrange the introductions for a small commission.

Buying from a gallery or dealer means establishing relationships with people who have the same enthusiasm as yourself. Most dealers sell photographs because they love the medium. Not all of them are millionaires, and there are many who have spent a long and sometimes difficult time in building up their businesses – for selling photographs, despite appearances, is not easy.

ROGER BALLEN
Dresie and Casie, Twins, Western Transvaal 1993
Silver gelatin print
Courtesy Gagosian Gallery, New York and Michael Hoppen Gallery, London
Ballen's powerful photographs are a recent example of work that rose rapidly in value in the course of one year.

With a little experience, the enthusiast-dealer can be spotted from the salesperson, and many collectors develop longstanding relationships with dealers whose enthusiasms match their own, and whose advice they come to trust.

When talking to a good dealer, you are making use of another person's eyes, and this can be invaluable to experienced collectors as well as to newcomers since it's always good to have another opinion, even when you have strong opinions of your own. Always ask plenty of questions, especially about an item's provenance and why it is priced as it is. A good dealer will give you straight answers, and above all, will allow you to make up your own mind. It's important to have time alone with the print you're thinking of buying, and also to reserve it for a couple of days. That means the dealer won't sell it until you've finally said either yes or no. If you do reserve an item, just mull it over for a day or so, maybe look at it again, and then make a clear, final decision. Dealers dislike clients who reserve things, forget all about them, and return after two months or even longer. This is gross bad manners, and will hardly get buyers on the favoured client list.

The best dealers are well worth cultivating. Not only do they have specialist knowledge on such matters as provenance and attribution, but they have an "inside track" on choice items that come on to the market, in any price range, and are always willing to point clients to such items once a relationship has been established.

A further bonus for collectors of less than unlimited means is that many galleries operate extended payment terms, allowing collectors to make stage payments on purchases, usually over six months. It is always worth asking about this, just as it is worth asking about a discount for

full and immediate payment, and for purchases in bulk.

At auction Auctions represent the glamorous side of buying and selling photographs. Every seasoned collector will have tales of the bargains they snatched from under everyone else's nose, or the occasions when they were carried away by auction fever and paid way over the odds for an item.

Generally, auction prices for most items should be slightly cheaper than you would expect to pay for an equivalent piece from a dealer or gallery. That's the theory at least. The rule of thumb is that if a gallery price is the retail price for a picture, the auction price would represent the wholesale price – star items excepted, where all the rules fly out of the window. But watch out for add-ons such as buyers' premiums (which can be up to 25 percent of the "hammer" price) or sales or value added taxes (which could be 17 percent or more). Together, such additions can total a significant amount on an expensive item, and should be taken into account when deciding what to bid, as should shipping and insurance costs if buying abroad.

Regular specialist auctions of photographs began in the mid-1970s with Sotheby's and Christie's in London and New York, and these two eminent houses remain the market leaders, though there are also significant auctions of photographic material in Paris and in Germany. Generally, each location attracts a particular kind of material. London and Paris are known for 19th-century photographs, while New York and Germany are stronger in 20th-century and contemporary material.

For the benefit of those unfamiliar with the process, an auction works as follows. A month or so before a sale, catalogues are sent out to subscribers. These list the items, or lots to be sold, and nowadays (at least at the leading auctioneers) are valuable scholarly works in themselves –

usually illustrating the lots and containing a wealth of information on condition and provenance. Which is why, even if you do not intend to bid, subscribing to buy catalogues is good practice for anyone who has a more than a passing interest in photography. They also list the particular auctioneer's terms of sale, and details of buyer's and seller's premiums, taxes, and other vital information which should be studied carefully. Moreover the catalogue contains the estimate for each lot, the house assessment of the price range within which it is expected to sell. These, however, are guides only, based on previous results, and can sometimes be wide of the mark, depending upon the volatility of the market and also the dynamic in the auction room on the day. As a rule, make your own estimation of what the item is worth, with expert help if necessary, or by checking out previous results on the various on-line databases which now give out such

MICHAEL SCHMIDT
Untitled (from *Waffenruhe*) undated
Silver gelatin print
Courtesy the artist
Schmidt's gritty landscapes in the documentary mode are freer and less monumental than the rigorous large-format images of the "Düsseldorf School".

DAVID NOBLE
Butlin's Ayr, The Continental Bar
c.1971
Type C colour print
Courtesy The Photographers' Gallery,
London and Janet Borden Inc., New York
The John Hinde photographers made
elaborately choreographed images of
British holiday camps for postcards during
the 1960s and 70s, which have recently
been reprinted in collectors' editions.

information, such as www.artprice.com or www.gordonsart.com. The estimate should not be confused with the reserve price, which is not divulged by the auctioneer and is a bottom line figure agreed confidentially between house and seller. So if the item fails to reach its reserve it is not sold, and is said to be bought in. As a rough guide, the reserve is usually somewhere around the middle of the low and high ends of the estimate, and should never exceed the high estimate. If an item has failed to reach its reserve and is bought in, it is usually possible to approach the house after the sale and offer the reserve price to buy it privately at the owner's discretion.

No matter how detailed the catalogue description, potential buyers should always inspect the goods before bidding, unless absolutely compelling circumstances dictate otherwise. Two or three days before a sale, everything is laid out for the viewing, and the lots can be inspected. This is when the old hands at the game carefully examine each item in which they are interested, and make arcane, often coded, notes in their catalogues as to condition, their priority and not-so-priority targets, and their all-important highest bid figure.

It's worth noting one of the biggest bugbears dealers and collectors have with auction houses – the catalogue descriptions. With more and more houses holding photographic auctions in different countries, the degree of expertise can vary widely. In most cases you are buying "as seen", as most houses guarantee only the authorship of an image and little else. In particular the question of what is or is not a vintage print can often be a grey area. Even experts can be fooled by some early photographic processes. In effect, the onus is upon the buyer, and at least one French court has ruled that it is the responsibility of the bidder to satisfy himself as to the validity of the catalogue descriptions. Of course the major houses such

as Sotheby's and Christie's are producing more and more scholarly information about condition and provenance in their catalogue entries now that prices have risen to such high levels, but even they can make honest mistakes, and in the case of small provincial auctions both descriptions and estimates must be taken with a good pinch of salt. It can be said fairly that the old adage, caveat emptor, applies doubly in the case of auctions, and potential purchasers must do their homework.

The major auction houses will produce condition reports upon request, and anyone planning major purchases should make use of them. In the US it is mandatory for an auction house to disclose if there are any conservation problems with regard to an item. But following that, the houses make it perfectly clear that the item is being offered "as is".

Another factor to be aware of is the damage that may be caused during the actual viewing by careless handling. Prints and other fragile photographic items conceivably receive more handling in the three days of auction viewing than in their previous existence, and accidents can happen.

So, having done one's due diligence, decide how much to bid. It is essential to decide on your highest bid on a lot beforehand and stick to it. Auctions proceed very rapidly, and unless you are disciplined, you can easily pay more than you intend – or should – for an item. Some say you should set a high bid figure and be prepared to go one bid beyond that, but it's a matter of preference. If doing this, remember that the next bid against you is two steps up the ladder, so be careful. If, say, the bidding is going in one hundred dollar steps, you make a bid at your limit. The person you are bidding against bids one hundred dollars more, so when the auctioneer throws it back to you and you make a "high plus one" bid, you will have offered two hundred dollars above your limit – in a matter of seconds.

PAUL GRAHAM
Roundabout, Anderstown, Belfast 1984
Type C colour print
Courtesy Anthony Reynolds Gallery, London
Paul Graham is an important photo-artist
making complex, enigmatic, and elliptical
pictures that update the expressive
documentary tradition.

At the actual sale, take deep breaths and take your time. The bidding quickly settles down to a pattern where the auctioneer plays one bidder against another, and anyone else has to attract his eye in order to participate. It's like interrupting a conversation – to do it well requires good timing. But when you get the chance to get into the action, make your bids clearly and decisively, and when opting out shake your head firmly. The old trick is to make a late bid, jumping in suddenly when the bidding has almost petered out, and trying to make surprise work in your favour. However everyone knows this by now; there seems little advantage in it, so you should just start to bid when you have the opportunity.

If you are successful in a bid, auction house staff will hand you a card to fill in and take to the cashier. Once the hammer has come down on a lot, a contract to buy has been made by the successful bidder with the auction house. Payment has to be made within three days and the goods collected, or interest may be charged. Most houses will not take cheques and release goods unless they know the buyer and, crucially, not all the houses take credit cards, with some charging a fee for doing so.

Different countries also have slightly different procedures, both in bidding and conditions of sale, and on whether you can actually take your purchase out of the country. Obviously, you must make yourself aware of these. For example, the French have a local auction custom known as pre-emption, designed in fairness to discourage the export of valuable French works of art, but a practice which infuriates all dealers in the private sector. If a particularly choice item is knocked down by the auctioneer, French museums can "pre-empt", which gives the museum the right to acquire the item before the successful bidder at the hammer price.

To sum up, the essential steps in buying at auction are as follows:

Read the catalogue carefully particularly the house's Conditions of Sale, which is your contract in event of a successful bid. Also carefully calculate the effect of sundry expenses such as Buyer's Premiums, any local taxes, and arrangement for making payment, including any fees that may be involved there. Learn to read between the lines of the auctioneer's descriptions, distinguishing between "vintage" and "printed later", and also such notations as "trimmed" or "unmounted." A trimmed or unmounted print might mean that, especially in the case of 19th-century work, the whole original work is not being offered for sale. On the other hand, it might just save you the trouble of removing a fine print from a potentially corrosive piece of backing card.

View in person Be fussy: if a print is in a frame, have the auction staff take it out so you can inspect the back as well as the front. Study each item, compare different images by the same photographer. Check carefully for any signs of physical damage and possible restoration, and make notes if the condition differs from the catalogue entry. If you want further assurance, or cannot view in person, ask the house for a condition report.

Register as a bidder Before you can bid at an auction, you must sign a registration form to identify yourself as a potential bidder and possible buyer. Do this as early as possible, because this usually involves a credit check, and the auction house does have the right to refuse to take bids from anyone deemed unsatisfactory; but if you are accepted you will be given a bidding number on a paddle, which you show to the auction house staff after making a successful bid.

Do your homework As soon as you receive the catalogue and have identified interesting lots, check into that photographer's recent prices and try to obtain what realtors call "comparables". Remember that as much as possible you are trying to compare apples with apples – similar images

ALEX NOVAK
Dealer, Chalfont, Pennsylvania

" While the Internet will never replace photography galleries and shows, it has become a very important medium in which to buy and sell photographic work.

Viewing, of course, is a problem with the Internet: a buyer preferably needs to see the actual photograph. Its sense of presence just doesn't exist in a digital or even a printed representation. A photograph is ultimately an object, so you must see it to make a final decision. But you can certainly get a good idea of whether an image is appealing or not on a website, and make a decision on that basis.

My advice for buying off the Internet would be make sure that anyone that you are buying from offers you a clear "return" guarantee; at the same time, don't abuse such policies. Don't bid in online auctions where you don't know the dealer, and pay attention to how dealers respond, or not, to your email inquiries, as some dealers can be deliberately ambiguous about condition. "

of similar vintage in similar condition by the same photographer which have sold in the recent past. When you view, keep making these comparisons, up to the moment you decide on a bid price.

Get a professional appraisal If you cannot attend in person and anticipate spending a substantial sum, get expert advice. Have a dealer or photographic appraiser who is attending the sale view evaluate the lots, having ascertained there is no conflict of interest over an item (if there is, it's probably a good indication of the item's worth). The dealer will charge a fee (usually five to ten percent) of the successful bid hammer price, or a set fee if either your bid is unsuccessful or you choose not to bid after receiving their report.

Stick to your high bid estimate Once you have estimated your highest bid, having carefully calculated the effect of extras, stick to it. Do not catch auction fever in the excitement of the moment or get into a battle with another bidder (though this might be understandable when you see a treasured item slipping away from you).

Take your time Bid clearly and take your time. Don't be rushed into making your bids, and you will have more chance of avoiding overbidding.

Arrange payment method in advance Make sure that you can not only pay readily for your successful bid items, but if bidding abroad, be aware of any local regulations regarding both the payment for and the shipping of your purchases. Be aware of any local regulations regarding the export of works of art.

Finally, always bear in mind what the Pennsylvania dealer Alex Novak has stated on his website (www.iphotocentral.com): "Auctions, while they can be a fun way to get a bargain, can also be an expensive way to get a lesson."

From a photographer Not all photographers – even good and potentially significant photographers – have signed exclusive contracts with dealers or galleries, so if you see a photograph you like somewhere, it's always worthwhile writing to the artist and inquiring about sales. Photographs are shown in many places other than galleries – in

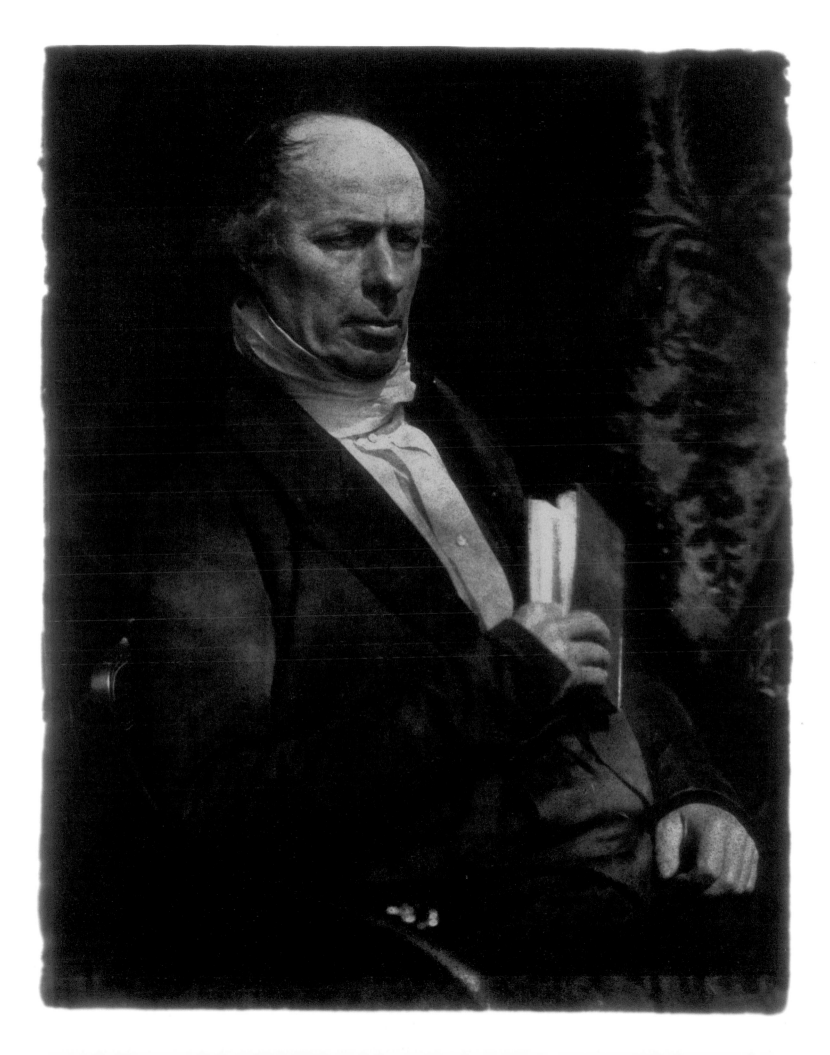

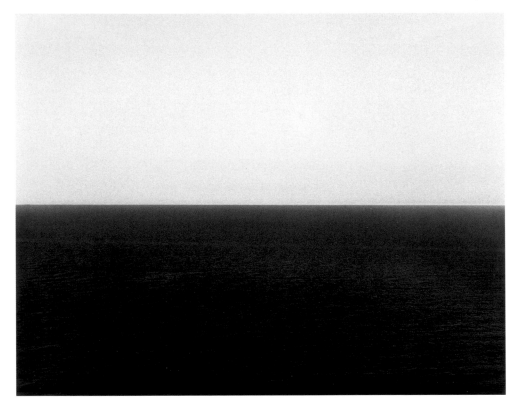

HIROSHI SUGIMOTO
465 Bass Strait, Table Cape 1997
Silver gelatin print
Courtesy Gallery Koyanagi, Tokyo
Sugimoto's enigmatic, Zen inspired
imagery and wonderful prints have
ensured that the prices paid for his work
are extremely high.

Saatchi Collection at a college show or through their first exhibit in a lesser-known gallery.

From a photo fair Since the early 1990s, photo fairs have become a popular feature of the photo scene. These now take place in many cities and at all levels of the trade, ranging from the big international fairs like AIPAD in New York in the spring and Paris Photo later in the year, where the top international dealers are represented, to smaller fairs where local dealers and even individual photographers will rent stands or tables and lay out their wares. Nowadays, in the contemporary art world, a lot of the work to be seen at such well-established fairs as Documenta in Kassel or the Venice Biennale is photographic in nature.

Fairs, like the viewings at auctions, are useful for gathering together dealers and work which you are not likely to see collected in one place, and also for gauging the state of the market. Even these days, there are bargains to be had for the sharp-eyed, and even if you aren't buying, fairs are a splendid way to see a lot of pictures. Photo fairs may be general, showing anything and everything, or quite specialist, such as those devoted to the many interesting side roads of photography, such as stereographs, photo-postcards, cartes-de-visite, and the like, as well as books and cameras.

From the Internet Since the late 1990s, this has become one of the fastest growing (or at least the most talked about) area of the collecting market. Whatever its initial teething problems – and there are problems for both sellers and buyers – there is no doubt that Internet buying is here to stay, and will settle down to provide a distinctive and valuable adjunct to the terrestrial art market, whatever share of the market it eventually takes. Buying photography by Internet can mean almost anything, from dealing with Internet "galleries", to using the computer as an alternative telephone, fax, or postal service, to online auctions.

The problems of buying on the Internet are

restaurants or shops, for example – so again a letter directly to the photographer might result in a treasured purchase.

Many seasoned collectors and dealers make a point of visiting college shows or not-for-profit auctions, where young photographers hoping to make their mark in the art world display their work for the first time, and the economics of student life being what they are, are extremely susceptible both to praise about their work and offers to part with it. All the photography world knows the story of the English photographer, Nick Waplington, who was discovered by Richard Avedon at the degree show of the Royal College of Art in London. Avedon not only purchased work but made introductions for Waplington in New York that eventually led to a contract with the publisher Aperture for publication of a monograph. And many young artist-photographers in London have begun their career with the purchase of their work by the

twofold: first, the usual issue of giving credit card or other personal financial details over the web, and secondly, not being able to see prints in person or check on their condition, which is not so much of a factor when buying contemporary material, but is when buying vintage prints, though reputable dealers allow for a print to be returned if the buyer is not satisfied. Which brings us to the basic rule for dealing with Internet galleries: deal only with reputable companies.

Online auctions are becoming an increasingly popular way to buy photography, although at present they account for only a small percentage of the market, particularly in gross turnover, as it deals generally with items selling at less than

$2,000–$3,000. A typical online auction will offer a mixture of photographic collectables – photographic ephemera, 19th-century topographical and vernacular photographs, photobooks, "late" prints and dealer's "stock", prints by young, yet to be established photographers. In other words, the online auction houses have mopped up the kind of material the regular auction houses would nowadays tend to reject, but in amongst them you can find gems. As such, it can prove to be an interesting and valuable part of the market, especially for picking up cheaper and more offbeat items. But remember the caveats about auctions and buying online – it follows that they count double here!

An online auction works like a regular auction –

EDOUARD DENIS BALDUS
Arènes de Nîmes 1853–6
Albumen print from a waxed paper negative
Courtesy Basil Hyman
Some regard Baldus as on a par with Gustave Le Gray, and his finest work can command similar prices, though it is generally more available.

SEBASTIAO SALGADO
Serra Pelada, Brazil 1986
Silver gelatin print
Courtesy nb pictures, London
During the 1990s Salgado became the most
popular photojournalist, and his finely
crafted prints are in great demand.

highest bidder takes the prize – except one is bidding against the clock. Like a tendering procedure, a time is set for the closing of bids. The countdown to the fall of the hammer is shown in a dialogue box on your computer, along with descriptions of the item and the bid history. This can lead to an online frenzy at the end of a popular lot, as buyers try to time their bids to the last second – although in practice at this particular time, most lots are lucky to attract one or two bids. The future of online auctions will probably lie in "realtime" auctions, where buyers gather round their computers at an appointed hour and bid against each other as in the auction house or by phone.

Buying photographs online is not as active as, say, the buying of photobooks, but this is a matter of perception. Collectors undoubtedly feel more assured about buying books on the Internet as opposed to original artworks; however, this will slowly but surely change. In what seems a significant move, in 2002 Sotheby's teamed up with leading online auctioneers, www.eBay.com, in a joint venture bid to consolidate this market and reap its potential rewards.

The online auction market will inevitably grow, but by how much, no one is quite sure. Currently it seems a useful way to pick up some nice dealer stock at favourable prices – especially contemporary work, where condition is not such an issue – but whether at prices lower than you could negotiate yourself, seems open to question.

From a photographic archive or library
Institutions such as museums and libraries, government bodies, city councils, learned societies, and the like, have extensive photographic archives, as distinct from collections of art photography. Many of them make prints of photographs in their archives available for purchase, so this can be a relatively inexpensive way of acquiring a photographic collection, although it would be strictly a collection of

reprints (if you're lucky) or, in most cases these days, copy prints. However, some of these collections contain work by very notable photographers indeed.

Probably the best-known sources for institutional photographs are the Library of Congress in Washington, D.C., and the Photographic Service of the French National Archives in Paris. The Library of Congress has work available by Civil War photographers such as Alexander Gardner and Timothy O'Sullivan, by the great labour law campaigner and photographer, Lewis W. Hine, and by the photographers who worked for the Farm Security Administration project in the 1930s, including Dorothea Lange and Walker Evans. The Parisian archive contains a vast selection of images by the great Eugène Atget, and many other early French documentary photographers.

Selling Photographs
Usually collectors are concerned with voraciously adding to their collections, but there comes a moment when every collector has to think about parting with items. It is at that time they discover that it is generally a lot easier to acquire photographs than to sell them – unless of course they have a desirable item that's been around accumulating value for 20 years, or it's an old Man Ray or Le Gray vintage print.

In general terms, any collector will have to work hard to dispose of photographs for quick cash. If you buy an image from a dealer, maybe paying a premium price for it, then look to sell it back to him three months, or even a year later, you might be shocked to find that you're offered something like 50 percent of what you paid. But that's the market. If the print is especially good (this is where the advantage of buying vintage becomes evident), and you're a convincing negotiator, you may be able to negotiate the price upwards, but you will always be selling at wholesale rather than retail

price. To do better, you must own something spectacular, and then you might want to think about putting the print into auction.

Unless you are selling to someone you know – another collector perhaps, or a museum – or taking a stall at a photo fair, your options for selling will be limited to dealers or putting the item into auction. The auction and dealer option each has its pros and cons. In the case of a dealer you negotiate. The dealer makes an offer. You can haggle and trade, but in the end, it comes down to a simple take it or leave it – in a contest

where the game is rigged. A seller (unless very experienced) inevitably thinks an item is worth more than it is, while a dealer knows exactly how much it's worth. However, you can, if you prefer (and this is a frequent practice) employ a dealer to sell the print for you on commission (around 20–25 percent but it can be as much as 50 percent). Or you can ask a minimum price for yourself and not worry about the dealer's mark up. Either way, the print is unlikely to be sold instantly, but this is a good and (generally) fair way of selling if you can wait for the sale monies.

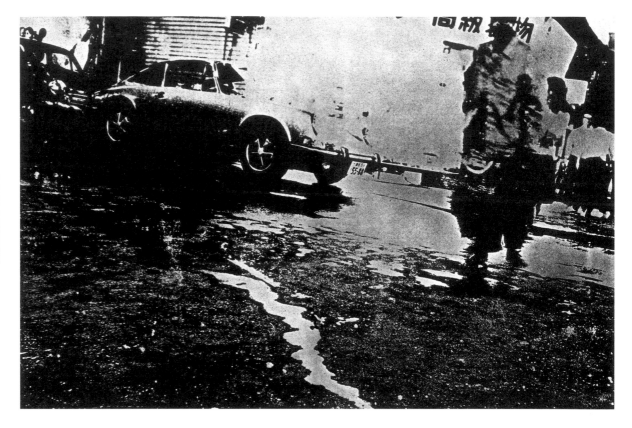

Once the dealer has exhausted his contacts, he will soon tell you whether your expectations were realistic or not.

An auction sale is perhaps more of a gamble, but has one great advantage – a captive audience of potential buyers in the room. But you pay for that with the auction house's commission, which is at least comparable to a dealer's, and should be factored into the equation, along with any sales taxes, handling and storage charges, etc. Again, assume a minimum of 25 percent and a maximum of 50 percent once you factor in everything.

Don't expect too much. You may be lucky and have two passionate collectors fighting over your particular lot, but remember that most of those attending photo auctions are hard-nosed experienced dealers and collectors, who have selected their targets for the day and won't pay a cent over their personal estimates of a lot's worth. If an item is special, it will sell well; if it's routine (and much of what is on offer in auctions is routine), it may be picked up by a dealer for "stock", but again at what may be regarded as a wholesale rather than retail price. You can set a reserve price, but be guided by the auctioneer on this if you're serious about selling; and don't be too greedy, otherwise all you'll end up with is the auctioneer's costs for an unsold consignment, a buy-in fee which is usually around five percent of the low estimate.

In the end, selling photographs comes down to this. In order to sell well, you must have bought well. We return to our old adages about the best pictures and condition. In collecting, in art investment, in buying and selling photographs, you cannot say fairer than that. If you don't need to sell immediately, it might be worthwhile to sit

back and enjoy your expensive purchase for a number of years before selling. Then you just might be pleasantly surprised.

Fakes and Forgeries

Inevitably, one of the first questions on any potential art collector's lips is, "What about fakes and forgeries?" Considering photography is a mechanical reproductive medium, and the recent high prices, one might suppose fakery is rife in the photographic market. But in fact – at least until the present – the opposite is true. As leading auctioneer Philippe Garner has indicated, "photography has been remarkably free of the attentions of fakers and mischiefmakers".

Garner put this down to the fact that the market, until recently, has been relatively small. Most of the principal players have been in it since the 1970s or early 80s, and have a great deal of experience in handling photographs, making effective forgery difficult. In other words, in photography there is a high level of connoisseurship, probably still the most effective defence against fakery. Garner has a point, but there are also other reasons. Contrary to what one might think, it's not so easy to make a convincing forgery of a historical photograph, the kind that fetches big money. First of all, the images that make the most are well known. Secondly, replicating old processes exactly is not as easy as it sounds, and then, if trying to pass off an undiscovered "masterpiece" by a well-known photographer, there is the question of subject matter and style.

Interestingly, the most successful attempt at fakery so far was an attempt to introduce a "new", hitherto unknown Victorian photographer by the name of Francis Hetling, and significantly, this was during the early 1970s, when the market was not so practised and aware. A 1974 exhibition at London's National Portrait Gallery, The Camera and Dr. Barnardo, contained a number of salt prints of young girls in rags, along the lines of Lewis Carroll's imagery, but purporting to show documentary images of poor Victorian children by Hetling. In an article in the London *Sunday Times* dated 19 November 1978, the Hetlings were exposed as fakes, and declared to be the joint work of the artist Graham Ovenden and the photographer Howard Gray. Ovenden, who was known for both painting and photographing prepubescent girls and also collecting Victorian photographs of them, had evidently taken the pictures, dressing and posing modern girls in rags. Gray, an expert in early photographic processes, had made the salt prints. The subterfuge had come to light when a relative of one of the girls had recognized her and contacted the newspaper. Ovenden and Gray fooled the photographic world for a while, but as intimated, the degree of connoisseurship at a point when the market was in its infancy was not as it is today, and looking at the pictures with hindsight, even those fooled will find it difficult to believe they were taken in so easily.

Probably daguerreotypes and photogenic drawings offer the most likelihood of success for would-be forgers. If the faker uses a genuine cheap portrait daguerreotype and bleaches the image, then recoats and makes a new photograph of a nude, presenting it in a genuine case, the new item might be worth a few thousand rather than a few hundred dollars. Similarly, a photogram made on old Victorian paper might be passed off as a genuine early photogenic drawing and make a few thousand. Only analysis for trace elements not present in Victorian photographs would detect the fraud.

Arguably a more pressing problem for the market is that of later or posthumous prints from well-known photographers being passed off as vintage. There have been two well publicized instances of these in recent years, indeed so well publicized that the market is constantly on the

JOHN BENNETTE
Collector, New York

" I try to spend no more than about $1,000 on a work. Amazingly, it is still possible to do that, though it's very hard and sometimes you have to break your own rules. So I tend to concentrate on emerging artists. I've no qualms with people who spend $200,000 on a vintage print, but my belief is if you love the image, you can be just as happy with a 60 cent postcard. The photograph is the important thing, and a photograph is the image, not its price tag. In any case, you never really "own" the image; you're only a caretaker.

Collecting is not just about having taste, it's about educating the eye. It also has an autobiographical aspect to it: you go out and acquire photographs that resonate in a personal way with you. When I first started collecting, I bought black and white images and a lot of 19th-century work in what are now called "alternative processes". Lately I see more and more colour entering the collection. But on the whole the collection is very broad ranging, which allows me to like a photograph without saying, " well, it doesn't fit in with my theme". I guess I have a classical approach. I certainly don't worry about images going in and out of fashion – I buy what I love. **"**

lookout for this kind of thing. In the first case, the collector Werner Bokelberg was sold a number of important images by Man Ray, which were purported to be vintage prints when in fact they had been printed (though from the original negatives) in the 1990s, long after Man Ray's death. Similarly, a number of dealers in America had been duped by "vintage", signed Lewis Hine prints. When physicist Michael Mattis made tests on some of these prints, it was shown that they were made on paper manufactured at least ten years after Hines' death. Since the difference between vintage and non-vintage prints in either case is many thousands of dollars, these were serious cases of fraud, but in both cases, the collecting field itself identified the problem and drew attention to the appropriate authorities. In the Hine case, a million dollars were put into escrow funds to reimburse disappointed buyers.

Following these two scandals, the market is on high alert, with two main defences – connoisseurship and science. In the case of well-known photographers, prints from a hitherto unsuspected source are now going to be treated with suspicion, as are 19th-century prints that look too new. Even the richest prints from the 1840s and 50s have acquired a patina of age which is difficult to duplicate. While fakers could always raise their game when the stakes are as high as they are in the current market, in the end, it is clearly in the market's best interests to guard against forgers and misrepresentation. The confidence of collectors is one of the market's most important assets, and it can easily be lost, especially in a market where collectors are unsure of how many primary prints of any one image exist. It emphasizes the importance of clear, proven provenances. But as the San Francisco collector Paul Sack has warned, "It's buyer beware. You should always hope for the best, fear the worst, and protect yourself."

BRUCE DAVIDSON
From *East 100th Street* 1966
Silver gelatin print
Courtesy Magnum Photos
Davidson's work is squarely in the humanist
tradition. The first edition of *East 100th
Street* is a classic with book collectors, and
has recently been republished.

Displaying and Caring for Photographs

FREDERICK H. EVANS
'A Sea of Steps', Wells Cathedral 1903
Platinum print
Courtesy Basil Hyman
A classic pictorialist image and a fine
example of printmaking, Evans's work
has always commanded premium prices
among collectors.

DR. JOHN MURRAY
'Nynee Tal', Study with Ruined House
*c.*1858–62
Waxed paper negative
Courtesy Daniella Dangoor, London
The large waxed paper negatives of Murray
are collectable in their own right. This
superb example retails for around $6,000,
together with a contemporary positive print.

Photographs, in the main, can be categorized as
"works on paper". Although one can spray light-
sensitive emulsion onto almost anything and print
an image – plastic, fabrics, wood, and metal are
favourites for experimentally minded photogra-
phers – probably well over 95 percent of all the
photographs collected are paper prints. Thus we
have a light-sensitive medium – indeed, a medium
activated by light – on a paper support. The vast
majority of photographs, therefore, warrant similar
preservation, storage, and display techniques as
are given to drawings, watercolours, etchings,
lithographs, screenprints, and the like.

Photographs are fragile, extremely susceptible
to damage, and in the past, they were not always
treated with the respect the medium commands
today. Even 30 years ago, there were few trained
in the science of conserving photographs, and
little research was being undertaken in the field.

Since the beginning of the 1970s, however,
the growing interest in collecting has changed all
that, and now every museum with a photographic
collection or major private collector either employs
permanent conservation staff or has ready access
to conservation consultants. Thus curators,
collectors, and photographers alike have become
much more aware of the issues involved, and a
new profession, that of photographic conservator,
has become established.

Without proper care in storage or display,
photographs can stain, fade, or discolour, or
otherwise deteriorate in ways that are sometimes
irreversible. Most photographic conservation
means following basic, commonsense practices,
but any work other than the basic, such as repair
or restoration, is best left to an expert. So if in
doubt, employ the services of a conservator, who
could both enhance the appearance and value
of your collection. The relatively small outlet
required for such a service will undoubtedly
save you money in the long run.

The two main factors which cause damage to
photographs are physical and chemical. Careless
handling or destructive attempts at restoration or
repair are the main physical factors, while the fact
that a photograph itself is a chemical entity and
paper potentially deteriorates due to our inher-
ently polluted atmosphere are the main chemical
factors. Not only will the emulsified surface of a
print degrade, so will the paper base supporting
the emulsion. Correct handling and conservation
merely slows that process down, until, in the case
of the best museums, it is virtually, but still not
totally arrested.

Handling a Photograph

As Lee Witkin and Barbara London have written,
"careful handling is the simplest and one of the
most important conservation techniques". But
any photographer who has shown work at a photo
fair will have horror stories about a member of
the public who has carelessly picked up a print it
has taken many hours to make, depositing greasy
finger marks over its delicate surface, producing
stress marks in the paper or emulsion by not
supporting it properly if it's unmounted, then
rubbing it against another print when putting
it down. Auctioneers, too, are often driven to

THOMAS JOSHUA COOPER
The North-Most Point – The North
Atlantic Ocean, Malin Head, County
Donegal, Ireland (Malin) **1986–2002**
Silver gelatin print
Courtesy Haunch of Venison, London
Cooper has been successful in updating the
Stieglitzian tradition in photography, and his
stunning, gold-toned prints are highly prized.

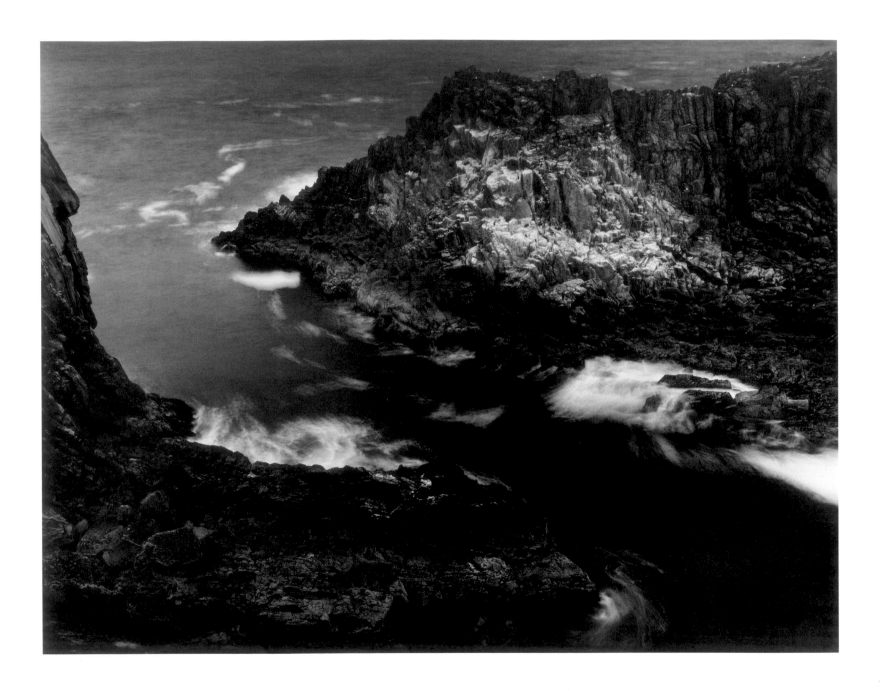

KARL BLOSSFELDT
From *Urformen der Kunst* 1928
Photogravure
Courtesy Focus Gallery, London
Blossfeldt gravures from his classic book
Artforms in Nature, retail for around
$300–$350 and are very good buys for
beginning a photo collection.

distraction by the way valuable lots are frequently handled during the viewing for an auction, a necessary but sometimes damaging part of the sales process. So be careful. Handle prints as little as possible, and always with clean hands. Most reputable dealers and museums provide white cotton gloves for the handling of prints, a practice considered effete by some, but if one values photography it surely deserves every possible care.

If the print is mounted on a card mount, handle it only by the mount. Perspiration and oil from the fingers will not only degrade a print surface cosmetically, causing stains and smudges, they will attack it chemically. If the print is unmounted, hold it carefully by the edges, supporting it with both hands, and try not to get any fingerprints on the print surface. In particular, great care must be taken when handling unmounted prints on thin paper. For example, albumen paper is generally lightweight and prone to curling, while some

images – by Edward S. Curtis for instance – have been printed on fine tissue paper. Rough or careless handling can easily produce stress marks in the paper, minute "wrinkles" which once there cannot be removed. And never shuffle a pile of prints like a pack of cards. Sliding one print against another not only produces a risk of stress marks, it is likely to cause surface abrasions. Dropping a print or putting something heavy on top of it can also cause serious physical damage. Once a print has been damaged in this way, there is often little that can be done to repair it fully. While all this sounds elementary, it is surprising how many people ignore these simple, common-sense precautions.

Light

One of the most dangerous elements for a photograph is light, the very thing that brought it into being. The light-sensitive chemicals in a photographic emulsion are made stabile – "fixed" – during processing, but stability is a relative concept. Light causes colours to fade, causes some photographic chemicals (particularly residual chemicals not washed out during processing) to discolour, and tends to make paper brittle by breaking down fibre compounds. The shorter light wavelengths, those towards the blue and ultra-violet end of the light spectrum, are the most damaging. So direct daylight, especially sunlight, is to be avoided, as are many types of fluorescent lamps. The golden rule is: never hang a photographic print in direct sunlight, and avoid strong daylight unless hanging for a short time. Filters are available for fluorescent fixtures that will remove most of their ultra-violet radiation, and plexiglass rather than glass in frames also protects against uv rays.

Whatever one might say about the potential action of light on ordinary modern prints, that is to say 20th-century black-and-white silver gelatin

PATRICK LAMOTTE
Chief Conservator, Bibliothèque de
France, Paris

❝ With regard to the care of prints, there is a significant difference between the restoration and the conservation of photographs. Conservation is a preventative process – a print may require the removal of certain elements which will help prevent deterioration in the future. So conservation can be seen as part of safeguarding the future of a work. Restoring a print, however, is another matter altogether. Obviously each case is different, but on the whole, it is potentially very damaging. Intensification of a print, whatever the period, is very complicated and frankly unwise, as it requires absolute precision in terms of the chemicals used. Indeed, in France it's prohibited: it's regarded as tampering with the historical integrity of an object. ❞

prints, counts at least double in the case of 19th-century albumen or salt prints, and colour photographs. Colour will be dealt with below; but the fragile nature of many 19th-century prints begs the important question: is it safe to hang an albumen or a salt print? If you frame and hang a favourite 19th century print, are you just going to witness a substantial investment disappear before your eyes? This is a tricky issue as it seems a great pity to buy a 19th-century print merely to keep it out of the light, and sight, in a storage box.

Nevertheless, if one has a good strong print, evidently processed with care and stored in good condition, hanging in indirect light could reasonably be considered. In this respect, albumen prints are likely to fare better than salt prints. Better still, if you have them, prints made with platinum rather than silver salts, and prints made by photo-mechanical processes such as carbon prints, woodburytypes, or photogravures, are extremely resistant to the action of light, and may be considered "permanent". But the rule about direct sunlight and strong daylight still applies.

Some collectors will never risk their valuable 19th-century prints – especially salted paper and albumen prints – and keep them in boxes or cabinet drawers, taking them out now and again to have a look at them. Others, using a system of frames with removable backs, might "rotate" them carefully on their walls, hanging them for a few months (in suitably subdued lighting), then choosing others, in an ever-changing display. Indeed, this is a useful strategy for the display of any photographic collection.

Heat and Humidity
Temperature and relative humidity are also potential enemies of photographic prints. Lowering both temperature and humidity decreases the risk of unwanted chemical activity, both in the print and its mount. Although excessively low humidity might possibly lead to brittleness and cracking of the photographic emulsion, the greater danger is high humidity, the cause of mould growths that can stain or yellow prints, from chemical reactions in the gelatin emulsion or the starch in paper or adhesives. For example, "foxing", a mould growth that manifests itself in rust-coloured spots on the surface of a print or mount, is caused by high humidity. So is fading due to the silver of a print oxidizing.

The safest way to prevent such problems is to keep the humidity low, coupled with good air circulation. Museums typically recommend a constant

temperature of about 18 degrees Celsius (65
degrees Fahrenheit) and about 40 percent relative
humidity. This is difficult to achieve without full
air conditioning with humidity control (and many
museums in truth do not achieve it), but most
problems can be avoided with a little common
sense. Do not store or hang prints near a fireplace,
above radiators, in damp cellars, or cold attics.
Try for a temperature no higher than *c.*21 degrees
C (70 degrees F) and a relative humidity below 60
percent. Moderation is the keynote. Extreme fluctu-
ations in both temperature and humidity are to be
avoided as they cause repeated and damaging
swelling, followed by contraction of photographic
emulsions, and sometimes moisture condensation
on print and mount. And anyone collecting
expensive photographs or works of paper in a very
humid climate should have recourse to air condi-
tioners, dehumidifiers, and bags of silica gel in
storage boxes or print drawers to remove moisture.

Chemical Pollution

There are three main areas where chemical pollu-
tants can cause deterioration in prints; two may
be termed external factors, the other internal. First,
the most common cause of atmospheric pollution,
sulphur dioxide resulting from industrial processes
and vehicular emissions, combines with oxygen
and moisture to produce sulphuric acid – "acid
rain" – a corrosive agent that attacks prints and
paper. Various other noxious emissions from
industry and motor vehicles, fumes from household
solvents and paints, smoke and smog, airborne
dust particles, salt and ozone in air by the sea, are
all harmful to photographic images if exposure to
them is prolonged or excessive. Here again, the
best protection comes from full air conditioning,
the kind where the air is filtered "clean" as well as
temperature and humidity controlled, though this
is an ideal only a few can attain.

Secondly, as acid is harmful to paper (and not
all paper manufactured is free from internal acids),
it is essential that everything that comes into
contact with a print should be "acid free" or "rag",
the manufacturing standard adopted by museums
over the last 30 years or so for any product used
for storing and conserving works on paper. After
handling, this is probably the most important
factor in conserving one's precious prints. The
rules are fairly simple. There is a wide range of
recommended archival materials commercially
available, both for the storage and mounting of
prints – acid free boards and papers, storage
envelopes and sleeves, archival portfolio boxes,
water-based glues, and so on. Although you pay
a premium for them, the expense involved is negli-
gible in relation to the value of most prints today.

But be careful. Many collectors and photogra-
phers do not realize that standard commercial
mounting boards, such as found in everyday art
stores, are not acid free, or rag. Indeed, they will
positively harm works on paper, as will ordinary

sticky tapes and glues, such as the Spraymount kind of material. They are not manufactured in relation to valuable artworks. Always ask for materials that are either labelled acid free, rag, or of archival standards, although some manufacturers can be a little free with the terms. And when having a print framed, make sure this is done to archival standards. As always, deal with reputable companies. These can usually be determined by a little research and asking around.

Photographers today should, if intending to sell their prints, have processed them "archivally", taking care in a series of complicated steps that all potentially harmful residual chemicals have been eliminated from the print. But any photograph and mount dating from say, before 1970, may not have been processed or mounted using standards or materials that would pass muster today. Or indeed, they may not have been stored in the kind of elementary conditions which are *de rigueur* nowadays. Yet many prints from the pre-World War Two era have survived in perfect condition. Many, of course, have not, and this leads to whether it is acceptable to restore an image.

Nineteenth-century prints, in particular, are prone to suffer from problems associated with the often highly acidic card on which they were mounted. The fading of such prints is not simply a question of light, but a combination of issues including inadequate "fixing" and washing, and unsuitable card mounts and glues. In the first few years of photography, for example, it took some time to realize the vital importance of fixing the image with "hypo", then washing away the residual, potentially harmful chemicals. When William Henry Fox Talbot held exhibitions of his prints in the mid-1840s, they had often faded before the work was taken down.

The inadequacy of mounts, both in the 19th century and later, leads to the question of whether it is desirable to separate the print from its

original, potentially harmful mount, and remount it using modern archival materials. Albumen and salt prints from the 19th century were usually mounted on to card with water-based glues, so it is a relatively easy matter to "soak" them off the mounts, re-dry them and remount them, or simply leave them unmounted. But whether one does this depends on the character of the mounting. Often titles and the photographer's name were printed on the mount, sometimes even a commentary on the image. Dry-mounted 20th-century prints might bear the artist's signature below the image or on the back of the mount. So in that case, the mount becomes part of the print as an object, and should not be separated from the image.

In other cases, particularly the more commonplace work (which is likely to have been less thoroughly processed and mounted on more inferior materials), it might be advisable to remove the print from its backing. A good dealer would be able to advise on this, and arrange for it. Nowadays dealers will often offer the ubiquitous 19th-century topographical print in an unmounted condition, having arranged for removal themselves.

One further word of advice. Never try to "soak off" a print yourself. Leave it to the experts. A few dollars expended in that may mean a greater number of dollars saved, not to mention a great deal of aesthetic pleasure.

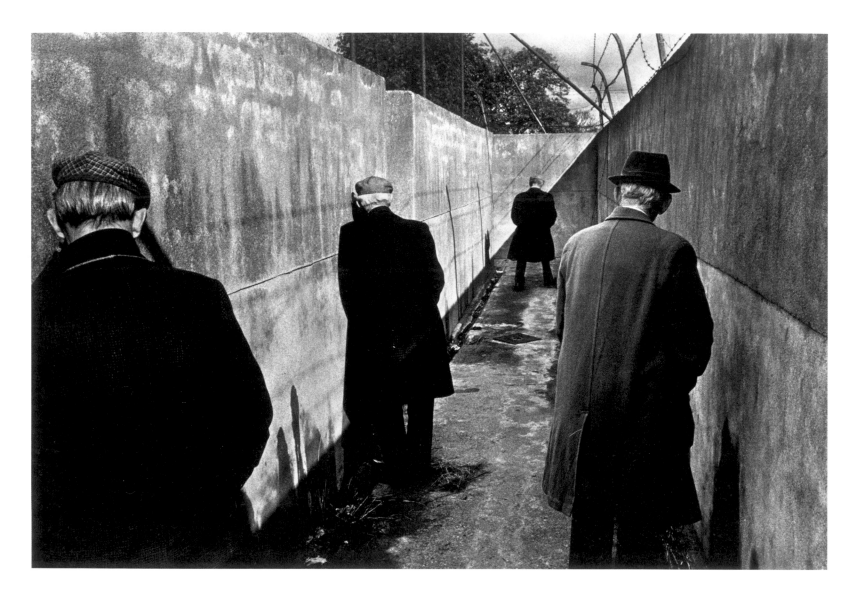

Colour and Digital Prints

Most of the work being made by contemporary photographers is in colour, printed usually either as resin-coated chromogenic (type C) colour prints, or printed in ink using computer printers, of which the iris print is best known, among a number of other processes. Until around the mid-1970s this was not really a problem for collectors, as few "serious" photographers entertained the idea of working in colour. "Black and white is the colour of reality," maintained the American photographer Robert Frank, and few disagreed with him – until 1976 when an influential and controversial exhibition at MoMA, New York, by a then little-known photographer, William Eggleston, put colour firmly on the agenda for art photographers. Today at least 80–85 percent of all the creative photography made is in colour.

However, the problem is that, unlike black and white, colour photographs are composed of dyes which are notoriously susceptible to light damage. Some 70s colour prints are already beginning to

show signs of yellowing and colour shifts, and some have been bought in at auction. Since the problem first became apparent, colour print technology has improved tremendously, and manufacturers of both conventional and digital photographic papers are continually endeavouring to bring their products up to the archival standards demanded by the market in general.

Inkjet materials are being manufactured from pigments rather than dyes and, together with improved paper bases, can provide archival standards that are very good indeed. Many photographers are beginning to use Fuji's "Crystal Archive" paper, which has superior archival qualities to more conventional type C print papers. So the collector in general can feel much more secure when buying colour work. However, if uncertain about the archival qualities of any colour process, if you log on to www.wilhelm-research.com you will be provided with up-to-date information, based on the research carried out by this institution.

Storing Photographs

One presumes that if one values a photograph and wishes to display it, it should be framed, which sounds obvious, particularly as we have previously categorized most photographs as "works on paper". However, with photography nothing is quite so simple, and the historical status of the medium intrudes once more. Even in the mid-20th century it was widely considered pretentious to frame a photograph, unless it was a family snapshot in a gilt frame on the dressing table. For exhibition purposes, the done thing was to glue prints without borders on to pieces of plywood, masonite, or block-board, or pin them directly to display panels or walls; anything to proclaim that photography was an ephemeral, non-precious medium. Why go to the expense of framing a photograph when there will be another along in a minute?

This anti-elitist attitude even penetrated the august halls of MoMA. The famous Family of Man exhibition of 1955 was unframed, the images pasted directly on to large freestanding and hanging display panels. The immense amount of travelling this exhibition was required to do might have justified this treatment, but not so Bill Brandt's MoMA retrospective of 1966, where each print was mounted using the blockboard method. Thus arguably the finest prints Brandt ever made were pasted directly on to wood and shown without glass, a situation which certainly would not apply today. Unless removed from the ply or blockboard support, conservation problems would inevitably ensue due to the leaching of harmful resins from the wooden backing, if not from the adhesive used to mount the prints.

Despite the strides made by photography in the last four decades, a residue of this anti-elitist attitude has remained, and recently there has been a revival of non-framing display techniques, particularly in some avant-garde circles. For certain artists, the photograph, even their own, is a kind of "found" object, not to be regarded with any degree of preciousness, so they might tear and wrinkle their prints – "distressing" them – before charging a collector many thousands for the privilege of adding them to his or her collection.

Some artists also tend to denigrate framing, simply because the frame is associated with traditional easel painting, giving rise to (amongst other things) the current fashion for pasting photographs, especially colour photographs, on to sheets of aluminium without protecting them with glass or plexiglass. Even the old standby of pinning unmounted prints directly to gallery walls is making a comeback.

But for most of us, framing is the ideal way both to display and protect a favourite photographic image. Once you have acquired more than, say, 20 photographs in your collection,

MARK HAWORTH-BOOTH
Curator, Victoria and Albert Museum, London

“ If we compare today's photography market to that of the 1970s, there is indeed less very good material available. This is certainly true of 19th-century work, though it also applies to a great extent to material from the 1920s. However, it depends what you want to do as a private collector. If you want to collect blue-chip photography from the 1850s to the 1920s, you are obviously going to be in an exclusive class of collectors. But there is so much else in photography to consider – including work by anonymous photographers. I think it's foolish to limit oneself to received history if you're going to be a collector.

The best thing for any collector to do is to look at as much material as possible. You have to use your personal judgment, but in fact subjective judgment is formed by objective knowledge. So if you're choosing a Bill Brandt photograph, for example, you must learn about the full range of Brandt's work, and make sure you see as many of his prints as you can, since he's printed work in different formats and at different periods. You need to acquire information about a photographer on as broad a front as possible.

Having informed yourself as much as you can, you need to trust your own instincts, and not be worried about what anyone else is doing or collecting. Choose things that give you a genuine kick. ”

wall space for hanging becomes a premium. Like museums, most individual collectors cannot hang all their collection, so a proportion of it – often a considerable amount – must be stored, unframed. And an unframed print is vulnerable. There are two basic options for storing unframed prints, mounted in card "window mats" or left unmatted.

Unmatted prints take up less room, and it's certainly cheaper to leave them that way, but leaving aside the expense, space-saving is the only tangible advantage enjoyed by unmatted prints. However, if storing them unmatted, always keep them in an archival standard envelope or sleeve, either made from acid-free or rag board, or a transparent material like polyethelene, polyester, or mylar. Transparent materials have the advantage that one can view the print without the attendant risks of removing it from and replacing it in the sleeve, but when buying clear sleeves, ensure they are archival and contain no harmful plasticizers. Polythene, as opposed to poly-ethelene, is not recommended. Polyester is ideal as it is acid free, inert, brilliantly clear, contains no plasticizers, and will not crack or yellow with age. Once again, buy the specially manufactured product from the specialist manufacturer. Only that way can you be absolutely certain of the product's archival suitability.

Unframed prints, matted or not, should be kept in archival standard portfolio cases, either relatively cheap "die cut" archival boxes made from acid-free boxboard, or the more expensive

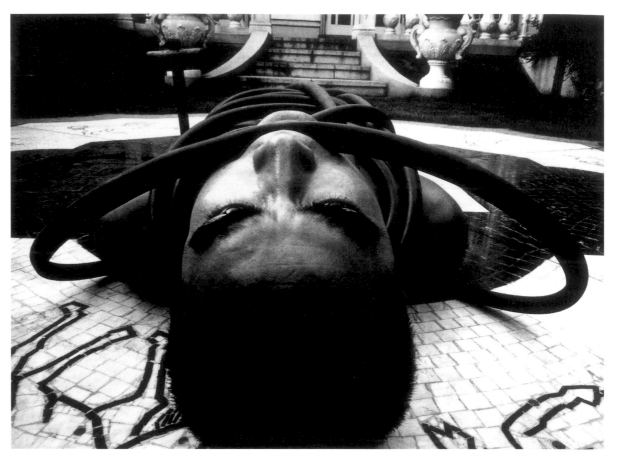

EIKOH HOSOE
From *Barakei* (Killed by Roses) 1961
Silver gelatin print
Courtesy Howard Greenberg Gallery,
New York
Hosoe was the first Japanese photographer
to gain an international reputation, and is a
fine printmaker.

portfolio boxes (sometimes referred to as museum cases), which are sturdier and finished with moisture resistant, archival quality buckram. If you have a large collection, it can be kept in planchests, either in archival boxes or not, but make sure that the flat file is made from either steel or aluminium rather than wood or plastic.

Restoration

Restoration is a contentious issue, especially the process known as "intensification". It is possible to "intensify" a faded image chemically, thus adding considerably to its potential value. A badly faded Le Gray, for example, which might be bought for under $2,000, could potentially be worth $30,000 or more if the image was intensified; that is to say, the rich tones restored and colour added to the image.

Intensifying a faded or weak image involves a complicated process of chemically bleaching and redeveloping the print in a fresh developing solution, then fixing and washing it in a modern way so it is less prone to fading in the future. There are several ways of doing this, which are explained in various publications. Intensification procedures are demonstrated in the Time-Life Library of Photography's *Caring For Photographs*. Intensification is most widely used to restore early salted paper prints, which were especially prone to fading, and are the most valuable of collectable items. However, among the more reputable dealers and members of the trade, the intensification of faded early photographs in order to increase their value massively is regarded as sharp practice, and indeed AIPAD outlaws it, regarding intensification

as tantamount to forgery. It is seen as being akin to restoring antique furniture by piecing in new wood. At some point, the object ceases to be an original in the strict sense of the word, and becomes something else – a copy – for which you are asked to pay "original" prices.

If buying only from reputable sources, you are unlikely to come across intensified prints. But if in doubt and considering a major purchase, commission an expert examination. Intensification can be difficult or easy to detect, depending on how well it has been done, and it's a somewhat tricky process. But an expert who has seen a lot of intensified prints should be able to detect it, or at least entertain a strong suspicion, without the necessity for chemical tests.

Other restoration techniques are more legit-imate, though any kind of restoration, however necessary, is likely to affect value. If a print has an edge tear or the image has a hole in it there is a clear case for repairing the damage. Obviously, physical repairs tend to have a negative effect on value, as collectors prefer to buy a print that doesn't need restoration in the first place; but if the tear or hole is there, it is better to repair it carefully and prevent further damage than do nothing. And when selling the print, be sure to mention any work to the buyer. A circumspect purchaser will notice any repairs, and if they have not been mentioned, the deal could be soured.

Minor blemishes such as foxing mentioned above can sometimes be "steamed" off, but the golden rule about restoration is quite simple: prevention is better than cure. Do as little as is necessary to your valuable prints, beyond making sure they are housed in archival mats and boxes. The less work needed the better, because however good the restorer, accidents can happen. Also the less restoration on a print, the more authentic it is perceived by the market. Finally, don't try to restore prints at home; take them to an expert.

Framing

Framing is very much a matter of taste and fashion, but several observations can be made about this most important stage in the presen-tation of any collection.

There used to be a fashion for aluminium rather than wooden frames around the 1980s, as metal was assumed to be chemically safer from the archival point of view. However, with the development of archival materials, wood is perfectly acceptable, and indeed, as photographs are rather mechanical in appearance, wood can be a more appropriate partner for photographs than metal. A photograph framed in metal can seem a little severe, but obviously some images are suited to this kind of treatment.

The hardboard backing to a frame is where leaching can occur of unwanted acids which might damage the photograph. So make sure you

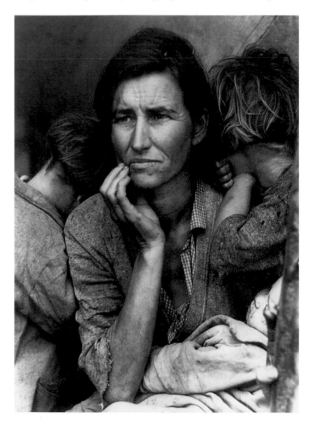

DOROTHEA LANGE
Migrant Mother, Nipomo, California 1936
Silver gelatin print
Private collection
A vintage print of this iconic image would fetch well over $100,000, but later reprints are available at much more modest prices.

have a chemical barrier of either acid-free paper or mylar between the backing board and the mount, and then you can choose any material within reason to make your frame. As mentioned, plexiglass, rather than glass, cuts down on the transmission of uv rays; however, it is the more expensive of the two, and more prone to scratching or yellowing slightly. You can buy uv-protective and non-reflecting glass, but these are very expensive compared to ordinary framer's glass. Providing the print is hung in a suitably cool, shady location, ordinary glass is perfectly adequate, as long as the print is matted. This ensures that only the front of the mount, and not the surface of the print, comes into contact with the glass.

If possible, don't use overly fussy frames with photographs. Look at the way major museums like MoMA, the Getty, the Louvre, or the British Museum frame their works on paper – prints, drawings, and photographs. Each institution uses their own standard, simple, but elegant wooden frames – not a hint of gilt or heaviness in sight. For a private collection, it's probably inappropriate to standardize, but nevertheless choose frames that don't overwhelm the photograph. Indeed, some collectors suspect that if a dealer frames photographs in over-elaborate frames, the images aren't quite as good as they seem. So framing is important, and needs care. It can enhance, or degrade, one's perception of an image.

Record Keeping and Insurance Appraisals

One important part of looking after an art collection is keeping records and insuring them against loss. Every collector should keep an index or catalogue of his or her collection, no matter how small. The catalogue should have an entry for each print or item, with details of the work – title, date, size, medium, and so on – the artist's name, and any information about the picture's provenance. It's also important to keep purchase or sales receipts, both as an aid to proving provenance, and also in case any capital gains taxes are due upon resale.

It is a truism to say that most collectors under-insure their collections, especially in these days of rapidly escalating prices. Detailed insurance advice is outside the scope of this volume, but in order to insure your collection properly you will need to get it valued by an independent appraiser who specializes in photographs. Well kept records are clearly of obvious value when dealing with valuations and insurance companies.

One word of warning, however. Anyone can call themselves an appraiser and set up in business, but there are professional associations, such as the Appraiser's Association of America (AAA) or the American Society of Appraisers (ASA), and similar bodies in other countries. An appraiser belonging to one of the professional bodies is more likely to be reliable than one who is not, and only an appraiser with such credentials is likely to be acceptable to an insurer or the third party in any other kind of transaction involving your photographs. As to the question of how often one should have one's collection appraised, it depends on the collection. For average collections, every two or three years should suffice, unless your insurer demands it. For major collections, containing rare and valuable material, an annual appraisal might be only a minimum.

Insurance costs are dependent upon such factors as location, neighbourhood, the space in which the photographs are housed, and security, even the amount of other business you might have with a particular insurance company. If you are tempted to think that insurance costs are too high, you should think of the alternative. Insuring your collection adequately and record keeping is not as much fun as bidding at auction. But it's as vital as proper storage, framing, and conservation, in ensuring that you not only enjoy your collection to the full, but have it around as long as you want.

Conclusion

Anyone new to photographic collecting who has worked their way through this book may be somewhat overwhelmed by the myriad contradictions thrown up by a medium which is both art and mass medium, and all things in between. However, the basic rules are the same as they are for any other area of art collecting, and can be summarised as follows.

First, and most importantly, do your homework. Learn both about the history of photography and contemporary trends. Visit museums, exhibitions, auctions, wherever you can see photographs displayed, and buy a basic reference library on photographs and photographers.

Look at as many original prints as you can and compare, compare, compare – particularly different prints of the same image and the way different photographers approach the same subject. And when looking, think very hard about what you like, not what other people tell you to like. The best collections are open books to their owners' analysts.

Keep abreast of prices as much you can. What seems a high price today, may not be tomorrow. Buy vintage if possible, but don't make an absolute fetish of it. And always go for the best possible quality you can afford. However, if you're collecting on a tight budget, remember that a great photograph by an "unknown" can often be a better buy than a mediocre photograph by a "name", and a $50 photograph can give a collector as much pleasure as one bought for $50,000.

Finally, on the practical side, look after your photographs, store and frame them with proper archival materials. Keep up-to-date records of your collection for appraisal purposes, insure your photographs adequately, and make sure that the space in which they are housed is adequately secured. Above all, enjoy your photographic collecting!

Chronology

The first thing any collector of art should be aware of is the general history of the medium he or she is collecting. While this volume is not the place for a detailed history of photography, this brief chronology outlines some of the events that shaped photography, technically, artistically, and culturally, with an emphasis on events that may be of interest to collectors.

1500–1800

The camera obscura, a box with lens at one end and a groundglass screen at the other, upon which an image is projected (the basic optical principle of photography) is widely used as an aid to drawing and painting. In 1553, the Neapolitan nobleman, Giovanni Battista Della Porta, is the first to describe its use in a publication, his *Magia Naturalis Libri III*. Amongst those known to utilize the camera are Vermeer, Caravaggio, and Canaletto.

1727

The German physicist, Johann Heinrich Schulze, discovers the basic chemical principle of photography by noting that silver darkens when exposed to light.

1802

Humphrey Davy reports on the results of Thomas Wedgwood's experiments with silhouettes of leaves and other objects placed on paper sensitized with silver nitrate. Unfortunately, neither Wedgwood nor Davy are able to fix the results permanently.

1826–7

Joseph Nicéphore Niépce makes the world's first surviving "photograph" using a camera obscura and a polished pewter plate coated with light sensitive bitumen of Judea. An eight hour exposure produces a dim image of a courtyard from the upstairs window of an outbuilding in his country house. This is around one year after he obtains a photographic impression – literally a "photocopy" – of a Dutch drawing by placing it in contact with a sensitized sheet of paper.

1829

Niépce enters into a partnership with Jacques-Louis-Mandé Daguerre to make further photographic experiments.

1833

Joseph Nicéphore Niépce dies, and is replaced by his son Isidore in the partnership with Daguerre. Daguerre continues with his experiments, perfecting the first practical photographic process – the daguerreotype – in 1837. The image is formed on a silvered copper plate sensitized with a mercury compound, and is unique and directly positive.

1834–5

William Henry Fox Talbot experiments with photographic processes, using paper sensitized with silver chloride in the camera obscura, and also making "photogenic drawings" in the manner of Wedgwood. In 1835, using his tiny "mousetrap" camera, Fox Talbot exposes *Latticed Window, Lacock Abbey,* the earliest surviving photographic negative. The basis for all modern photography is established: one exposes a negative, from which any number of positive prints can be made.

1839

On the 7th of January Daguerre's sponsor, Count François Arago, announces the birth of photography to the French Academy of Sciences, and brokers an arrangement with the French government whereby Daguerre and Niépce would receive lifelong pensions in return for the rights to the process.

Fox Talbot hears of Arago's announcement and claims that he is the true inventor of photography.

Hippolyte Bayard produces direct positive photographs on paper, but is persuaded by Count Arago to withhold publication of his process, leaving Daguerre to reap both the plaudits and financial rewards for inventing photography.

Sir John Herschel applies to photography his 1819 discovery that hypo (thiosulphite of soda) dissolves silver, so that a photographic image can be permanently fixed by bathing it in a hypo bath. Herschel is one of the first to use the term photography, and also initiates the common usage of the terms negative and positive.

In a joint session of the Academies of Arts and Science on the 19th of August, Arago demonstrates the Daguerreotype method to the assembled members. The French government announces that this great French invention will be given free to all the world (except England and Berwick-Upon-Tweed).

1840–41

Fox Talbot works to improve his process, which he terms the "calotype". This term enters into general use, though Fox Talbot later tries to introduce the term "talbotype".

1843

Albert S. Southworth and Josiah J. Hawes open a daguerreotype portrait studio in Boston, and take what are generally agreed to be the finest portraits in that medium.

Mrs Anna Atkins produces the first volume of her three volume *Photographs of British Algae: Cyanotype Impressions* (1843–53), a privately printed album of cyanotype plant impressions, which many consider the first photobook, although others award the palm to *The Pencil of Nature*.

1843–8

The painter David Octavius Hill forms a partnership with the photographer Robert Adamson to produce calotype portraits of Edinburgh notables. From their studio on Calton Hill, they produce many of the finest portraits of the 1840s.

1844

William Henry Fox Talbot opens the Reading Establishment, a factory for the production of photographic prints and publications on a commercial scale.

1844–6

The Pencil of Nature, the first commercially produced photographically illustrated book, is published by the Reading factory in six parts over two years, consisting of 24 calotypes by Fox Talbot in total. The first part, consisting of five calotypes, is published at a price of 12 shillings on June 29, 1844, and sells 274 copies. By the time Part VI is published on 23 April 1846, there are only 73 subscribers.

1845

Fox Talbot publishes *Sun Pictures in Scotland* in one volume with a subscription price of one guinea, containing 23 calotypes on places associated with the popular romantic novelist, Sir Walter Scott. The book is not a success.

1849

Sir David Brewster perfects a stereoscopic viewer. When a matching pair of photographs is placed in the viewer, a three dimensional effect is produced. Stereographs become extremely popular in the 1850s and 1860s. Instantaneous photographs – photographs that arrest motion – become possible with the short exposures required by the small stereo cameras.

1850

Gustave Le Gray, the most technically accomplished French photographer of his generation, introduces his waxed-paper negative method, whereby ironing hot beeswax into a paper negative makes it more transparent and capable of resolving finer detail than before.

1851

What is, in effect, the world's first open photographic exhibition is mounted at the Great Exhibition in the Crystal Palace in London's Hyde Park, attracting 700 entries from six nations, including Britain, France, and America. The British entries do not win any medals – even the work of Hill and Adamson rates only an "honourable mention."

The Mission Héliographique, under the auspices of the Commission des Monuments Historiques, commissions five photographers – Hippolyte Bayard, Henri Le Secq, Gustave Le Gray, Edouard Baldus, and O. Mestral – to photograph historic buildings and ancient monuments in the French regions.

The waxed-paper process is trumped by the introduction of George Scott Archer's collodion on glass, or wet-plate system. Using glass as the support medium for photographic chemicals makes negative–positive yield details as fine as those of the daguerreotype. Despite the system's drawbacks, that the glass plate must be coated immediately before exposure and exposed slightly damp, then developed on the spot in the dark, the collodion wet-plate method becomes the standard for much of the 19th century, and sweeps aside both daguerreotype and paper negatives within a decade.

1851–7

In September 1851 Louis-Désiré Blanquart-Evrard opens his Imprimerie Photographique at Loos-lès-Lille, an establishment of some 40 workers, mainly countrywomen, designed specifically to offer "artists and amateurs the production, in unlimited numbers, of positive prints from glass or paper negatives." Between 1851 and 1855, when the factory ceases production, Blanquart-Evard prints or publishes at least 20 albums and large archaeological/travel works with more than one hundred plates, an estimated total print output of one hundred thousand. Amongst the Imprimerie's publications are three classic Middle Eastern works (detailed below). The Lille Imprimerie is followed only a month later by a rival establishment in Paris, the Imprimerie run by H. de Fonteny.

1852

Gide and Baudry of Paris publish Maxime Du Camp's *Egypte, Nubie, Palestine et Syrie*, illustrated with 125 salt prints made at the Lille Imprimerie. Isabelle Jammes has called this, "the first book published under normal commercial conditions and illustrated with photographs of real value whose pictures have remained in a perfect state of preservation."

1854

Two more important products of the Lille Imprimerie are published, John B. Greene's *Le Nil*, and Auguste Salzmann's *Jérusalem*.

1855

Roger Fenton, James Roberston, and Charles Langlois independently photograph the Crimean War, the first systematic coverage of a conflict, although technical limitations and political considerations mitigate against direct scenes of violence. Fenton's pictures are published by Thomas Agnew and Sons of Manchester.

1855–6

Gustave Le Gray makes his renowned seascapes by developing a method for producing plausible cloud effects, thus solving the problem of blank skies inherent in wet collodion photography. They become some of the best selling pictures of the period.

1856–7

Francis Frith photographs in Egypt and the Holy Land, laying the foundation for one of the most successful commercial photographic companies. He makes pictures in different sizes to suit different tastes and pockets – stereographs, 6 x 9 inch negatives, and 16 x 20 inch negatives.

1857

Oscar Rejlander, a Swede living in England, successfully exhibits his image *The Two Ways of Life*, an allegorical composite photograph contrasting virtue and dissolution, made from 32 different negatives. Despite the fact that the picture shows nude women (in the dissolute section), Queen Victoria finds it edifying and purchases a copy for Prince Albert.

1858

Henry Peach Robinson follows Rejlander with his *Fading Away*, a composite genre picture made from five negatives. He becomes a prominent advocate for a rule-based photographic "art" aesthetic.

The French commercial portrait photographer, Nadar, makes the first successful aerial photograph, from a balloon. Honoré Daumier caricatures the event in a highly popular lithograph.

1859

Photographic visiting cards ("Cartes de visite") become immensely popular. Those of famous society figures, such as Sarah Bernhardt, Napoleon III, or Queen Victoria, are readily available for sale to the public.

1860s–70s

The golden age of 19th-century travel photography, as photographers (mainly British) record the world on behalf of the colonial powers. Ethnographic and topographical photographs are published as documents in scientific volumes, and sold as "views" to tourists for incorporation into albums. Notable topographical photographers are Robert MacPherson, the Alinari Brothers, and Giorgio Sommer in Italy, Bourne and Shepherd and Scowen and Co., in the Indian sub-continent, Félix Bonfils and Antonio Beato in the Middle East, John Thomson and Félice Beato in the Far East, and James Valentine and George Washington Wilson in the British Isles.

1860–61

The Yosemite Valley in California is photographed by Charles Leander Weed and Carleton Watkins, using mammoth-plate cameras taking negatives up to about 16 x 20 inch in size. The cumbersome equipment required for this is carried over the Sierra Nevada mountains by mule. Watkins' images are much praised in international exhibitions.

1861

Nadar uses artificial light ("flash") to photograph the Paris catacombs and sewers.

Sir James Clerk Maxwell demonstrates a colour photography process.

1861–5

A portrait photographer from New York, Matthew Brady, in association with the photographic entrepreneur, Edward Anthony, conceives a plan to market photographs recording the impending American Civil War. He engages a group of photographers, including Alexander Gardner, Timothy O'Sullivan, and George N. Barnard, to make the images. Gardner eventually breaks with Brady and hires photographers of his own. Others, like Barnard, work both for the Federal forces and on their own behalf. The Civil War becomes the first conflict to be extensively documented, with Timothy O'Sullivan's photograph of bloated corpses on the field of Gettysburg marking a new, brutal realism.

1862

Julia Margaret Cameron, an English housewife in her forties, begins to make close-up portraits of "famous men and fair women" of her acquaintance, including Lord Tennyson, Sir John Herschel, and Thomas Carlyle. Her startling, ground-breaking images are criticized rather more at the time than her sentimental genre scenes in the manner of Rejlander and Robinson.

1864

The carbon print process and the woodburytype are introduced in England, by Sir Joseph Wilson Swan and Walter Bentley Woodbury respectively.

1866

Gardner publishes *Sketchbook of the War*, in two volumes, with photographs by himself and other Civil War photographers. Barnard publishes *Photographic Views of Sherman's Campaign*.

1866–7

The US government begins to sponsor photographic surveys of the largely unpopulated American West, primarily to facilitate expansion of the railroad system. Timothy O'Sullivan photographs in Nevada with Clarence King's Geological Exploration of the Fortieth Parallel. O'Sullivan's salary was $100 a month.

1871

William Henry Jackson's photographs of Yellowstone help Congress pass the first US National Parks bill.

Photography is used by the French authorities to identify those who took part in the unsuccessful Paris Communard uprising.

1872
Eadweard Muybridge is commissioned by Leland Stanford to photograph the racehorse, Occident, in motion, thus beginning his long series of human beings and animals in motion.

1873
William Willis patents the platinotype (platinum print) process in England.

1877–9
John Thomson publishes *Street Life in London*, texts based on Mayhew's *London Life and the London Poor* illustrated with woodburytype photographs – the first major work on social problems to be illustrated with photographs. This is followed by Thomas Annan's *Photographs of Old Closes, Streets, Etc.* (1878–79), for the Glasgow City Improvement Trust, 40 carbon prints of slum areas targeted for demolition under the Glasgow City Improvements Act of 1866.

1880
The introduction of the photographic halftone plate makes photographic reproduction in books and newspapers both easier and cheaper. The first newspaper photograph is reproduced in the *New York Daily Graphic* of the 4 March 1880.

1885
Peter Henry Emerson begins to work on the Norfolk Broads and makes his first attack on the high art artificiality of Henry Peach Robinson, Rejlander and their followers. Emerson calls for an aesthetic of "naturalistic" photography that does not imitate painting, inspiring the Pictorialist movement, from a term he himself coined.

1887
Muybridge publishes *Animal Locomotion*, his great work on human and animal movement.

1886
George Eastman introduces the first Kodak, a cheap hand-held camera that revolutionizes photography, making it available to anyone, by separating the craft of processing from taking. His famous slogan is "You press the button,

we do the rest. The only camera that anybody can use without instructions."

1890s
"Snapshot" photography, as it is known, makes photography one of the fastest-growing pastimes for amateurs and hobbyists.

The decade sees the beginnings of the photographically illustrated magazines and "photojournalism", the result of smaller, faster cameras and halftone printing.

c.1890
A French actor with a failing career, Eugène Atget, turns to photography and begins to make what he terms "documents for artists", turning his attentions to an immense documentation of Old Paris after a few years, and photographing the city and its immediate hinterland for over 35 years.

1892
Paul Martin makes snapshot images at Great Yarmouth and other English seaside resorts, making candid, instantaneous pictures of social life.

The Brotherhood of the Linked Ring is formed in England by a group of pictorialist photographers dedicated to promoting photography as a fine art.

1893
Alfred Stieglitz becomes the first American to be elected to the Linked Ring.

Thomas Edison invents 35mm film.

1895
Auguste and Louis Lumière begin to show their first films in Paris, and patent the apparatus for making and showing movies.

1896
Arnold Genthe uses a concealed camera to make photographs in San Francisco's Chinatown.

1897–1902
Stieglitz edits *Camera Notes*, the journal of the Camera Club of New York.

1902

Stieglitz is one of the founders of the Photo-Secession, a breakaway pictorialist group devoted to contemporary subject matter.

1903

Stieglitz begins publication of his own magazine, *Camerawork*, a polemical quarterly which features both fine art photography and contemporary art. The sumptuous, expensive journal continues to be published until 1917.

1904–5

Lewis W. Hine begins to make social documentary pictures in New York, particularly documenting immigrants arriving at Ellis Island.

1907

The first volume of Edward S. Curtis's monumental multi-volume book, *The North American Indian*, is published. Financed by J. P. Morgan, the final volume of the 20 volume work appears in 1930.

Stieglitz makes his picture, *The Steerage*. This complex, highly formal image of a social situation is arguably the first modernist photograph and is highly influential.

1909

Leading pictorialist, Alvin Langdon Coburn, publishes his book *London*, illustrated with hand-pulled and mounted photogravures. This is followed a year later by a companion volume, *New York*.

1910

The pictorialist movement arguably reaches its apogee when the Photo-Secession arranges an international exhibition of photography at the Albright Art Gallery in Buffalo.

1913

The controversial Armory Show in New York City introduces modern art from Europe to an American audience.

1917

The final issue of *Camerawork* appears, a double issue devoted to the work of a young American photographer, Paul Strand, and his semi-abstract, "brutally direct" modernist approach, which heralds the end of Pictorialism and the beginnings of "straight", pure modernism. Several of the images in the issue, such as *Wall Street*, *The White Fence*, and *Blind Woman*, become modernist classics.

Alvin Langdon Coburn makes his "vortographs", a series of cubist-inspired, abstract modernist photographs.

1918

August Sander begins an almost lifelong project documenting social types and class mores in Germany.

Christian Schad, a member of the dadaist art movement, makes cameraless images directly on to photographic paper (schadograms).

1920s

The decade of modernism. In America, such photographers as Edward Weston, Imogen Cunningham and Paul Strand advocate "straight" photography, the sharp-focus, almost abstract depiction of objects, a trend also followed by German photographers such as Albert Renger-Patzsch and known there as Neue Sachlichkeit (New Objectivity). A different European photographic tradition is followed by such artists as László Moholy-Nagy, Man Ray and Alexander Rodchenko, who experiment with processes of all kind, including cameraless photographs, abstractions, and photo-montage, the opposite of the purism of the American modernist school.

1923

Edward Steichen becomes chief photographer of the Condé Nast publications, *Vogue* and *Vanity Fair*.

1924

The Museum of Fine Arts, Boston, is given a group of photographs by Alfred Stieglitz, the first photographs by any artist to enter a US museum collection as works of art.

1925

The Leica camera is introduced. Using 35mm film, it enables photographers to work fast and in available light, transforming photojournalism and social documentary photography.

1927

Eugène Atget dies after a photographic career of almost 40 years. After years of obscurity, in the last few years of his life, certain surrealists took an interest in his work, and two young Americans, Berenice Abbott and Julien Levy, buy half the contents of his studio, some 8,000 prints and negatives, for $1,500.

1927–9

Several major bookworks featuring the "new objective" modernist photography are published in France and Germany. They are Germaine Krull's *Métal* (Paris, 1927), Karl Blossfeldt's *Urformen der Kunst* (Art Forms in Nature) (Berlin, 1928), Albert Renger-Patzsch's *Die Welt ist Schön* (The World is Beautiful) (Munich, 1928), and August Sander's *Antlitz der Zeit* (The Face of Our Time) (Berlin, 1929).

1928

The exhibition Film und Foto, in Stuttgart, features the work of leading modernist photographers from both Europe and the United States.

1929

The F64 Group is formed in San Francisco by leading Californian modernists to promote "straight" photographic modernism. Members include Edward Weston, Ansel Adams, Imogen Cunningham, and Willard Van Dyke.

1930s

The new miniature cameras herald an important era for photojournalism. Erich Salomon, Tim Vidal, Alfred Eisenstadt, André Kertész, Henri Cartier-Bresson and others use the smaller cameras and available light to record stories of daily life and the turbulent political events of the decade.

1930

Edward Weston makes his iconic image, *Pepper No. 30*.

Julien Levy opens a gallery in New York, devoted to selling the work of the surrealist group. He also shows and sells photographs as works of art.

c.1930

Man Ray, the leading American surrealist, makes three prints of an image called *Glass Tears*.

1932

Roman Vishniac begins to photograph Jewish communities in Eastern Europe.

1933

The Parisian based Hungarian photographer, Brassaï, publishes *Paris de Nuit* (Paris by Night), his photographs of street scenes, cafés, cabarets, brothels, and nightlife. This genre of creative documentary book becomes popular, and is followed by others, including Bill Brandt's *A Night in London* (1938).

1934

Under the direction of sociologist Roy Stryker, the photographic unit of Resettlement Administration (later the Farm Security Administration (FSA)), begins a photographic survey of American life during the Great Depression. Amongst the photographers hired by Stryker are Dorothea Lange, Walker Evans, Ben Shahn, Arthur Rothstein, and Russell Lee.

Kodachrome colour slide film is introduced.

1935

Henri Cartier-Bresson shoots arguably his most famous picture and a perfect example of the "decisive moment", *Picnic on the Marne*.

1936

An important new magazine showcase for photo-journalism, *Life*, is launched on 23 November. The cover features a photograph of the Fort Peck Dam in Montana, by Margaret Bourke-White, from the magazine's first major picture story.

The Photo-League, a radical organization to promote social documentary photography and advocate political reform, is founded in New York. Members include Sid Grossman, Aaron Siskind, W. Eugene Smith, Walter Rosenblum and Dan Weiner.

Dorothea Lange photographs *Migrant Mother, Nipomo, California*, one of the most iconic images of the Depression.

1937

An important socio-cultural history of photography, Robert Taft's *Photography and the American Scene*, is published.

Beaumont Newhall curates a centenary overview exhibition of photography at New York's Museum of Modern Art, Photography 1839-1937. The exhibition's catalogue becomes a standard history of photography.

The New Bauhaus at the Institute of Design in Chicago, headed by László Moholy-Nagy, includes photography in its curriculum.

The Hindenburg Zeppelin airship explodes and bursts into flames. News photographs of this event become amongst the best-known and most widely distributed of their kind.

1938
Walker Evans is given a one-man exhibition at the Museum of Modern Art. The book accompanying the exhibition, *American Photographs*, becomes regarded as a seminal photobook.

1941
Ansel Adams makes his most renowned single image, *Moonrise, Hernandez, New Mexico*.

A department of photography is established at New York's Museum of Modern Art (MoMA), the first of its kind, headed by Beaumont Newhall.

1944
Kodak colour negative film is introduced.

Robert Capa makes dramatic photographs of the D-Day landings, although much of his film is damaged by careless lab processing.

W. Eugene Smith, a star photojournalist for *Life* magazine, photographs the war in the Pacific.

1945
Photographs of liberated German concentration camps are published, to general disbelief and outrage at the horror.

1946
W. Eugene Smith, recovering from serious wounds sustained in the Pacific, photographs *The Walk to Paradise Garden*, the image that symbolizes his rehabilitation.

1947
The Magnum photographers' co-operative is founded in Paris by Henri Cartier-Bresson, Robert Capa, George Rodger, David Seymour, and Bill Vandivert.

The Photo-League is branded as a "subversive organization" by the US department of Justice.

Edwin Land invents the Polaroid camera, producing instant prints.

Edward Steichen is appointed Director of the Photography Department at the Museum of Modern Art, New York.

1949
The International Museum of Photography is established at George Eastman House in Rochester, New York.

1952
Minor White, Ansel Adams, Dorothea Lange, Barbara Morgan, and Beaumont Newhall found the photographic journal *Aperture*. Edited by White, it becomes one of the most influential magazines of the 1960s and 70s.

Henri Cartier-Bresson publishes his great book, *The Decisive Moment*.

1955
English collectors Helmut and Alison Gernsheim, who have one of the best and most extensive private collections of photography, publish their influential *History of Photography*.

The Family of Man, an exhibition of 503 photographs by 273 photographers from 68 countries, organized by Edward Steichen at MoMA, is a great popular success. During a world tour lasting several years, it is seen by more people than any exhibition in photographic history.

1955–6
Walker Evans sponsors a young Swiss photographer, Robert Frank, for a Guggenheim Fellowship that enables Frank to undertake a series of journeys across the States and make photographs.

1956

William Klein publishes his influential book, *New York* (*Life is Good and Good for You in New York*, Trance, Witness, Revels).

1958

Robert Frank's book, *Les Americains*, the result of his Guggenheim travels, is published by Robert Delpire in Paris.

1959

The American edition of Frank's book, *The Americans*, with an introduction by Jack Kerouac, is widely criticized in the press, but strikes a chord with young American photographers.

1960s

There is growing attention to photography in US colleges and museums. Advanced photographic courses are offered, and the medium becomes more widely recognized as a serious art form. The extensive photographic coverage of the Vietnam War is a powerful factor in turning the US public against the conflict.

The Pop Art movement sees painters such as Robert Rauschenberg and Andy Warhol use photographic imagery in their work. Warhol is famously prolific in his reproduction of "found" photographs in garish colours by the silkscreen process.

1961

Shomei Tomatsu and Ken Domon publish *Hiroshima Nagasaki Document*, a searing indictment of the A-bomb attacks.

1962

John Szarkowski succeeds Edward Steichen as Director of the Photography Department at MoMA. He will become one of the most influential curators and writers on photography of the late 20th century.

1963

Eikoh Hosoe publishes *Barakei* (Killed by Roses), which features Yukio Mishima, Japanese writer and radical political figure.

A Californian artist, Ed Ruscha, publishes *Twentysix Gasoline Stations*, a small artist's book of photographs of gasoline stations. It marks the beginning of what comes to be known as "conceptual" photography.

1964

Following insufficient interest on the part of British institutions, the Gernsheim Collection is acquired by the University of Texas at Austin.

1966

Szarkowski's exhibition and book, *The Photographer's Eye*, sets the tone for his curatorship at MoMA, and a photographic aesthetic that encompasses art, commercial work, and the snapshot.

The Dutch photographer, Ed Van Der Elsken, publishes his masterpiece, *Sweet Life*.

1967

New Documents, an exhibition featuring the work of Diane Arbus, Lee Friedlander, and Garry Winogrand, opens at the MoMA. Its curator, John Szarkowski, declares that "a new generation of documentary photographers has directed the documentary approach towards more personal ends. Their aim has been not to reform life, but to know it."

Andy Warhol's serigraph series of a photograph of Marilyn Monroe becomes one of the most popular images of the century.

1968

A collective of young Japanese writers and photographers, including Daido Moriyama and Takuma Nakahira, form the Provoke group, a radical movement which questions all established values in art. The three issues of *Provoke* magazine, published before the group disbands, have a profound effect upon Japanese photography.

1969

The Museum of Modern Art in New York purchases the Eugène Atget archive acquired by Berenice Abbott and Julien Levy in 1928.

Lee Witkin opens a New York gallery devoted to exhibiting and selling fine photographic prints.

1970s

Photography becomes firmly established in the art museum and academy, and many critics begin to question its "aestheticization". Despite this, galleries open to sell photographs as works of art, and the leading auction houses begin to hold regular photographic auctions.

Encouraged by photography's new found respectability, more and more photographers are making photographs for themselves and the gallery wall rather than commercial clients. They begin to explore many kinds of photographic processes, and much interesting work is being done by women photographers, inspired by the women's movement.

1970

Bernd and Hilla Becher publish *Anonymous Sculptures*, a book of serial, repetitive images of industrial structures, and a key work of the new conceptual photography movement.

1971

Diane Arbus dies. A year later, she is the first US photographer to have her pictures exhibited at the Venice Biennale. A touring retrospective exhibition of her work is an enormous success, and the monograph deriving from that show sells over 100,000 copies.

1972

Daido Moriyama publishes *Bye Bye Photography* in Japan, one of the grittiest and most radical photobooks ever published. Copies of the first edition now command around $7,000 or $8,000.

1975

New Topographics: Photographs of a Man-altered Landscape, organized by William Jenkins, opens at the International Museum of Photography at George Eastman House, Rochester, New York. It shows the work of a new generation of landscape photographers, who concentrate upon the "man altered" rather than the natural landscape. The artists are Robert Adams, Lewis Baltz, Bernd and Hilla Becher, Joe Deal, Frank Gohlke, Nicolas Nixon, John Schott, Stephen Shore, and Henry Wessel Jr. The exhibition becomes one of the most influential of the late 20th century.

1976

William Eggleston has a controversial but hugely influential one-man exhibition at MoMA, effectively sanctioning colour photography as a serious medium for art photographers.

1977

Susan Sontag publishes her book, *On Photography*, an influential collection of essays challenging the modernist view that reduces the medium to an art form, rather than the broad and tricky cultural phenomenon it is.

1980s

The precepts of modernism are criticized in the movement known as postmodernism. Many artists are making photographic works, although there is a considered distinction between photographers, who make photographs, and artists, who make "pieces".

1981

Cindy Sherman's *Untitled Film Stills* are exhibited at Metro Pictures in New York, establishing her reputation as a leading postmodern artist.

1984

The Getty Museum in Malibu acquires a number of important private collections of photographs, including those of New York based Sam Wagstaff and Chicago based Arnold Crane, and opens a Department of Photography, under the curatorship of Weston Naef.

1986

Nan Goldin's influential book, *The Ballad of Sexual Dependency*, is published.

1988

Electronic scanners for films and photographs are introduced, as well as the first digital cameras.

1989

Many exhibitions are held to celebrate photography's 150th birthday. Three of the biggest are On The Art of Fixing a Shadow, at the National Gallery of Art, Washington, D. C., and the Art Institute of Chicago; The Art of Photography, 1839–1989, at the Royal Academy of Arts, London; and Photography Until Now, at the Museum of Modern Art, New York.

1990s

The computer begins to take over photography, especially at the printing stage. Many photographers and artists still use traditional cameras and film but scan the negatives into the computer and produce inkjet rather than traditional chemically based prints.

The work of artists utilizing photography reaches new heights in the saleroom, and photography is declared the "new painting".

Sales of photographs on-line become part of the e-commerce, notably with the launch of www.eyestorm.com in 1999.

1993

Elton John pays £122,500 at Sotheby's, London, for one of the three known vintage prints of Man Ray's *Glass Tears*.

1995

A complete set of Cindy Sherman's *Untitled Film Stills* series is sold to the Museum of Modern Art, New York, for a sum said to be more than $1 million.

1999

A substantial part of the André and Thérèse Jammes Collection of 19th century and modernist photography is auctioned at Sotheby's in London. The 'Sale of the Century" realizes a grand total of over £6,000,000 and many lots set record prices. Gustave Le Gray's *La Grande Vague – Sète*, is knocked down for a world record £507,500 (approximately $800,000) prompting the *International Herald Tribune* to call the sale "one of those historic days when an extraordinary sale brings home the fact that a major change in cultural perception has taken place".

New York collector John Pritzker pays over $1 million for a print of Man Ray's *Glass Tears*.

2000

Curated by Thomas Weski and Heinz Liesbrock, the exhibition How You Look At It is a highly ambitious overview of 20th-century photography, shown at the Sprengel Museum, Hannover, as part of the Expo 2000 in that city.

2001

A print of Andreas Gursky's *Montparnasse* (1994) is sold for some $600,000 at Christie's East, New York, a record for a contemporary photographic work.

The Andreas Gursky retrospective exhibition at MoMA, curated by Peter Galassi, is an enormous success.

2002

Two further auctions of material from the Jammes Collection are held in Paris. An image by Joseph Nicéphore Niépce – the copy of the Dutch drawing made in 1825 – is deemed the world's first photographic image. It is declared a National Treasure and bought by the French government.

Sotheby's and www.eBay.com form a joint venture to hold online auctions.

2003

Curated by Emma Dexter and Thomas Weski, the exhibition Cruel and Tender is the first major strictly photographic exhibition to be held at the Tate Modern, London, a museum which had hitherto considered only photographs by artists to be within its collecting and exhibiting remit.

Glossary

There are a bewildering number of technical terms used in the world of photography collecting, and this glossary, while not exhaustive, gives a guide to the various terms used by dealers, collectors, and photographers themselves. It includes the main technical – primarily printing – processes in use since the medium's beginning, the types of print a photographer might make as well as other technical terms the collector may come across.

The period of most general historical use for each process is also indicated, but it should be noted that, in the current photographic boom, even the most archaic and arcane processes have enjoyed some kind of specialist revival at the hands of certain artists. Similar glossaries to this can be found in many histories and anthologies on photography, but especially recommended as a basic primer is Gordon Baldwin's *Looking at Photographs: A Guide to Technical Terms* (The J. Paul Getty Museum, Malibu, and the British Museum Press, London, 1991).

Albumen, or Albumen Silver Print (1850–90s)

The most characteristic print of the 19th century, particularly when used in conjunction with the collodion wet-plate negative. Introduced by Louis-Désiré Blanquart-Evrard (1802–1872) in 1850, thin paper was coated with a layer of albumen (processed egg-white) containing salt that gave it a smooth glossy surface, and dried. The coated paper was then sensitized with a solution of silver nitrate and dried once more, this time in the dark. Prints were produced by placing the paper in contact with the negative in a printing frame and exposing it to bright light, usually sunlight. Albumen paper, which is a printing-out process, produces a long tonal scale and precise detail, and gives prints which generally vary in tone from reddish to purplish brown, depending on their toning. When they fade and deteriorate, the highlights turn yellow.

Ambrotype, or Collodion Positive (1852–70s)

Ambrotypes were made from about 1852, after the introduction of the collodion wet-plate negative process. It was found that a collodion negative, developed in an iron developer and treated with a bleaching process, would appear as a positive image when viewed by reflected light against a dark background. The method, developed in America by James Ambrose Cutting (1814–1867), was quickly adopted by photographic studios everywhere to produce a cheap version of the daguerreotype, which it superseded. The glass was produced in similar sizes to daguerreotype plates, with a cover glass pressed against the image plate. Behind the picture was a piece of black velvet or paper, causing it to appear as a positive image.

Autochrome (1904–30s)

An autochrome is the first really practicable colour photograph, and is basically a colour transparency or slide, but on glass rather than film. Invented by Louis Lumière (1864–1948) it involved of exposing a bromide emulsion through a three colour translucent screen made of potato starch grains. When the emulsion was developed, bleached, exposed to a white light and redeveloped, a residual positive coloured impression was left.

Bromoil Print (1907–20s)

See oil pigment print and gum bichromate print. The bromoil print process, which originated in England in 1907, resembled oil prints, but unlike them was not limited to printing by contact, and was usually made from an enlarged gelatin silver bromide print.

Burning in (see Dodging)

Calotype, or Talbotype (1841–late 1850s)

The first practical negative–positive process, the calotype was devised by William Henry Fox Talbot (1800–1877) as an improvement on his photogenic drawings, and forms the basis for all modern photography. Patented in 1841, the calotype employs thin writing paper as the base for both negatives and the subsequent positive prints. This paper is coated with silver salt solutions, exposed to light in the camera, and then developed, thereby producing the negative. In order to produce a positive "print", the negative is contact printed in sunlight with another, similarly sensitized sheet of paper. The resulting print is known as a salt print, or salted paper print. Salt prints from paper negatives are characterized by a roughish texture resulting from the fact that the paper fibres of the negative are also incorporated in the final image, resulting in a broad effect and loss of detail.

The word calotype is frequently used loosely to refer to the prints made from paper negatives as well as the negatives, but Fox Talbot used it only for negatives, and as Gordon Baldwin writes, it seems both simpler and more correct to reserve it for negatives only.

Carbon Print (1855–1900s)

Alphonse Louis Poitevin (1819–1882) is one of the most important yet largely unheralded figures in the history of photography, for during the 1850s he made many of the initial experiments that led to the development of several major photo-mechanical printing processes, including collotype, photolithography, and photogravure, all of them based on the fact that gelatin in combination with potassium or ammonium bichromate hardens in proportion to the amount of light which falls upon it. Based upon Poitevin's researches, the carbon print was perfected by Joseph Wilson Swan (1828–1914) in 1864. Carbon tissue (paper coated with gelatin and carbon) was sensitized with potassium bichromate and exposed in contact with the photographic plate. The tissue was squeezed in contact with a second sheet of paper and the unhardened gelatin washed away to reveal the image attached to the second sheet. The primary virtue of a carbon print is its permanence, as it contains no silver impurities to cause deterioration.

Carte de visite

A photograph mounted on a stiff piece of card about 4½ x 2½ inches (11.4 x 6.4 cm). Almost always albumen prints, they were popularized in the mid-1850s to the 1860s by André Disdéri (1819–1889), particularly portraits of celebrities of the day for collection into home albums. When not portraits, subjects might be scenic views, landscapes, reproductions of works of art, and news events. There were also other sizes of standard card mounted photographs, and in the 1870s, the carte de visite was superseded in popularity by the larger cabinet card.

Chromogenic Colour (Type C), or Colour Coupler Print (1950s–present)

Type C is a generic name for the most popular modern colour print process. The name derives from Kodak Ektacolor Paper Type C, which dominated the colour print market for many years. Colour sensitive emulsion layers in the paper, each responsive to a different part of the colour spectrum, respond proportionately to the colour information in the negative. After initial development of the paper, further development follows in several steps in which chemical compounds (dye couplers) are added to form layers of superimposed hues which appear as a full-colour image. Type C prints are not as permanent as dye transfer or colour carbro prints, but recent technology has brought the permanence factor up to around one hundred years.

Cliché Verre

A glass plate is engraved, painted or drawn upon, or stained and smeared with photographic chemicals or other agents. The plate is then used as a negative to make a photograph in whichever way the artist desires.

Collodion Wet Plate Negative (1851–early 1880s)

The wet collodion process was published by Frederick Scott Archer (1813–1857) in 1851. It was faster (more light sensitive) than the calotype, and enabled photographers to produce negatives on a glass rather than paper base, free from the grainy texture of paper negatives. Collodion, which was a mixture of commercially available gun cotton dissolved in ether or alcohol with potassium iodide added, was a tensile, sticky, syrupy substance. This was applied evenly to a glass plate, which was then sensitized by a silver nitrate bath. The sensitized plate, while still damp, was exposed in the camera, then developed immediately before it could fully dry.

Despite its obvious disadvantages – it was a tricky, extremely fiddly process and necessitated the transportation of a darkroom to wherever the photograph was to be made – the collodion plate produced images capable of rendering great detail and a long tonal range, and quickly supplanted both the calotype and the daguerreotype. A variant of the wet collodion method, the dry collodion plate, was even trickier to use, so never became widely popular. Dry photography only became feasible with the introduction of the gelatin dry plate in 1871.

Collodion Positive (see Ambrotype)

Collotype (1868–1920s)

Another technique based on the patent Alphonse Louis Poitevin (1819-1882) took out in 1855, the collotype process was perfected by Josef Albert (1825-1886) in 1868. Analogous processes include the phototype, artotype, albertype, and the heliotype. Basically, the collotype is similar to the photolithograph, except that glass replaces stone as the printing plate surface. A glass plate was coated with bichromated gelatin, exposed in contact with the photographic negative, then washed. When dried, the collotype plate had the finely reticulated (wrinkled) surface that characterized the technique. When the plate was inked and printed, the collotype image displayed both an ability to resolve very fine detail and considerable subtlety of tone.

Colour Carbro, or Trichrome Carbro Print (1920s–50s)

The colour carbro process was developed from the carbon print via the carbro print, which is a monochrome version. The colour carbro is made by creating three negatives of a subject, photographed through red, green and blue filters respectively. From these negatives, three carbon tissues are made, each in the respective primary colour. The carbon images are then transferred on to a final paper support, in careful register. The colour carbro process has been superseded by the dye transfer technique, but is regarded as arguably the finest of colour processes. The Fresson process is a variation of trichrome carbro.

Colour Coupler Print (see Chromogenic Colour)

Combination Print

A photograph in which different images are combined as seamlessly as possible. This may be done in the camera, by multiple exposure, or in the enlarger, by sandwiching or multi-printing negatives. Or nowadays, as is more likely, in the computer – using a photo manipulation programme.

Contact Print

A contact print is one made where the negative is in contact with the printing paper, so it is the same size as the negative, as opposed to the more familiar enlargement. When a negative is enlarged, a certain amount of definition is lost owing to light diffusion, but not so in a contact print. A contact is the sharpest and most perfect of photographic prints, so even today some photographers employ large, unwieldy cameras that take a big negative, such as the 8 x 10 inch view camera, in order to present their work solely in contact print form.

Most 19th-century prints are contact prints, because enlarging wasn't practical with the materials of limited sensitivity then available. Much of the appeal of the large 20 x 16 inch prints of photographers like Francis Frith or Carleton Watkins stems from the fact that they are contact prints, and we admire them not only for their exquisite tonal qualities and ultra sharpness,

but also their makers for wrestling with gargantuan cameras and heavy glass plates in the most difficult of conditions.

Copy Print (and Copy Negative)

A copy print is made by re-photographing a print, thus it is not made from the original negative. There is an inevitable loss of definition and tonal quality in the resulting copy negative, so most copy prints are degraded in quality and cannot be considered original prints. Press prints, for example, are often made from copy negatives, severely depleting their value as collectable items unless exceptional circumstances prevail.

Certain processes however, such as photomontage, frequently employ the re-photographing of a pasted-up composite. And some photographers, having laboured long and hard to produce a perfect print, will then copy it in order to produce a negative that will enable them to make further prints with less trouble. If it is the photographer's habitual practice to work in this way and make prints from copy negatives, then in that instance they are accounted "originals" and are valued as such.

Cyanotype (1842–1900s)

Also known as the blueprint process, the cyanotype was first demonstrated by Sir John Herschel (1792–1871) in 1842. Based upon the light-sensitive properties of iron rather than silver salts, the emulsion of ferric ammonium citrate and potassium ferricyanide was coated on to cloth or paper, and processed simply after exposure (by contact) by washing it in water to remove unexposed emulsion. The cyanotype is stable and long lasting, with the characteristic deep blue colour seen for so long in architects' and engineers' offices.

Daguerreotype (1839–late 1850s)

The daguerreotype was invented by Louis-Jacques-Mandé Daguerre (1787–1851), following the researches of Nicéphore Niépce (1765–1833) in the early 19th century, and was announced to the world in 1839, an event that has come to mark the official birthdate of photography. The first commercially successful photographic process – because the French government gave it free to the whole world (excluding England and Berwick-on-Tweed) – the daguerreotype was a unique direct-positive image produced on a highly polished silver halide coated copper plate, without the intermediary stage of a negative. After exposure of the plate, the image was developed by fumes of mercury.

A daguerreotype image was extremely clear and detailed, so it quickly became popular for portraiture, despite the relative expense of the process. However, it was also a unique, one off image, which needed to be held at an angle for viewing without distracting reflections in the mirrored plate, so it was eventually superseded by negative–positive systems, which could yield many prints. Daguerreotypes were frequently hand tinted, and usually mounted in cases with cover glass to protect the delicate image surface.

Developing and Fixing

It was William Henry Fox Talbot's discovery in 1840 that after exposure in the camera, his sensitized sheets of paper, although acted upon by the light, contained an invisible or latent image that required immersion in a chemical bath to develop it and make it visible – transforming the exposed silver halides into the metallic silver that forms the image. Once it was developed, the image required fixing, immersion in a bath of sodium thiosulphate (hypo) to prevent any further chemical reactions. After fixing, it is important to wash out any residual chemical that may affect the look or permanence of the image in the future. It is only relatively recently that photographers have become aware of archival processing – processing for maximum permanence by carefully washing out any residual chemicals between every step of the process. Any collector purchasing a modern print should ascertain that it has been processed in accordance with archival procedures.

Digital Print (mid-1980s–present)

The biggest revolution in photographic technique since the invention of the dry plate and halftone block has been the advent of digital photography – photography by computer. Digital photography is still in its infancy, but will eventually herald the end of silver photography, the darkroom and wet chemicals for most photographers – within the next two decades or even sooner. At the moment, we are in the transitional phase, with many photographers using a combination of traditional and digital techniques – using gelatin films, for instance, in tandem with digital printing.

Computer prints are beginning to make rapid headway in the photographic art market since the introduction in the last few years of more archivally stable inks and pigments. It is a wide and varied field, and there is no space to describe every process, but basically, the collector is likely to be faced with the choice of purchasing two main categories of digital print (excluding those where the computer has been utilized in facilitating photo-mechanical prints along traditional lines). The two are inkjet prints and lambda prints or similar techniques using photographic paper. Other digital processes, such as laser, dye-sublimation, solid ink, or thermal-wax prints, are not so popular with the fine art photographer, and are used more in commercial graphics.

Direct Positive Print (1840s)

Strictly speaking, the term direct positive applies to any photographic process where a positive image is produced without the intermediate step of a negative. Colour transparencies, computer prints, photocopies and so on are all direct positives. But historically, the term refers to early processes, like that of Hippolyte Bayard (1801–1887), one of the triumverate (the others being Daguerre and Fox Talbot), credited with inventing photography. Bayard's process used sensitized writing paper, like Fox Talbot's, but pre-exposed it to light, turning it black. He then dipped the sheet into potassium iodide, exposed in the camera, where the iodide bleached out the paper in proportion to the light received, forming a positive rather than a negative image. Unlike Fox Talbot's system, each image was unique, and could only be reproduced by re-photographing it.

Dodging and Burning In

When making a print, during its exposure under the enlarger light, a sensitive photographer can control local areas of tone, lightening or darkening an area as desired. Dodging is used to lighten an area – by holding an object between the enlarger lens and photographic paper less light is thrown on to it, thus when it is developed the tonal values will be lighter. Burning in is the opposite: once the print has received an overall, general exposure, more light is thrown on to area, usually through a hole in a piece of card, so this area will turn out darker in tone when developed. Using these simple means, photographers have a palette of tonal variations to hand when making a print.

Dye Transfer Print (1870s–present)

Dye transfer is related to the colour carbro process but uses a gelatin mould rather than carbon tissue. From a colour transparency, three separation negatives are made by photographing the original through red, green, and blue filters respectively. From these negatives, three matrixes (or moulds) are made, each in the respective primary colour, from gelatin coated film which is treated to harden selectively. When the unhardened gelatin is washed away, each mould is place in an appropriate dye bath and then serially applied in exact register on to a final paper support to produce the final image. Like colour carbro prints, dye transfer prints are relatively permanent, but the technique, which is difficult and time consuming, has become extremely expensive.

Edition Print

An edition print is one that forms part of a limited edition run. It will almost certainly be an exhibition quality print made for the photographic print collector, and will be signed, numbered, and dated.

Emulsion

The light sensitive coating of modern photographic film, plates, and printing papers is an emulsion of silver halide crystals suspended in gelatin. Different combinations of silver salts, and different opacities of emulsion are made, depending upon whether it is film (a transparent emulsion) or paper (opaque emulsion), whether black and white or colour, and the kind of light sensitivity (speed).

Enlargement

A print larger than the original negative, made by projecting a magnified image of the negative on to sensitized material. Today's miniature cameras make enlarging a necessity, but for every degree of enlargement, image quality is sacrificed.

Estate Print, or Posthumous Print

When a photographer has died, his or her estate will sometimes commission editions of prints from the photographer's negatives. These are usually superbly made prints, sold at moderate prices, and enable collectors of more modest means to obtain the work of significant figures in the medium who would normally be outside their price range.

Estate prints, however, will not have the cachet or the investment value of prints made by a photographer during his lifetime, and it is arguable whether they can be considered original prints at all.

Etched Daguerreotype (1840s)

See also photoetching. An early photo process in which a printing plate was made directly from a daguerreotype. Acid was used to etch the exposed silver to produce a plate which could be inked and paper impressions taken from it.

Exhibition Print

An exhibition print, as the term implies, is one made to be exhibited, and hopefully sold as a work of art, and as that further implies, would be the very best print of which the photographer or his printer were capable. Exhibition prints are frequently mounted, signed and dated, and further beautified by toning, and if the exhibition itself is of note, tend to have the most impeccable provenance of any kind of photograph. A signed, dated exhibition print from a notable showing within five years of the negative's making – i.e., a vintage exhibition print – would be the serious collector's ideal, and a dealer's top drawer item.

Ferrotype (see Tintype)

File Print (see Press Print)

Fixing (see Developing)

Fresson Print (see Colour Carbro)

Gelatin Dry Plate (1871–present)

Although a dry collodion process did exist, the term dry plate generally refers to the invention by Richard Leach Maddox (1816–1902), who in 1871 introduced gelatin rather than collodion as the medium for photographic emulsions. Unlike the collodion wet plate, gelatin emulsions were usable when dry, and in addition, were more sensitive and needed much less exposure to light. By the early 1880s, these thin glass plates coated with gelatin containing the light sensitive salts, which could be bought ready made, had almost completely superseded collodion wet plates for making negatives. They are still in use to this day for certain specialist scientific applications.

Gelatin Silver Print (1880s–present)

The standard 20th century black and white print, consisting of paper coated with silver halides suspended in gelatin. Introduced in 1882, following the invention of the dry plate and a trend towards smaller cameras, the gelatin silver print virtually replaced albumen because they were more stable, easier to use, and facilitated making enlargements. The silver print family is extensive, including the paper popular in the 1920s and 30s for contact printing – silver chloride – and the choice of those preferring warmer toned results – silver chlorobromide. Today however, silver bromide papers tend to be most extensively used by monochrome enthusiasts.

Gum Bichromate Print (1890s–1920s)

Based upon Poitevin's famous patent of 1855, a gum bichromate print is formed of pigment, such as watercolour dyes, suspended in gum arabic sensitized with potassium or ammonium bichromate. When exposed to light, this emulsion hardens according to the light intensity and is made permanent by washing away the unexposed, and thus unhardened, areas. Such a print can be made in any single colour or combination of colours by recoating and re-exposing the paper. Gum bichromate prints have broad tones with little resolution of detail, and resemble drawings or charcoal sketches. Since they do not contain silver, they are relatively permanent.

Gum Platinum Print (1900s–20s)

A gum platinum print was a combination of two processes, the gum bichromate and platinotype (platinum print), which produced a very rich and subtle impression. The technique was not often used, but was much favoured by Edward Steichen, who utilized it to make some of his greatest images just after the turn of the 20th century.

Halftone (1878–present)

The invention of the halftone block, patented by Frederick Eugene Ives (1856–1937) in 1878, was a crucial development in photomechanical reproduction. It led to the truly widespread dissemination of photographic images because it enabled them to be printed on the same press as ordinary raised type. Firstly, a photograph is rephotographed through a screen of fine crosslines

that converts the continuous tone of the original picture into a pattern of tiny dots that are larger and closer in dark areas, smaller and further apart in light areas. The dot-image pattern is then chemically etched on to a printing plate, which is then inked to transfer the image to paper. The first published halftone appeared in the New York Daily Graphic of 4th March, 1880.

Many technical refinements have been introduced to the basic process. In duotone printing, the halftone image receives two press runs, in tritone printing, three, often with different coloured inks to produce a richer and more lustrous image. Nowadays, traditional halftone methods have largely been superseded by electronic means of reproducing images from photographs.

Heliogravure (see Photogravure)

Inkjet Print (1990s–present)
Inkjet prints are the most common form of computer-generated print. Firstly, the photographic image is digitized, a digital computer file being created by scanning a print, transparency, or negative of the original. Or the image may be loaded directly into the computer from a high resolution digital camera. The digital file is manipulated on the computer to achieve the desired result in printing, the old techniques of dodging and burning in being achieved electronically, as is colour manipulation and many of the other tricks once done by hand.

The print can be made on various kinds of paper or substrate, the only limitation being that it must be capable of being loaded into the printer. As the name implies, inkjet printing means that computer controlled printing heads spray minute droplets of ink at the paper. Multiple droplets are overlaid to create a continuous tone reproduction, rather than the screen or dot patterns associated with traditional photomechanical printing techniques. When properly made on the more professional printers, inkjet prints can offer exquisite image quality, and now that the newer inks are offering archival permanence, will become a much more established part of the contemporary photo art market.

Iris Print (1990s–present)
A superior inkjet print made on a machine manufactured by Iris Graphics of Bedford, Massachussetts, which has become so popular that the terms iris and inkjet have almost become synonymous. To confuse consumers even further, the Iris print is also sometimes known as a Giclée print (from the French term meaning to spray forcefully), and Iris have now trademarked an Iris Giclée print, but strictly speaking, all Giclée prints are not necessarily Iris prints.

Lambda Print (1990s–present)
Lambda prints are made from machines manufactured by the Durst company, and is a system whereby a digital image is printed on to traditional silver photographic materials using laser technology. Lambda prints have the life expectancy of whatever paper is used. Similar prints are available from comparable lightjet systems.

Later Print
A print made more than five years after the negative, and therefore a non-vintage print by definition. Some may sneer at this, but this does not necessarily negate its aesthetic quality as a print, only its antique value. Many photographers indeed will make better interpretations of a negative if they revisit it at a later date, when they themselves have more experience. And some photographers from the 1930s or 1940s – especially photojournalists or documentary photographers – produced mainly work prints or press prints during those decades, then signed exhibition prints in the 60s and 70s, when their work finally became collectable as fine art. So some later prints can be as desirable as vintage prints, but in the print market, the following truism generally holds good: if we are comparing apples with apples, a good early print is more valuable than a good late one.

Modern Print
Modern prints are similar to estate prints, but the term applies more to modern "restrikes" of 19th or 20th century prints, from the original negatives. Such reprints can vary from the superb prints made by a company like the Chicago Albumen works, using 19th-century techniques and newly made albumen or salted paper, to inappropriately made prints on modern resin coated paper.

In the case of a photographer like E. J. Bellocq, the work has become known through the modern prints made by Lee Friedlander from the cache of original negatives he bought. Friedlander

went to great trouble to match his printing paper to the techniques of the time, and these prints have become highly collectable items, as have the albumen prints from Eugène Atget negatives made by the Chicago Albumen Works for sale by the Museum of Modern Art in New York.

Negative–Positive

William Henry Fox Talbot's invention, the calotype, was much more useful than either Daguerre's or Bayard's, because it had the capacity to reproduce itself, and bear identical progeny. Fox Talbot discovered that, when making his experiments with light-sensitized papers, the silver coating darkened in proportion to the amount of light reflected from the subject. The more light, the more his paper darkened, thus he ended up with an image where tonal values were reversed – they were "negative." By placing a similarly sensitized sheet of paper in contact with this "negative" (a term suggested by Sir John Hershel) and exposing that, the same light effect ensured that the values were reversed once more, and a "positive" or print, was obtained. This is the basis of all modern photography.

Oil Pigment Print (1890s–1920s)

An oil pigment print consisted of pigments suspended in gelatin. Like other pigment processes, such as bromoil, oil prints relied upon the hardening of bichromated gelatin with exposure to light. After exposure, the print was washed in water, which penetrated the paper in proportion to the softness of the gelatin. An oily pigment (of a chosen colour) was then brushed or rolled on, penetrating in inverse proportion to the amount of water absorbed by the gelatin. Repeated applications of pigment gradually built up the matrix to whatever density was required, then it was used once, in a printing press and while wet, to make an impression on another sheet of paper.

Orotone (1900s–20s)

An orotone was a positive print made on a glass plate covered with silver gelatin emulsion. The back of the plate was painted with a mixture of gold resins to give it a gold appearance, and then framed. It was a technique made popular by E. S. Curtis in his images of native Americans.

Palladium Print (1920s and 30s)

Also known as a palladiotype, a palladium print is almost the same process as a platinum print except that a compound of the metal palladium is used rather than platinum. When the price of platinum rose steeply in the 1920s, photographers turned to palladium as a cheaper alternative giving much the same qualities.

Photoetching (1840s–present)

Photoetching is a term for the photomechanical method of reproduction using an intaglio metal plate, produced by etching it in acid. The photographic image is formed on the plate by the direct action of light through a negative or transparency upon a sensitive coating which acts as a selective barrier against the action of the acid.

Photogenic Drawing (1830s)

Photogenic drawing was the name given by Fox Talbot to his first photographic experiments in the years preceding the calotype process. Photogenic drawing was in effect a calotype made without a camera – a photogram – where paper sensitized with salt and silver nitrate was placed in contact with leaves, lace, or other such objects in bright sunlight. When an impression of dark and light had been obtained, the image was fixed – the light action stopped – with a strong solution of salt. Until it was discovered that sodium thiosulphate (hypo) was a more efficient fixing agent, these early experimental photographs were highly fugitive and prone to rapid fading.

Photogram (1840s–present)

A cameraless photographic image, in which objects are placed directly on to a sheet of photographic paper. After a brief exposure to light, the imprint of the object, solid or translucent as the case may be, is left as an image. This is one of the earliest forms of photography, seen in the photogenic drawing experiments of Fox Talbot and the cyanotypes of Anna Atkins. It was also popular with some of the experimental modernist artists of the 1920s and 1930s, under various names such as the Schadographs of Christian Schad, or the Rayograms of Man Ray. It is also currently enjoying a revival with some of today's photographic artists.

Photogravure (1870s–1920s)

Photogravure, also known as heliogravure, is perhaps the finest photomechanical process, and derives both from traditional etching and Poitevin's patent of 1855. The technique, utilizing Swan's carbon tissue (see carbon print), was devised by the Austrian printer Karl Klic (1841–1926) in 1879, but Poitevin, Charles Nègre and other early French photographers, and Paul Pretsch in England, had been experimenting with heliogravure since the 1850s. Carbon tissue was exposed in contact to a photographic negative. This was then sandwiched with a copper plate. The tissue paper backing was then peeled away leaving the gelatin matrix, the unexposed gelatin dissolved away, and the plate etched in an acid bath to different depths corresponding to the tones in the original image. The etched plate was then printed, like an etching, in a copperplate printing press.

Photolithograph (1850s–present)

Photolithography was based, like traditional lithography, upon the mutual repulsion of water and grease. A stone or metal plate was sensitized with potassium bichromate. When exposed to light in contact with a negative, the gelatin is rendered insoluble to water in proportion to the amount of light received. Water removes the soluble parts of the gelatin, then the plate is inked, the ink adhering to the areas of hardened gelatin (the darks in the image) but not where the gelatin has been washed away (the highlights). An impression was then made in a printing press.

Photomontage

Photographic and other imagery is taken from various sources and combined on a sheet of paper to form an image. If a duplicate of this image is required, it can be photographed and printed as desired. The photomontage or photocollage is distinguished from the combination print by the fact that the collaged elements are brought together manually, whereas in the latter process they are combined mechanically in the camera, enlarger, or computer.

Platinum Print (1870s–1930s)

Also known as a platinotype, a platinum print is one in which the final image is formed from platinum rather than silver salts. Patented by William Willis (1841–1923), commercially coated platinum papers were readily available until 1937, when the increased cost of platinum made the process impractical. The technique employs light-sensitive iron salts that, during development, precipitate to form the image. Platinum prints are distinguished by their extremely long tonal scale. They are much more permanent than silver prints.

Posthumous Print (see Estate Print)

Press Print, or File Print

A press or file print is one given out to the printing trade for reproduction, and is most likely to be a work print rather than an exhibition print. Press prints, like work prints, were often made on inferior paper, such as single-weight rather than double-weight, or resin-coated rather than fibre, and are usually stamped with the photographer's or an agency stamp, sometimes indicating the terms of reproduction and requesting the print's return after use. This last detail means that collectors considering purchase of a press or a file print from an agency should make sure the seller has proper title to it.

It should be noted that, particularly with journalistic or documentary photographers, who may not have had much necessity to make exhibition prints (at least before the current photo-gallery boom), vintage press prints can command high prices, because they retain a whiff of raw authenticity connected with the photograph's basic function. The press prints of the crime reporter Weegee, for example, tend to be favoured over his more polished prints, especially if distressed with use, and marked with creases and coffee cup stains!

Printing Out Paper (POP) (1880s–1920s)

Printing Out Paper produces a visible image upon exposure to light, without any chemical development. The early photographic processes, such as salt prints and albumen prints, were mostly printing out rather than developing out techniques, but the term POP refers to the paper that was one alternative successor to albumen. Printing Out Paper was gradually made obsolete by silver bromide and other gelatin silver papers, which were much more convenient. However, POPs are still manufactured by specialist manufacturers and it enjoys a vogue among certain photographers.

Proof Print (see Work Print)

Sabattier Effect and Solarization
A partial reversal of tones caused by re-exposure to light during the development of either film or sensitized paper, producing a part positive, part negative effect. Named after Armand Sabattier (1834–1910), who discovered the effect in 1862, and often termed solarization (although strictly speaking, the two phenomena are slightly different). Sabattier effect occurs when an extreme light source, like the sun (hence the term) appears in a highly exposed photograph. The sun becomes a black disk, but the tonal reversal occurs only in that area. The Sabattier effect was popular with some 1930s surrealist artists, notably Man Ray, possibly because results are difficult to predict and are somewhat serendipitous.

Salt Print (1840s and 1850s)
A salt print was the earliest positive print, invented by William Henry Fox Talbot in 1840, and was normally made by contact printing from a calotype, or sometimes a glass collodion negative. Writing paper was sensitized with common salt and silver nitrate, which reacted to produce light-sensitive silver chloride. Placed in contact with the negative and exposed to sunlight, it was a printing out process. When the print had reached the desired intensity, it was fixed with sodium thiosulphate (hypo), washed and dried. It could be toned with gold chloride greater for permanence and a richer tone.

Salt prints are one of the most beautiful photographic processes, reddish or purplish brown when unfaded. Unlike glossy albumen paper, salt prints are matt, thus the image seems to sit in the paper rather than float on the surface. In combination with the broad qualities of paper negatives, they can look like sketches or charcoal drawings.

Solarization (see Sabattier Effect)

Stereograph
A stereograph was a pair of photographs mounted side by side, usually on a card support. When viewed through a stereoscopic viewer designed to hold it, the two images combined to approximate human binocular vision and present an image with the appearance of three dimensions. Stereographic images became immensely popular in the early days of photography, and could be a pair of daguerreotypes or albumen prints, usually about 3–4½ inch (7.6 –11.4 cm) high and 3 inch (7.6 cm) wide. The photographs were not identical, but exhibited a slight lateral shift, being made on special cameras with dual lenses set the same distance apart – 2½ inches (6.3 cm) – as a pair of human eyes. The usual stereoscopic subject was the topographical view, though genre scenes and even the nude were also common.

Talbotype (see Calotype)

Tintype, or Ferrotype (1850s–90s)
The Ferrotype, better known as the tintype in America where it achieved its greatest popularity, was derived from the ambrotype, and was a negative image which appeared positive when viewed against a dark background. It was made on a thin sheet of iron (not tin) coated with sensitized collodion just before exposure. Most tintypes appear flat and soft in comparison with either daguerreotypes or ambrotypes, but were popular for portraits because they were inexpensive, and were often made and sold by street vendors.

Trial Print (see Work Print)

Trichrome Carbro Print (see Colour Carbro)

Van Dyke Print (1900–20s)
An early 20th century process that utilized an emulsion of light-sensitive iron and silver salts to produce a brown image.

Vintage Print
A vintage print is one made around the time of the making of the negative – within five years is now the generally accepted definition. A vintage print is the type most valued by dealers and collectors because it not only represents the photographer's first – and possibly freshest thoughts – but also because of its historical and material links with the picture's making. Photographic papers and materials are constantly changing (papers, for example, have less silver content today than previously), so a vintage print is considered the most authentic expression of a photographer's vision because it is made from materials contemporaneous with the negative.

A vintage print, however, is not necessarily

the best print in aesthetic terms. Strictly speaking the definition is chronological rather than qualitative, although its beauty as a marketing term is that vintage clearly has connotations of quality. A vintage print may well be an exquisitely printed, signed, and mounted work of outstanding beauty and importance. On the other hand, it might be a dog-eared press print, or a trial print made on the way to obtaining the prime print.

Waxed Paper Negative (1850s)

The variation to the calotype published by Gustave le Gray (1820–1882) in 1851 improved its translucency and thus its ability to resolve finer points of detail. This was done by rubbing the paper with beeswax prior to sensitizing it, a refinement which also allowed the paper to be prepared several days before use and without the necessity for immediate development, a particularly useful feature for the travelling photographer. Indeed, such was the improvement in quality and ease of execution, some photographers preferred the method long after the advent of the wet collodion process.

Woodburytype (1864–90s)

The woodburytype was patented in 1864 by Walter Bentley Woodbury (1834–1885), and is similar in principle to carbon printing. A coating of collodion was poured on to a glass plate dusted with talc. When dry, the plate was recoated with bichromated gelatin. The gelatin was stripped from the glass, exposed in contact with the negative to be reproduced, and the unexposed gelatin dissolved away with washing. The gelatin mould was now pressed into contact with a soft lead sheet, and a reversed mould made for the final printing. The lead mould was filled with pigmented gelatin and printed in a hand press, resulting in a print which was very rich and true to the original, permanent and with continuous tone.

Work Print, Trial Print, or Proof Print

Every photographic printer usually takes two or three attempts at a print before getting it right. These not-quite-so-good attempts are known as work prints (or trial or proof prints), and as a rule must be accounted less desirable than fully realized exhibition prints – whether they themselves are vintage or not. A print the photographer quickly knocks out just to see what is on the negative is also known as a work print, and is also likely to be inferior to an exhibition print, frequently being made on cheaper, inferior paper.

Because they were seconds, work prints were often given away to be used as press prints, the basis for reproduction in a magazine, book, or catalogue, being considered quite good enough for that purpose but not for exhibition or sale.

Xerograph (1970s–present)

A generic term which has come to be used for any kind of image produced by means of office photocopy machines. Xerographs were popular with some photographic artists in the 1970s and 80s, when there was much exploration of alternative and non-silver processes.

Key Photographers

The following is an alphabetical listing of the 250 most important names in today's collector's market, determined by their importance in the history of photography and the values and importance their work has assumed in the auction houses of America and Europe. The market canon of photographers is not quite the same as the photographic historian's canon, but each feeds into the other. We have studied auction catalogues from the USA and Europe noting the photographers with the highest collectable profiles.

We have also included some important names amongst collectors, such as Hippolyte Bayard and Dr. Thomas Keith, whose work is extremely rare. The same categorization may be applied to much more familiar figures from the modernist era, such as László Moholy Nagy or John Heartfield. Examples of their prime work are nearly all in museums or the best private collections. Nevertheless, such figures have been, and are, an important part of the collecting world, and have been included accordingly.

The most problematic area of the directory is in the contemporary field, partly because it is new and untested, more subject to the whims of fashion than any other area of the market, and because the contemporary art/photography scene is so open and fluid, with many artists working wholly or partially with the camera. We have included them by considering whether photography is an important part of their practice; for example, Andreas Gursky clearly makes photographic works alone, while Anselm Kiefer or Gilbert and George, who have done extremely interesting work with photography, nevertheless fall, we feel, outside the scope of purely photographic collecting.

The prices given are generally for vintage prints unless otherwise noted. As we are dealing with the most "collectable" figures, many prices are stratospheric, but potential collectors should not be discouraged. As we have frequently intimated, fine photographs can be still found for modest sums. The price estimates are approximate figures only, as individual factors such as image, condition, date of printing, and provenance, can affect the price of a photograph to a tremendous degree. The difference between prints of the same image, especially 19th-century classics, can be many thousands of dollars. And if you find prints under the prices indicated, as you most certainly will, they are not necessarily a bargain.

Berenice Abbott
(American) 1898–1991
Documentary, portrait, and scientific photographer.
Subject Matter Portraits of literary and artistic notables (1920s), New York cityscapes (1930s), scientific photographs illustrating the laws of physics (1940/50s).
Media Silver gelatin prints – vintage prints, mainly contact; later prints, enlargements.
Price Vintage prints – $4,000– $25,000 plus. Later prints – from $3,000.

Ansel Adams
(American) 1902–1984
Doyen of 20th-century American landscape photographers.
Subject Matter Western landscapes on the grand scale (1920s–1970s).
Media Silver gelatin prints. Also Polaroid and some colour. Unsigned editions of "studio" contact prints made by others available from the Ansel Adams Gallery, Yosemite.
Price $5,000–$100,000 plus for a large size print or important vintage print. 'Studio' prints – $150.

Robert Adams
(American) b. 1937
Arguably the most influential American landscape photographer since Ansel Adams.
Subject Matter The 'man altered' landscape of the American West – malls, tract homes, urbanization, deforestation – shot in studied but passionate mode (1970s–present).
Media Silver gelatin prints.
Price From $4,000–$10,000 or more for significant vintage prints.

Manuel Alvarez Bravo
(Mexican) b. 1902–2002
The finest 20th-century Mexican photographer, and a leading modernist.
Subject Matter Landscapes, cityscapes, still-lives, nudes, and social documentary (1930s–90s), always exploring what it means to be Mexican.
Media Silver-gelatin prints. Later platinum and palladian prints. Also some colour.
Price Vintage prints – from $5,000. Later silver prints and colour – from $2,000. Platinum/palladium prints – from $3,000.

Thomas Annan
(Scottish) 1829–1887
Portrait, topographical, and documentary photographer.
Subject Matter Portraits, topographical views, but best known for *The Old Streets and Closes of Glasgow* (1860s), early social documentary.
Media Salt, albumen prints and carbon prints, photogravures.
Price Salt, albumen prints – rare, expensive, around $2,000–$7,500 plus. Carbon prints – around $2,000. Photogravures (1900) – around $200.

Nobuyoshi Araki
(Japanese) b. 1940
Japan's most prolific and influential photographer.
Subject Matter Japanese urban landscape and cityscape, still lives, portraits, and nudes, frequently in sado masochistic poses (1970s–present).
Media Silver gelatin and type C colour prints – up to about 4 x 3 feet.
Price $1,500–$10,000 plus.

Diane Arbus
(American) 1923–1971
Influential portraitist of the American "social landscape".
Subject Matter Portraits of American types, often those outside conventional society – nudists, transvestites, circus performers and so-called "freaks" (1960s).
Media Silver chlorobromide prints, usually printed to 14 x 14 inches on 16 x 20 inch paper. Vintage prints stamped on verso, signed. Estate prints (in editions of 55) stamped on verso and signed by Doon Arbus.
Price Vintage prints – $30,000– $300,000. Estate prints – $5,000– $25,000.

Eugène Atget
(French) 1857–1927
The great documentary photographer of Paris.
Subject Matter Paris and its environs (1890s–1927).
Media Contact prints on albumen or printing-out-paper. Silver gelatin prints made by Berenice Abbott. Modern albumen prints from the Museum of Modern Art, New York.
Price Good vintage prints – $10,000–$150,0000 plus. Fair vintage – from $1,500. Abbot prints – from $2,000. MoMA restrikes – $500.

Anna Atkins
(English) 1799–1871

Her album, *Photographs of British Algae* (1843–53), lays a claim to being the first photobook.

Subject Matter Photograms of British plants, leaves, and grasses (1840s).

Media Cyanotype photogenic drawings.

Price From $15,000.

Richard Avedon
(American) b. 1923

The doyen of American fashion and portrait photographers.

Subject Matter Fashion and studio formal portraits of celebrities. Also social portraits of "ordinary" people (1950s to present).

Media Silver gelatin prints – contact prints to "lifesize" or larger.

Price $4,000 up to $80,000 plus for oversize and important vintage prints.

David Bailey
(English) b. 1938

Leading English portrait, fashion and editorial photographer; the epitome of the "Swinging Sixties".

Subject Matter Portrait, fashion, nudes, editorial and advertising photography (1960s–present).

Media Silver gelatin, type C colour prints.

Price From around $3,000–$15,000 plus.

John Baldessari
(American) b. 1931

Leading conceptual artist and photographer.

Subject Matter The nature of perception in photography and media, expressed primarily in collaged imagery (1960s–present).

Media Silver gelatin and type C prints, photo-emulsion on canvas, photolithography, mixed media.

Price From $5,000 to $30,000 plus.

Edouard-Denis Baldus
(French, b. Prussia) 1813–1889

A serious rival to Gustave Le Gray's pre-eminence in early French landscape and architectural photography.

Subject Matter Landscapes, industrial landscapes, and architecture (1850s–1870s).

Media Salted paper and albumen-silver prints from waxed paper and wet collodion negatives.

Also the mid-1870s heliogravures (photogravures).

Price Early large salt and albumen prints – $5,000–$80,000 plus. Later, smaller prints and photogravures – from around $700.

Roger Ballen
(American) b. 1950

Documentary photographer in the Diane Arbus mode.

Subject Matter Confrontational, flash-lit images of South Africa's white underclass (1980s to present).

Media Silver gelatin prints from $2\frac{1}{4}$ sq. format negatives.

Price $3,000–$15,000 plus.

Dmitri Baltermants
(Russian) 1912–1990

Leading Soviet war and reportage photographer.

Subject Matter Soviet reportage, especially during World War Two – Moscow, Sebastopol, Leningrad, the Crimea (1940s). Post-war reportage (1950s–70s).

Media Silver gelatin prints.

Price Vintage prints – from $5,000. Later prints – from $2,000.

Lewis Baltz
(American) b. 1945

Leading "New Topographic" photographer and photo-installation artist.

Subject Matter Industrial parks, tract housing, rubbish dumps (1970s–80s). Photo-installations with similar subject matter (1990s–present).

Media Silver gelatin prints. Video and computer generated art.

Price Silver gelatin prints – from $3,000.

George N. Barnard
(American) 1819–1902

American Civil War photographer.

Subject Matter Photographic Views of Sherman's Campaign (1864). Other Civil War documentary landscapes and topographical views

Media Daguerreotypes (extremely rare), albumen stereocards and albumen prints from collodion glass-plate negatives.

Price Good Sherman campaign prints – $1,500–$10,000 plus.

Tina Barney

(American) b. 1945

Photographs the privileged world of the American East Coast upper classes – the Upper East Side, the East Hamptons, Rhode Island.

Subject Matter Family groups, indoor and outdoor life.

Media Type C colour prints, in small editions from 30 x 40 inches to 48 x 60 inches.

Price From around $5,000.

Gabriele Basilico

(Italian) b. 1944

Architect turned urban landscape photographer in the "Düsseldorf School" mode.

Subject Matter Cities and cityscapes (1980s to present).

Media Mainly silver gelatin prints, up to 4 x 3 feet or more. Also type C colour prints.

Price From around $3,000.

Hippolyte Bayard

(French) 1801–1887

The "forgotten" inventor of photography.

Subject Matter Still-lives, self portraits, architecture and landscapes (1840s/50s).

Media Direct positives on paper, daguerreotypes, salt and albumen prints. Modern prints (1970s) by Claudine Sudre from Bayard negatives.

Price Direct paper positives – $30,000–$200,00 plus. Other good vintage material – from $10,000. Claudine Sudre reprints – around $500.

Herbert Bayer

(American, born Austria) 1900–1985

Architect, designer, and Bauhaus teacher, noted particularly for typographical design.

Subject Matter Experimental photography – photocollage, combining photographs with typography and other media (1930s).

Media Silver gelatin prints, photocollages and photomontages, often re-photographed.

Price Vintage photocollages – from $30,000. Editioned (re-photographed images) – from $10,000.

Peter Beard

(American) b. 1938

Legendary photographic artist with obsessive interest in Africa.

Subject Matter Africa – animals, people, landscapes, usually combined into elaborate photo-collages (1960s–present).

Media Photocollage, usually silver gelatin or iris prints, combined with writing, drawing, and painting.

Price Iris prints – from $3,000. Silver gelatin prints and collages – from $6,000–$100,000 plus.

Felice Beato

(English, b. Italy) c.1830–c.1904

Along with sometime partner, James Robertson, leading photographer of the Far East.

Subject Matter The Crimean War, Malta, Indian Mutiny (with Robertson, 1850s), Japan, China (1860s), Middle East (1870s–80s).

Media Albumen prints from collodion wet plate negatives, some hand coloured, also salt prints. Multi-print panoramas especially desirable.

Price From around $500–$25,000 plus for the best panoramas.

Cecil Beaton

(English) 1904–1980

Leading society photographer and designer.

Subject Matter Fashion and celebrity portraits (1920s–1970s), travels to Middle and Far East (1930s–1940s), World War II reportage (1940s).

Media Silver gelatin prints, some colour.

Price From around $2,000–$15,000 plus for the best vintage prints.

Bernd Becher

(German) b. 1931

Hilla Becher

(German) b. 1934

One of the most important contemporary photographic influences as artists and teachers.

Subject Matter Disappearing industrial structures, shot elevationally and in flat grey light.

Media Silver-gelatin prints, presented singly or grouped in a single frame.

Price Single or multiple image pieces – $8,000 up to $80,000 plus.

Hans Bellmer

(German) 1902–1975

Surrealist artist-photographer in 1930s Germany and Paris.

Subject Matter Constructed photographs of disarticulated female doll (La Poupée), nudes (1930s–50s).

Media Silver gelatin prints, often hand coloured. Limited edition photobooks with original prints.

Price Vintage silver prints – from $5,000. Book, *Les Jeux de la Poupée* (1949) – $25,000–$40,000 plus.

Ernest James Bellocq
(American) 1873–1949

New Orleans journeyman photographer. After his death, 89 glass-plate negatives found in his desk were bought by Lee Friedlander.

Subject Matter Portraits of prostitutes in Storyville (c. 1912), the only known surviving work.

Media Few known vintage prints. Modern contact prints are made by Lee Friedlander, on gold toned Printing Out Paper.

Price Vintage prints – over $15,000. Friedlander reprints – from $1,000–$2,000.

Ruth Bernhard
(American, b. Germany) b. 1905

Leading modernist photographer from the 1930s onwards.

Subject Matter Portraits, natural objects, but chiefly the female nude (1930s–70s). Some are multiple exposures.

Media Silver gelatin prints.

Price Good vintage prints – from $25,000. Later prints – from around $4,000.

Richard Billingham
(English) b. 1970

Artist who photographs his own working-class family.

Subject Matter Life in a cramped high-rise apartment. Also some landscapes.

Media Video, and type C colour prints, enlarged up to as large as 4 x 3 feet, flush mounted on to aluminium sheets.

Price From around $3,000 depending on size.

Ilse Bing
(American, b. Germany) 1899–1998

Notable avant-garde photographer in 1930s Paris.

Subject Matter Portraits, street photography, nightscapes, Paris, landscapes, Holland (1930s–50s).

Media Silver gelatin prints, some from solarized negatives.

Price Vintage prints – from $5,000–$20,000 plus.

Auguste-Rosalie Bisson
(French) b. 1826–1900
Louis-Auguste Bisson
(French) b. 1814–1976

Bisson Frères were probably the leading commercial architectural photographers of the 1850s and 60s.

Subject Matter Travel views (Alps), architecture and monuments in France, Belgium, Italy, portraits (1850s/60s).

Media Daguerreotypes, salt prints from waxed paper negatives, albumen prints from wet collodion negatives.

Price From around $2,000–$30,000 plus for the best prints.

Karl Blossfeldt
(German) 1865–1932

Karl Blossfeldt's book *Artforms in Nature* (1928), is a landmark of the New Objectivity art movement and modernist photography.

Subject Matter Plant parts photographed against neutral backgrounds.

Media Silver gelatin prints. Photogravure prints from his books.

Price Vintage silver prints – $10,000 to $100,000 plus. Gravure plates from books – around $150.

Erwin Blumenfeld
(American, b. Germany) 1897–1969

Experimental and highly successful fashion and editorial photographer.

Subject Matter Fashion, portraits, editorial work. Also personal and experimental nudes (1940s–50s).

Media Silver gelatin prints, some colour. Prints can be from solarized, reticulated, combined negatives.

Price Good vintage prints – from $10,000.

Félix Bonfils
(French) 1831–1885

Commercially successful topographical photographer of the Middle East.

Subject Matter Egypt and the Holy Land – architecture, people and ancient monuments (1870s).

Media Albumen prints from wet collodion negatives.

Price Good examples – between $400 and $700.

Edouard Boubat
(French) b. 1923–1999
Classic French photojournalist.
Subject Matter Humanist reportage
photography from around the world. His *Lella*
(1947), of an enigmatic woman in a white blouse,
is a perennial best-selling image (1940s–90s).
Media Silver gelatin prints.
Price Vintage prints – from $5,000–$25,000.
 prints – from $3,000.

Margaret Bourke-White
(American) 1904–1971
Renowned American photojournalist, who was
given the cover of the first issue of *Life* magazine
in 1936.
Subject Matter Photojournalism, industrial,
and advertising photography (1920s–60s), Russia
(1930s), the Depression (1930s), Second World War.
Media Silver gelatin prints.
Price Vintage silver gelatin – from around
$2,000–$100,000 plus for rare early prints.

Samuel Bourne
(English) 1834–1912
The Calcutta firm of Bourne and Shepherd was
the most prolific supplier of Indian topographical
views during the 19th century.
Subject Matter India, Burma, Ceylon – views,
architecture, people (1860s–70s).
Media Albumen prints from wet collodion
negatives.
Price Good prints – around $500– $1,000.
Weaker toned prints – around $100.

Mathew Brady
(American) 1823–1896
Photographer and entrepreneur who organized
the photographic documentation of the American
Civil War.
Subject Matter Best known for portraits
(1850s–60s), also Civil War scenes (1860s).
Media Daguerreotypes, albumen prints from
wet collodion negatives (imperial to carte de
visite size, and stereographs).
Price Good authenticated prints – from
$7,000–$30,000 plus. Good stereographs, cartes
de visite – from $100.

Constantin Brancusi
(Romanian) 1876–1957
Renowned modernist sculptor who made

expressive and sought after photographs of
his own works.
Subject Matter His own work, also snapshots
of his studio and friends (1910s–40s).
Media Gelatin silver prints.
Price Vintage prints – $10,000– $100,000 plus.

Bill Brandt
(English) 1904–1983
Britain's most renowned and versatile
photographer.
Subject Matter English social documentary
(1930s), landscapes and wartime London
(1940s), portraits (1950s), and abstract nudes
(1950s and 60s).
Media Silver gelatin prints. Vintage prints small
and dark. Later prints extremely contrasty, larger.
Price Average quality vintage prints – from
$3,000. Estate prints (platinum) of nudes – $4,000.
Best prints – $20,000 plus.

Brassaï (Gyula Halász)
(French, b. Romania) 1899–1984
Brassaï was one of the prominent group of
European photographers in the 1930s centred
in Paris.
Subject Matter Paris by night (1930s), portraits
of the French artworld (1940s), cliché verre nudes
and graffiti (1950s).
Media Silver gelatin prints.
Price Good vintage prints – $15,000 or more.
Later prints – from $3,000.

Adolphe Braun
(French) 1812–1877
Superior French commercial photographer of the
19th century.
Subject Matter Topographical views (Europe
and Egypt), architecture, art reproductions, still
lives (1850s–70s).
Media Albumen prints from wet collodion
negatives. Carbon prints (up to 20 x 24 inches or
larger).
Price Good albumen – $1,000– $5,000 plus.
Carbon – from $4,000.

Annie Brigman
(American) 1869–1950
Leading pictorialist at the beginning of the 20th
century.
Subject Matter Figure studies, landscapes,
but chiefly known for nudes in the landscape

(1900s–1920s).
Media Mainly silver gelatin prints, but also gum bichromate, palladium and platinum prints. Also *Camerawork* gravures.
Price Vintage prints – from around $5,000 to $70,000 plus. *Camerawork* gravures – from $500.

Francis Brugière
(American) 1879–1945
Extremely interesting transitional figure between pictorialism and early modernism.
Subject Matter Experimental photography – cut paper and light abstractions, solarizations, multiple exposures, cliché verres. Also architecture.
Media Silver gelatin prints (some hand tinted), gum bichromate prints, and colour (autochromes). Also *Camerawork* gravures.
Price Vintage prints – $5,000– $50,000 plus.

Wynn Bullock
(American) 1902–1975
Innovative West Coast photographer of the 1950s.
Subject Matter Highly symbolic landscapes, nudes in landscape.
Media Silver gelatin contact prints. Some colour. Estate prints (silver gelatin) from computer scanned master prints.
Price Vintage prints – $5,000–$25,000 plus. Estate prints (digital) – from $900.

Harry Callahan
(American) 1912–1999
Influential both as a photographer and teacher – a stark, elegant modernist whose work could be though of as an extension to that of Alfred Stieglitz.
Subject Matter Cityscapes, abstract landscapes, beach scenes, his wife Eleanor (1940s–90s).
Media Silver gelatin, and later some colour prints.
Price Vintage prints– from $5,000–$25,000 plus.

Julia Margaret Cameron
(English) 1815–1879
The greatest and most innovative 19th-century portraitist.
Subject Matter Psychologically intimate portraits, genre tableaux (1860s).
Media Albumen prints from wet collodion negatives. Later carbon prints (by her son) and *Camerawork* photogravures.
Price Good albumen prints – $10,000–$80,000

plus. Carbon prints – $2,000–$3,000. *Camerawork* gravures – $500.

Robert Capa
(Hungarian) 1913–1954
Leading war photographer and co-founder of the Magnum photographers' co-operative.
Subject Matter Photojournalism, mainly of conflict – Spanish Civil War (1930s), World War II (1940s), Indo China (1950s).
Media Silver gelatin prints.
Price Vintage Prints – around $3,000–$15,000 plus.

Paul Caponigro
(American) b. 1932
Leading contemporary landscape photographer in the Alfred Stieglitz mode.
Subject Matter Romantic and metaphorical landscapes and still lives, where the images may be seen as "equivalents" for the photographer's feelings (1950s–present).
Media Silver gelatin prints from large format negatives.
Price Vintage prints – $5,000– $15,000 plus. Later prints – from around $3,000.

Lewis Carroll
(English) 1832–1898
The author of *Alice's Adventures in Wonderland* was also a keen amateur photographer.
Subject Matter Some portraits of fellow academics, landscapes, but chiefly young girls (1860s).
Media Albumen prints from wet collodion negatives, up to 8 x 10 inches.
Price From $10,000–$60,000 plus.

Keith Carter
(American) b. 1948
A popular contemporary "poet of the ordinary".
Subject Matter Landscapes, people, animals, often shot with differential focus to emphasize their poetic qualities (1980s–present).
Media Toned silver gelatin prints from 2¼ inch square negatives, in editions up to 25.
Price From $1,000, rising as edition sells out.

Henri Cartier-Bresson
(French) b. 1908
The photographer who, above all others, validated the use of the 35mm camera.

Subject Matter Portraits, cityscapes and landscapes – humanist documentary (1930s–90s).
Media Silver gelatin prints, the vintage in small numbers, and later signed exhibition prints.
Price Vintage prints – $10,000–$50,000 plus. Later prints – from $4,000.

Désiré Charnay
(French) 1828–1915
Great expeditionary photographer of the mid-19th century.
Subject Matter Central America – Aztec and Mayan ruins, Madagascar (1850s–60s).
Media Albumen prints from wet collodion negatives, including multiple-print panoramas.
Price Good prints – from $5,000– $30,000 plus.

Larry Clark
(American) b. 1943
The great bohemian of photographic culture.
Subject Matter Documentation of American counterculture – drug addicts, teenage sex, street kids (1970s to present).
Media Silver gelatin and some colour prints.
Price Vintage prints – from $5,000. Modern prints – from around $4,000.

Lucien Clergue
(French) b. 1934
Leading French photographer and teacher. Founder of the annual Arles Photography Festival.
Subject Matter Landscapes, abstractions, gypsies, bullfights, nudes in the sea (1950s–present).
Media Silver gelatin prints.
Price Vintage nudes – from around $2,500. Later prints – from around $1,000.

Alvin Langdon Coburn
(British, b. America) 1882–1966
Leading transitional figure between pictorialism and modernism.
Subject Matter Portraits, landscapes, cityscapes (1900s–1925). Also abstract "Vortographs" made with kaleidoscope-like mirror (1917–20). Maker of fine photographic books.
Media Platinum, palladium and gum-bichromate prints. Also photogravures, from books.
Price Vintage platinum and other chemically produced prints – around $5,000–$40,000 plus. Photogravures – from $800.

Thomas Joshua Cooper
(American) b. 1946
Conceptual landscape photographer in the romantic mode.
Subject Matter Rocks, trees, the sea – emphasising the mystical and mythological aspects of nature (1970s to present).
Media Silver gelatin prints, toned – up to 4 x 3 feet from 7 x 5 inch negatives.
Price $5,000 –$15,000 plus.

John Coplans
(American, b. Great Britain) b. 1920
Postmodern self-portraitist.
Subject Matter Semi-abstract close-ups of his naked body – hands, feet, torso – investigating issues of masculinity and old age.
Media Large silver gelatin prints, sometimes in diptychs or triptychs.
Price From $5,000.

Gregory Crewdson
(American) b. 1962
Photographer of contemporary suburban melodramas.
Subject Matter Staged photographs of suburban life, some directed with actors, others using built tableaux (1990s–present).
Media Silver gelatin, type C colour prints, up to 30 x 40 inches or larger.
Price From $5,000.

Imogen Cunningham
(American) 1883–1976
First-generation American modernist with long and distinguished career.
Subject Matter Abstract plant close-ups, nudes, portraits (1910s–1970s).
Media Silver gelatin prints.
Price Vintage prints – $10,000– $120,000 plus. Late prints, and posthumous, stamped estate prints – from around $2,000.

Edward Sheriff Curtis
(American) 1868–1952
Made a massive documentation of the vanishing native American way of life.
Subject Matter Native American tribes, published in the twenty volume book, *The North American Indian* (1907–1930).
Media Silver gelatin, platinum prints, orotones, photogravures.

Price Vintage silver gelatin, platinum prints, or orotones – $3,000–$30,000. Photogravures – from $500.

Eugène Cuvelier
(French) c. 1837–1900
Photographer of the "Fontainebleau" school.
Subject Matter Landscape, country life – almost all in and around the Forest of Fontainebleau (1850s/60s).
Media Salt prints, albumen prints from waxed paper negatives.
Price Good examples – from $15,000–$80,000 plus.

Louise Dahl-Wolfe
(American) 1895–1989
Celebrated fashion photographer of the 1940s and 50s.
Subject Matter Fashion, portraits, nudes (1930s–60s).
Media Silver gelatin and some colour prints.
Price Vintage prints – from around $3,000. Later prints – from $1,000.

Bruce Davidson
(American) b. 1933
Leading member of the Magnum co-operative since the 1960s.
Subject Matter Photo essays dealing with the social scene, especially in New York – Brooklyn gangs, East 100th Street, subway, Central Park (1960s–present).
Media Silver gelatin and some colour prints.
Price From around $3,000.

Lynn Davis
(American) b. 1944
Contemporary landscape photographer on monumental scale.
Subject Matter Nudes, portraits (1970s–80s), landscapes – icebergs, waterfalls, ancient monuments (1980s–present).
Media Silver gelatin prints, to 4 x 4 feet.
Price From $3,000–$15,000 plus.

Frederick Holland Day
(American) 1864–1933
Eccentric, wealthy pictorialist from Boston.
Subject Matter Staged classical and painterly tableaux, often with homoerotic undertones (1880s–1910s)

Media Mainly platinum prints, but also cyanotypes, gum bichromate, and silver gelatin prints.
Price Good vintage prints – $30,000–$80,000 plus.

Roy DeCarava
(American) b. 1919
Social documentary photographer of the New York School, especially known for his portraits of jazz musicians.
Subject Matter Social life, New York City (Harlem), jazz musicians (1950s–80s).
Media Gelatin silver prints.
Price Vintage prints – from $3,000. Later prints – from $2,000.

Louis de Clercq
(French) 1836–1901
Important early photographer of the Middle East, one of the last to use the paper negative process.
Subject Matter Middle Eastern landscapes and ancient monuments, often in multiple print panoramas (1850s).
Media Albumen prints from waxed paper negatives.
Price From $3,000. Panoramas – from $6,000–$20,000 plus.

Robert Demachy
(French) 1859–1936
French pictorial photographer, member of the Linked Ring.
Subject Matter Portraits, nudes, genre scenes, landscapes, modernist scenes (racing cars), cityscapes (1890s–1910s).
Media Chiefly gum bichromate prints. Also oil transfers, platinum, and silver gelatin prints. *Camerawork* gravures.
Prints $5,000–$20,000 plus. *Camerawork* gravures – around $500.

Thomas Demand
(German) b. 1964
Leading contemporary German artist-photographer.
Subject Matter Photographic pieces made from architectural and building interior models made by the artist (1980s–present).
Media Type C colour prints, up to 6 x 4 feet or larger.
Price From $7,000–$45,000 or more, depending on size and edition.

Susan Derges
(English) b. 1955
Maker of landscape and natural form photograms.
Subject Matter Natural elements – water, sky, trees, rain on glass – captured with both camera and cameraless photographic processes (1980s–present).
Media Silver prints, type C prints – colour photograms, to around 8 x 4 feet.
Price From $5,000.

Philip-Lorca diCorcia
(American) b. 1953
Leading contemporary photo-artist, employing the rhetoric of the "street" photographer.
Subject Matter Candid street portraits, urban streetlife shot in the "directorial" mode (1980s–present).
Media Type C colour prints, up to 4 x 3 feet or larger.
Price From $10,000.

Rineke Dijkstra
(Dutch) b. 1959
Large format colour portraitist.
Subject Matter Portraits of social types shot in series – adolescents, matadors, mothers just following birth (1990s–present).
Media Type C colour prints up to 4 x 3 feet and larger, video.
Price From $7,000–$30,000 plus.

Robert Doisneau
(French) 1912–1994
Along with Elliott Erwitt, the great humorist of humanist photography.
Subject Matter Reportage, especially French life and Paris (1940s–80s).
Media Silver gelatin prints.
Price Vintage prints – $4,000– $25,000 plus. Later prints – from $2,500.

Frantisek Drtikol
(Czechoslovakian) 1883–1961
Symbolist photographer of the 1930s.
Subject Matter Primarily the female nude, shot in a formalist, allegorical, and symbolist manner (1920s–30s).
Media Bromoil, oil pigment, and silver gelatin prints. Also posthumous portfolio reprints.
Price Vintage prints – from around $8,000 to $40,000 plus. Reprints – from $4,000.

Maxime Du Camp
(French) 1822–1894
Distinguished writer who made photographs on renowned trip to the Middle East with Gustave Flaubert.
Subject Matter Ancient monuments and landscapes from his book, *Egypte, Nubie, Palestine et Syrie* (1852).
Media Salt prints from paper negatives, made by the Blanquart-Evrard factory in Lille.
Price Good examples – from around $1,500–$20,000 plus.

Harold E. Edgerton
(American) 1903–1990
Pioneer of high-speed stroboscopic photography.
Subject Matter Scientific photography – especially high-speed flash photography that records such phenomena as a speeding bullet and a humming bird in flight (1930s–70s).
Media Silver gelatin and some colour prints.
Price Vintage prints – from $5,000–$15,000 plus. Later prints – from $2,000.

William Eggleston
(American) b. 1939
The doyen of contemporary colour photography, who, along with Stephen Shore and Joel Meyerowitz, demonstrated its potential in the 1970s.
Subject Matter People, landscapes and objects, mainly in the American South (1970s–present).
Media Dye transfer, type C colour and lightjet iris prints.
Price Dye transfer prints – from $15,000. Type C – from around $8,000. Iris Prints (in large editions) – $400–$500.

Alfred Eisenstaedt
(American, b. Germany) 1898–1995
Pioneer photojournalist, working for Associated Press in Berlin, then *Life* magazine in America, during the 1930s.
Subject Matter Reportage – "human interest" stories (1930s–60s).
Media Silver gelatin and some colour prints.
Price Vintage silver gelatin – $3,000 –$12,000 plus. Later prints – from around $2,000.

Ed van der Elsken
(Dutch) 1925–1990
Social documentary photographer and film-maker

in the "stream of consciousness" mode.
Subject Matter Social documentary, travel photography, jazz musicians, shot in fast, intuitive way (1950s–80s).
Media Silver gelatin prints, some colour.
Price Vintage prints – from $1,000–$5,000 plus.

Peter Henry Emerson
(English, b. Cuba) 1856–1936
Advocate for "naturalistic" photography rather than "high art" pictorialism in the 1880s. Author of fine photobooks.
Subject Matter East Anglian landscapes, seascapes, genre scenes of rural life (1880s–1890s).
Media Platinum prints, hand-pulled photogravures.
Price Platinum prints from *Life and Landscape on the Norfolk Broads* – $10,000–$30,000 plus. Gravures – around $1,000–$2,000.

Elliott Erwitt
(American) b. 1928
American editorial photographer in the classic French mode, and renowned photo-humorist.
Subject Matter Reportage, street photography, people, dogs, and the relationship between people and dogs (1960s–present).
Media Silver gelatin and some colour prints.
Price Vintage prints – from $3,000. Modern prints – from $2,000.

Frederick H. Evans
(English) 1853–1943
Pictorial photographer, known for his exquisite, unmanipulated prints.
Subject Matter Mainly architectural interiors, also landscapes and portraits (1890s–1920s).
Media Platinum prints, some silver gelatin prints. Also *Camerawork* gravures.
Price Vintage prints – from around $5,000–$30,000 plus. *Camerawork* gravures – from $600.

Walker Evans
(American) 1903–1975
Widely influential, complex documentary modernist photographer. Worked for the FSA in the 1930s.
Subject Matter The American social landscape, vernacular architecture (1930s–70s), FSA work (1930s), subway and street portraits (1940s).

Media Silver gelatin prints, colour (Polaroid SX70). Library of Congress reprints.
Price Vintage prints – $4,000– $200,000 plus. Library of Congress reprints (from copy negatives) – $50–$75.

Patrick Faigenbaum
(French) b. 1954
Leading French photo-artist.
Subject Matter Portraits, statues, still lives, interiors, investigating the subjective nature of historical realities: Rome, Naples, Prague, Bremen (1970s–present).
Media Silver gelatin, type C colour prints, in small editions or "one offs".
Price From $5,000.

Bernard Faucon
(French) b. 1930
Leading French maker of contorted photo-tableaux.
Subject Matter Photographic tableaux, often featuring lifesize dolls in disquieting and surrealist situations (1980s to present).
Media Type C colour prints.
Price From around $5,000.

Louis Faurer
(American) 1916–2001
Major influence in post-WWII New York street photography.
Subject Matter Street photography in the available light, "stream of consciousness" manner, fashion and editorial photography (1930s–80s).
Media Silver gelatin and type C colour prints.
Price $3,000 –$15,000 plus.

Hans Peter Feldmann
(German) b. 1941
Leading German conceptual artist.
Subject Matter His own and recycled photographs in sequences exploring the representation of the everyday, frequently presented in bookworks (1970s to present).
Media Silver gelatin, type C colour prints, Polaroid, offset lithography.
Price Bookworks – from $100– $2,000. Other works – from $2,000.

Andreas Feininger
(American, b. France) 1906–1999
Architect turned successful photographer and

Life magazine staffer.

Subject Matter Formal modernism, architecture, landscape, nature, motion studies and people, tending to abstraction (1930s–70s).

Media Silver gelatin prints, some colour.

Price Vintage prints – from $4,000–$20,000 plus. Later prints – from $3,000.

Roger Fenton
(English) 1819–1869

Arguably the finest English photographer of the 1850s.

Subject Matter Landscape (Russia, England. Scotland), war photography (Crimea), still lives, portraits, architecture, art (British Museum) (1850s).

Media Salt and albumen prints, from paper and wet collodion negatives, up to around 17 x 13 inches.

Price From around $3,000– $200,000 plus for the best large examples.

Joan Foncuberta
(Spanish) b. 1955

Spanish photo-artist who manufactures fantasy photographs.

Subject matter Manufactured photographs exploring scientific photo-systems, especially relating to flora and fauna (1980s to present).

Media Silver gelatin prints.

Price From around $3,000.

Franco Fontana
(Italian) b. 1933

Leading Italian colour and editorial photographer.

Subject Matter Landscapes, nudes, cityscapes, fashion (1970s– present).

Media Type C colour prints.

Price From $600.

William Henry Fox Talbot
(English) 1800–1877

The inventor of the negative–positive process.

Subject Matter Landscapes, cityscapes, still lives, portraits, and genre studies. Also photograms (1830s–40s).

Media Salt prints from calotype negatives. Photograms.

Price Good examples – $6,000 to $30,000 plus.

Robert Frank
(American, b. Switzerland) b. 1924

One of the most influential and enigmatic 20th-century photographers, especially through his book, *The Americans* (1959).

Subject Matter Street photography – Europe, Peru, America (1940s–50s). Later "diaristic" and mixed media work (1980s to present).

Media Silver gelatin prints. Later work, multiple print "pieces", hand-drawn and painted silver gelatin prints.

Price Vintage silver gelatin prints – $10,000–$50,000 plus. Later work – from $10,000.

Gisèle Freund
(French, b. Germany) 1912–2000

Reportage, portrait photographer, and photographic theorist.

Subject Matter Chiefly portraits of artists and literary figures, and documentary photo-essays (1930s–70s).

Media Silver gelatin and some colour prints.

Price Early vintage prints – $4,000–$12,000 plus. Later prints – from around $2,000.

Lee Friedlander
(American) b. 1934

Enormously influential and prolific photographer of the late 20th-century American "social landscape."

Subject matter Urban landscapes, portraits, jazz musicians, nudes, trees, and flowers (1960s–present).

Media Silver gelatin prints from 35mm and medium formats.

Price From around $3,000. Vintage – $5,000–$20,000 plus.

Francis Frith
(English) 1822–1898

Frith founded one of the most popular English purveyors of topographical views.

Subject Matter Early views of Egypt, by Frith himself (1850s). Later views by company photographers (1860s–80s).

Media Albumen prints from wet collodion negatives (up to 20 x 16 inches for early Egyptian views).

Price Large Egyptian views – from $15,000 – $50,000 plus. Views by Frith & Co. – from $150.

Jaromir Funke

(Czechoslovakian) 1896–1945

Classic Czech modernist photographer.

Subject Matter Architecture, portraits, still lives (1920s–40s).

Media Silver gelatin prints. Later portfolio prints from the negatives made in the 1990s.

Price Vintage prints – from $5,000–$30,000 plus. Later portfolios (complete) – from $5,000.

Adam Fuss

(English) b. 1961

Pre-eminent figure in the revival of the photogram.

Subject Matter Photograms – cameraless images, using objects, liquids, people (babies) (1980s–present).

Media Type C colour prints, up to 4 x 3 feet and larger.

Price From around $5,000.

Alexander Gardner

(American, b. Scotland) 1821–1882

Photographer of the American Civil War and the expansion of the West.

Subject Matter The Civil War (working for Mathew Brady and himself), portraits, the West (Union Pacific Railroad) (1860s–70s).

Media Albumen prints from wet collodion negatives (from stereographs to 11 x 14 inches).

Price Best prints – from $5,000– $25,000 plus.

William Garnett

(American) b. 1916

The pre-eminent aerial photographer.

Subject Matter Primarily aerial photography (1950s–80s).

Media Silver gelatin, type C colour prints.

Price Vintage prints – from $5,000. Later prints – from around $3,000.

Arnold Genthe

(American, b. Germany) 1869–1942

Known primarily for his documentation of San Francisco's Chinatown in the early 20th century.

Subject Matter Life in San Francisco (Chinatown, the 1906 earthquake), portraits, nudes, theatre, travel (1900s–20s).

Media Platinum, silver gelatin prints, some colour (autochromes).

Price Prime vintage prints – $10,000–$50,000 plus.

Mario Giacomelli

(Italian) 1925–2000

The best known post-WWII Italian photographer.

Subject Matter Landscape, people (country life, old peoples' homes), shot in a raw, graphic style (1940s–80s).

Media Silver gelatin prints, from 35mm negatives, often grainy and harsh in contrast.

Price Vintage prints – from around $2,000–$10,000 plus.

Nan Goldin

(American) b. 1953

Probably the best known contemporary photographer in the "diaristic" mode.

Subject Matter The life and loves of her frequently raffish friends (1970s–present).

Media Type C colour prints from 35mm negatives, up to 4 x 3 feet and larger.

Price From $3,000–$40,000 plus.

John Gossage

(American) b. 1946

Leading landscape photographer in the New Topographical mode, an important link between American and German photography.

Subject Matter The "man-altered" landscape, considered both socio-politically and as a cultural construction.

Media Silver gelatin prints.

Price From around $3,000.

Emmet Gowin

(American) b. 1941

Photographer and teacher at Princeton University, known for his traditional approach, and famed for his in-depth portrait of his wife, Edith, and his aerial photographs.

Subject Matter Wife Edith and family, in Danville, Virginia (1960s–80s), landscapes in Arizona, Ireland, Italy, Jordan, Turkey, Mount St. Helen's (1980s–90s), aerial landscapes (1980s–present).

Media Silver gelatin prints from large– and medium-format negatives, frequently heavily gold toned.

Price From $3,000, priced individually according to whether it is a "good" or a "great" print.

Dan Graham

(American) b. 1942

Prominent conceptual artist, sculptor, and

photographer.

Subject Matter Serial photography, investigating social phenomena and their representation, especially suburbia (1970s–present).

Media Type C colour prints, often in pairs or other sequences.

Price From around $3,000.

Paul Graham
(English) b. 1956

Contemporary artist-photographer whose work sits between the documentary and the expressive.

Subject Matter Contemporary life, often with a political slant – English dole offices, Northern Ireland, Europe, Japan, New York (1980s–present).

Media Type C colour prints, up to about 4 x 3 feet.

Price From around $2,000, depending on size.

John Beasley Greene
(American) 1832–1856

The archaeologist son of a Paris-based American banker, Greene was a singularly talented photographer of empty Middle Eastern landscapes.

Subject Matter Egypt – monuments and desertscapes, Algeria (early 1850s).

Media Salt prints from waxed paper negatives.

Price Good salt prints – around $5,000–$40,000 plus.

Jan Groover
(American) b. 1943

Conceptual artist turned modernist photographer.

Subject Matter Conceptual photography (urban landscape triptychs), portraits, landscapes, still lives (1970s–present).

Media Silver gelatin, type C colour, and platinum/palladium prints.

Price $5,000–$20,000 plus.

Andreas Gursky
(German) b. 1955

The contemporary market leader epitome of the large-format rigorous "Düsseldorf School".

Subject Matter Landscapes, urban landscapes on the grand scale, exploring themes of monumentality, uniformity (1980s–present).

Media Type C colour prints, up to 10 feet wide or larger.

Price $40,000–$600,000. Small, early prints – from around $5,000.

Philippe Halsman
(American, b. Latvia) 1906–1979

Leading editorial photographer and celebrity portraitist of the 1950s.

Subject Matter Commercial, editorial, and advertising photography, but mainly portraits, including series of celebrities jumping (the "jump" pictures) (1930s–60s).

Media Silver gelatin prints, some colour.

Price Vintage prints – from around $3,000–$20,000 plus.

John Heartfield (Helmut Herzfeld)
(German) 1891–1968

The great satirical photomontage artist of the 20th century.

Subject Matter Political photomontage (anti-Nazi, anti-capitalism), book covers and illustration (1930s–50s).

Media Photomontages, and photomechanical reproductions of montages in publications, silver gelatin prints.

Price Original photomontages – around $20,000–$100,000 plus.

Robert Heinecken
(American) b. 1931

Influential, experimental mixed media pioneer of the 1970s.

Subject Matter Mixture of erotic, pornographic, advertising, magazine, and found imagery (1960s–present).

Media Film, paper, photosensitized linen, drawing, painting, collage, reproduced as photolithographs, offset litho prints, silkscreen, photoetching.

Price From around $3,000–$20,000 plus, depending on size, edition and medium.

Florence Henri
(American) 1893–1982

Experimental, "cubist" photographer who studied at the Bauhaus.

Subject Matter Nudes, still lives, portraits, often photographed with mirrors to produce a "cubist" effect. Also streetscapes from unusual angles (1930s–40s).

Media Silver gelatin prints.

Price Vintage prints – from $3,000–$50,000 plus.

David Octavius Hill
(Scottish) 1802–1870
Robert Adamson
(Scottish) 1821–1848
Scottish partnership who produced the first great body of photographic portraiture.
Subject Matter Portraits of Edinburgh notables (Church and arts), but also social portraits (Newhaven fisherfolk), architecture, landscape (1840s).
Media Salt prints from calotype negatives. Also posthumous photogravures and carbon prints made by others (1890s–1910s).
Price Good salt prints – from around $10,000. Carbon prints – $700–$1,200. Gravures – from $500.

Lewis Wickes Hine
(American) 1874–1940
The great social reformer/documentary photographer of the early 20th century.
Subject Matter Social documentary – immigrants, child labour (1910s–30s), Tennessee Valley Authority projects (1930s), men at work (1930s).
Media Silver gelatin prints. Library of Congress reprints.
Price Vintage early work (small prints) – from $2,000. Vintage later work (*Men at Work* series) – $10,000–$50,000 plus. Library of Congress reprints – $50–$75.

David Hockney
(English) b. 1937
Well-known English painter with a keen interest in photography.
Subject Matter Landscapes, interiors, portraits, conversation pieces – his "joiners", large images made from many images of a subject to give multiple viewpoints (1980s –present).
Media Type C colour prints, xerographs.
Price From $10,000–$100,000 plus.

Candida Höfer
(German) b. 1944
Photographic artist of the "Düsseldorf School".
Subject Matter Interiors and buildings, examining the nature of institutions.
Media Type C colour prints, up to 5 x 5 feet or larger, in small editions (generally 6).
Price From around $3,000.

Emil Otto Hoppé
(German) 1878–1972
Well-known society photographer in London during the 1910s and 1920s.
Subject Matter Portraiture (1910s–20s), travel photography (1930s).
Media Silver gelatin, platinum prints.
Price Vintage platinum – from $3,000. Silver gelatin – from $2,000.

Craigie Horsfield
(English) b. 1949
Artist–photographer whose large monochrome prints investigate the sombre side of life.
Subject Matter Urban landscapes, nightscapes, interiors, nudes, portraits (Eastern Europe, England, Spain (1970s–present).
Media Silver gelatin prints, to 5 x 5 feet and larger. Horsfield often prints his negatives years after they were taken.
Price From $10,000.

Horst P. Horst
(American, b. Germany) 1906–1999
Influential fashion and commercial photographer whose career spanned over five decades.
Subject Matter Fashion, nudes, portraits, still lives, marked by strong design and classical elegance (1930s–80s).
Media Silver gelatin, platinum, palladium prints, photogravures.
Price Vintage silver gelatin – from $10,000. Later printed large platinum/palladium prints – from $6,000. Photogravures – around $2,000.

Eikoh Hosoe
(Japanese) b. 1933
Leading, internationally known Japanese photographer, best known for his collaboration with the writer Yukio Mishima in *Killed by Roses*.
Subject Matter Fantasy and dreams, explored with a blend of eroticism and allegory (1960s– present)
Media Silver gelatin and some colour prints.
Price From around $3,000.

George Hoyningen-Huene
(American, b. Russia) 1900–1968
Leading fashion photographer known for his elegant vision and as the mentor of Horst.
Subject Matter Fashion, celebrity portraits (Hollywood) (1920s–50s).

Media Platinum, silver gelatin prints.
Price Good vintage prints – from
$10,000–$50,000 plus.

Peter Hujar
(American) 1934–1987
Fashion photographer who turned to distinctive
and idiosyncratic personal work.
Subject Matter Portraits, nudes, animals in the
landscape, the Palermo catacombs (1970s–80s).
Media Silver gelatin prints.
Price Vintage prints – from $3,000.

Axel Hütte
(German) b. 1951
Large format landscape photographer of the
"Düsseldorf School".
Subject Matter Highly formal landscapes
with signs of human activity (1970s–present).
Media Silver gelatin, type C colour prints,
up to 4 x 3 feet or larger.
Price From $4,000.

William Henry Jackson
(American) 1843–1942
One of the most prolific of early Western
photographers.
Subject Matter Topographical views of the
American West, railroads, ethnographic studies
(1870s–1900s).
Media Albumen prints (from stereographs to
20 x 24 inches) from wet collodion and dry plates,
silver gelatin prints.
Price Extremely variable – as low as $150. Good
early prints from large negatives – $5,000 plus.

Lotte Jacobi
(American, b. Germany) 1896–1990
New York portrait photographer from 1930s
to 1960s.
Subject Matter Celebrity portraits, nature,
cameraless abstractions (1930s–70s).
Media Silver gelatin prints. Also bromoil
and platinum. Late palladium prints (1970s)
made by Carlos Richardson from her
negatives.
Price Good vintage prints – from $5,000. Late
palladium prints – from $3,000.

Bill Jacobson
(American) b. 1955
The master of contemporary soft focus imagery.

Subject Matter Portraits, landscapes,
streetscapes, shot out of focus (1990s to present).
Media Silver gelatin, type C colour prints.
Some monochrome printed on type C paper.
Price $1,500–$4,000 plus, depending on size.

Charles Jones
(English) 1866–1959
English gardener on private country estates
who photographed the fruits of his labour.
Subject Matter Flowers and vegetables,
isolated by a backdrop and photographed
close-up (1890s–1910s).
Media Gold-toned silver gelatin printing-out-
paper (contact prints).
Price From $3,000–$10,000 plus.

Sarah Jones
(English) b. 1959
Photographer and leading "Young British Artist".
Subject Matter Staged tableaux featuring
psycho-dramas revolving around adolescent girls
(1990s–present).
Media Type C colour prints, up to around
4 feet square.
Price From $4,000.

Seydou Keita
(Malian) 1921–2002
Mali studio portraitist of the 1940s–1980s,
recovered from obscurity in the 1990s.
Subject Matter Studio portraits from Mali
(1940s–1980s).
Media Silver gelatin prints.
Price From $2,000. Signed prints have been
sanctioned by the photographer, unsigned
prints not, but this does not seem to affect the
prices asked.

Yousuf Karsh
(Canadian, b. Armenia) 1908–2002
Celebrity portraitist in the grand manner.
Subject Matter Monumental, formal portraits
of well-known figures in the arts, sciences and
politics. Also still lives, social documentary
(1940s–70s).
Media Silver gelatin prints from 8 x 10 inch
negatives, up to 20 x 24 inch.
Price Good vintage prints – from $5,000. Later
prints – from $3,000.

Dr. Thomas Keith
(Scottish) 1827–1895
Edinburgh gynaecologist who was one of the
finest exponents of the waxed paper negative.
Subject Matter Old Edinburgh, architecture,
landscapes, Iona (1850s).
Media Salt prints from waxed paper negatives.
Later platinum prints made by Alvin Langdon
Coburn from the negatives (1900s).
Price Salt prints – from $15,000–$50,000 plus.
Coburn reprints – from $10,000.

Michael Kenna
(American, b. England) b. 1953
Photographer of moody landscapes who is one
of the best selling photographers in the United
States.
Subject Matter Landscapes, often shot at night
or at dusk, or in inclement weather conditions
(1980s–present).
Media Toned silver gelatin prints.
Price From $2,000–around $15,000.

André Kertész
(American, b. Austria-Hungary) 1994–1985
Pioneering photojournalist and modernist
documentary photographer.
Subject Matter Reportage, portraits,
commercial work, nude distortions (1910s–70s).
Media Silver gelatin prints, Polaroid SX70s,
and commercial colour.
Price Vintage prints – $30,000– $200,000 plus.
Later prints – from around $3,000. Late contact
prints (1981) – $7,000.

Astrid Klein
(German) b. 1951
Leading postmodern-formalist photo-artist.
Subject Matter Large format, semi-abstract
collaged "photo paintings", generally
investigating technological systems and process
in modern civilization (1980s–present).
Media Montaged silver gelatin prints, up to 10
feet wide or more.
Price From around $6,000, depending on size.

William Klein
(American) b. 1928
Photographer and film-maker – leading member
of the "New York" school of the 1950s.
Subject Matter "Stream of consciousness" street
photography, fashion (1950s to present).

Media Silver gelatin, type C colour prints
(currently enlarged up to 4 x 3 feet or larger).
Price Vintage silver gelatin prints – from $5,000
to $20,000 plus. New work – from around $2,000.

Josef Koudelka
(Czechoslovakian) b. 1938
Magnum member and lyrical documentarist.
Subject Matter Czechoslovakia 1968, street
photography, gypsies (1970s), panoramic
landscapes (1990s–present).
Media Silver gelatin prints.
Price From around $3,000.

Barbara Kruger
(American) b. 1945
Postmodern artist who appropriates advertising
for feminist messages.
Subject Matter Integration of found photography
with text, using the rhetoric of advertising to make
ironic, feminist imagery (1980s–present).
Media Silver gelatin prints, up to 12 x 6 feet
and larger.
Price From around $10,000.

Germaine Krull
(French) 1897–1985
Leading French modernist photographer.
Subject Matter Modernist abstractions, nudes,
portraits, city life, still-lives (1920s–30s).
Media Silver gelatin prints, photogravures.
Price Vintage silver gelatin prints – from around
$3,000. *Métal* portfolio of 1927 (photogravures) –
$15,000 to $20,000.

Heinrich Kühn
(Austrian, b. Germany) 1866–1944
The leading Austro-German pictorialist.
Subject Matter Portraits, landscapes, genre
scenes (1890s–1920s).
Media Gum bichromate, oil transfer, and
platinum prints. Colour (autochromes). Also
Camerawork gravures and halftones.
Price Good vintage prints – $20,000–$100,000 plus.
Camerawork gravures and halftones – from $500.

David Lachapelle
(American) b. 1968
Exuberant contemporary editorial and fashion
photographer.
Subject Matter Celebrity portraits, fashion, and
commercial photography, extravagantly staged

and shot in garish colours (1980s to present).
Media Type C colour prints.
Price From around $3,000.

Dorothea Lange
(American) 1895–1965
Great social documentary photographer of the 1930s.
Subject Matter Social documentary work during the Great Depression, some for the FSA (1930s), portraits, later work on travels to Egypt, Ireland (1940s–50s).
Media Silver gelatin. Reprints from Library of Congress.
Price Vintage prints – $4,000 to $100,000 plus. Library of Congress reprints – $50 to $75.

Jacques-Henri Lartigue
(French) 1894–1986
Photographer who produced probably his finest work between the ages of seven and twelve.
Subject Matter Family snapshots and social gatherings (pre-1914), later fashion, commercial and personal work (1960s–80s).
Media Silver gelatin and some colour prints.
Prices Vintage prints – from $30,000. Modern prints to artist's approval – from $4,000.

Clarence John Laughlin
(American) 1905–1985
Visionary and individualistic photographer in the "Southern Gothic" mode.
Subject Matter Architecture. still lives, landscapes, fantasy subjects, sometimes shot with multiple exposures (1930s–70s).
Media Silver gelatin prints. Some early colour.
Price From $5,000 to $15,000 plus.

Gustave Le Gray
(French) 1820–1882
Arguably the finest French photographer of the 19th century.
Subject Matter Portraits, landscapes, architecture and seascapes (1850s–60s).
Media Salt and albumen prints, from paper and wet collodion negatives.
Price $40,000 to $500,000. Le Gray's seascape, *La Grande Vague – Sète* holds the world record auction price of £507,500 (*c.*$800,000) for a single photograph.

Annie Leibovitz
(American) b. 1949
The doyenne of contemporary portraitists.
Subject Matter Portraits of "A-List" celebrities. Also female nudes, social portraits, editorial and advertising photography (1970s to present).
Media Silver gelatin, type C colour prints.
Price From $3,000 to $20,000 plus.

Henri Le Secq
(French) 1818–1882
Early French architectural and landscape photographer.
Subject Matter Chiefly architecture – documentation of French cathedrals and monuments. Also landscapes, still lives, and genre scenes (1850s).
Media Salt prints from paper negatives. Some cyanotypes.
Price Good examples – $40,000 to $100,000 plus.

Helmar Lerski
(Swiss) 1871–1956
Modernist photographer and film maker.
Subject Matter Close-up portraits of everyday faces – beggars, hawkers, workers, and servants (1930s).
Media Silver gelatin prints.
Price Vintage prints – from $10,000 to $25,000 plus.

David Levinthal
(American) b. 1949
Studio based photographic tableaux resembling narrative paintings.
Subject Matter Tabletop tableaux made with model toys based on mass media imagery – *Hitler Moves East* (1970s to present).
Media Toned silver gelatin prints, type C colour prints.
Price From $3,000.

Helen Levitt
(American) b. 1918
Distinguished street photographer of the 1940s and 50s.
Subject Matter The street – New York, Mexico City, children (1940s–70s).
Media Silver gelatin, dye transfer, and type C colour prints.
Price Vintage silver gelatin and dye transfer – from $5,000. Later prints – from $3,000.

Michael Light
(American) b. 1963
Photographer and printer of NASA images.
Subject Matter Own photography – cowboys and the West (the *Ranch* photo-novel). Prints from NASA negatives (1990s–present).
Media Silver gelatin, type C colour, inkjet (iris) prints.
Price Own imagery – from $2,000. NASA images – $1,500 to $3,000.

O. Winston Link
(American) b. 1914
The great American railroad photographer.
Subject Matter Early commercial photography, the Norfolk and Western Railroad, frequently shot at night with banks of strobe lights (1950s–60s).
Media Silver gelatin prints.
Price Vintage prints – from $3,000. Later prints – from $2,000.

Herbert List
(German) 1903–1975
Fashion and travel photographer.
Subject Matter Fashion, portraits, travel – Egypt, Greece, Italy – male nudes (1930s–60s).
Media Silver gelatin prints.
Price Vintage prints – from around $3,000.

Danny Lyon
(American) b. 1942
Gritty social documentary photographer.
Subject Matter Social life from the other side of the tracks – bikeriders, prison life, prostitutes, urban life in South America (1970s to present).
Media Silver gelatin and some colour prints.
Price Vintage prints – from $5,000. Later prints – from $3,000.

Dora Maar (Henrietta Theodora Markovitch)
(French) 1907–1997
Surrealist and modernist photographer.
Subject Matter Portraits, urban landscapes, fashion, editorial photography, surrealist photomontages (1930s–40s).
Media Silver gelatin prints.
Price Vintage photographs – from around $3,000. Photomontages – $5,000 to $30,000 plus.

Sally Mann
(American) b. 1951
Controversial photographer of her own family life.
Subject Matter Family life – tableaux of her children's games (1980s–90s), Virginian landscapes (1990s to present).
Media Silver gelatin prints from 8 x 10 inch negatives. Tea toned prints from collodion negatives.
Price From around $5,000 to $25,000 plus.

Man Ray (Emmanuel Rudnitsky)
(American) 1890–1976
The leading surrealist artist and photographer, and 20th-century photographic market leader.
Subject Matter Nudes, portraits, fashion, commercial work, staged imagery, experimental photography (1920s–60s).
Media Silver gelatin prints, including photograms, solarization, manipulated prints, clichés verres.
Price Good vintage prints – from $50,000–$900,000 plus. *Electricité* portfolio of gravures (1931) from around $25,000.

Robert Mapplethorpe
(American) 1946–1989
America's leading photographer of homoerotic themes.
Subject Matter Flowers, portraits, nudes, homoerotic subjects (1970s–80s).
Media Silver gelatin prints from $2\frac{1}{4}$ square inch negatives. Platinum prints. Colour, Polaroid SX70 prints.
Price From $5,000 to $70,000 plus.

Etienne-Jules Marey
(French) 1830–1904
Scientist and photographer specialising in motion studies.
Subject Matter Animals and people in motion (1880s).
Media Salt, albumen, silver gelatin prints.
Price From around $3,000 to $15,000 plus.

Charles Marville
(French) 1816–c.1879
Documented Paris in the same manner as Atget some three decades earlier.
Subject Matter Landscape, topographical views, architecture, Paris during the Hausmann rebuilding (1850s–60s).

Media Salt and albumen prints, from paper and wet collodion negatives.
Price Good examples – $10,000 to $80,000 plus.

Adolphe de Meyer
(American, b. France) 1868–1946
The first great fashion photographer.
Subject Matter Celebrity and society portraits, fashion, ballet, advertising, still lives (1900s–1930s).
Media Platinum, silver gelatin prints. Also *Camerawork* gravures.
Price Platinum and silver gelatin prints – $5,000–$70,000 plus. *Camerawork* gravures – from $500.

Joel Meyerowitz
(American) b. 1938
A leader of the 1970s "New Colour" school.
Subject Matter Early 35mm street photography (1960s–70s). 8 x 10 inch colour urban landscapes – St. Louis, New York, Ground Zero – and seascapes – Cape Cod (1970s to present).
Media Silver gelatin, type C colour prints.
Price Vintage prints – from $3,000. Colour – from $3,000–$5,000 plus.

Duane Michals
(American) b. 1932
Well known for his photo-sequences and photo-text pieces.
Subject Matter Portraits, nudes, street photographs. Tableau sequences invoking erotic and dream states (eg *Journey of the Spirit after Death*) (1960s–present).
Media Silver gelatin prints, often with handwritten texts, sometimes painted and drawn upon.
Price From around $5,000 for single-image vintage prints, to $20,000 plus for sequences.

Boris Mikhailov
(Ukrainian) b. 1938
Controversial and compelling photo-artist from Eastern Europe.
Subject Matter The social landscape, especially the Ukraine, with an emphasis on the personal, the bizarre, and the erotic (1970s–present).
Media Generally silver gelatin prints, often brown or blue toned. Also collage and type C colour prints.
Price From around $3,000.

Lee Miller
(American) 1907–1977
Photographer, model, and painter, former assistant to Man Ray, who became known for a wide range of photography, from Surrealism to war reportage.
Subject Matter Surrealist photography (1930s), fashion portrait and editorial photography (1930s–50s), World War II fashion and reportage (1940s).
Media Silver gelatin and some colour prints.
Price Vintage prints – from around $3,000. Modern estate prints – $450–$650, depending on size.

Richard Misrach
(American) b. 1949
Poetic, yet socially aware colour landscape photographer.
Subject Matter Early toned black-and-white nightscapes. Landscapes of the American West – the *Desert Cantos* (1970s –present).
Media Toned silver gelatin, type C colour prints, iris prints.
Price Vintage toned nightscapes – from $5,000. Type C prints – $1,000– $15,000 plus, depending on size and edition. Modern iris prints of nightscapes – $2,000.

Lisette Model
(American, b. Austria) 1901–1983
Gritty street portraitist, the mentor of Diane Arbus.
Subject Matter Street portraits, urban landscapes (reflections in shop windows, etc.) (1940s–70s).
Media Silver gelatin prints.
Price From $5,000 for late prints to $40,000 plus for vintage.

Tina Modotti
(American, b. Italy) 1896–1942
Modernist photographer and Mexican revolutionary.
Subject Matter Landscape, still life, and portraiture – in semi abstract modernist style (1920s).
Media Silver gelatin, platinum prints.
Price Vintage platinum prints – $75,000–$250,000 plus. Silver gelatin prints – $50,000–$150,000 plus.

Tracy Moffat
(Australian) b. 1960
Leading Australian photo-artist and filmmaker.

Subject Matter Photosequences and films investigating cultural identity, childhood, being Aboriginal, Victorian women (1990s to present).
Media Type C colour, silver gelatin prints, offset lithography, photogravure.
Price From around $2,000–$20,000 plus.

László Moholy-Nagy
(American, b. Austria-Hungary) 1895–1946
Influential Bauhaus teacher and tireless experimenter in various media.
Subject Matter The process of photography – photograms, photomontage, formal experiments, some documentary street scenes (1920s–40s).
Media Silver gelatin prints, colour slides, mixed media collages.
Price Good examples – $10,000–$100,000 plus.

Pierre Molinier
(French) 1900–1976
French artist who made fetishistic self portraits and tableaux.
Subject Matter Self portraits and other erotic tableaux, frequently featuring himself in stockings, garter belt and high heels as a "woman" (1960s–70s).
Media Silver gelatin prints, photomontages.
Price From around $2,000.

Barbara Morgan
(American) 1900–1992
Experimental modernist, known particularly for her dance images.
Subject Matter Dance, Martha Graham (1930s–40s). Photomontage, abstract light drawings, children, portraits, trees and natural forms (1940s–60s).
Media Silver gelatin prints.
Price Vintage prints – from $10,000. Later prints – from $5,000.

Daido Moriyama
(Japanese) b. 1938
Key contemporary Japanese photographer. The leading member of the "Provoke School" of the 1960s.
Subject Matter Contemporary Japanese life, shot in extreme "stream of consciousness" style (1960s–present).
Media Silver gelatin, type C colour prints.
Price Vintage prints – from $4,000. Later prints – from $2,000.

Karin Apollonia Muller
(German) b. 1963
German photographer of the American urban landscape.
Subject Matter The urban landscape of the American West, especially Los Angeles, shot in large format colour.
Media Type C colour prints, up to around 4 x 3 feet.
Price From $1,500 to around $4,000.

Martin Munkácsi
(America, b. Hungary) 1896–1963
Innovative photographer who applied photojournalistic techniques to fashion photography and took it out of the studio into the open air.
Subject Matter Editorial, travel, and sports photography in Europe (1920s–30s), fashion and editorial photography in New York (1930s–50s).
Media Silver gelatin prints.
Price Vintage prints – from around $4,000–$20,000.

Dr. John Murray
(Scottish) 1809–1898
Surgeon based in Agra who made superb large format images of North India.
Subject Matter Architectural and topographical views in and around Agra and other sites in North India (1850s, early 1860s).
Media Salt and albumen prints from waxed paper negatives. (The negatives themselves are collected).
Price From around $5,000 to $25,000 plus for the best prints and negatives.

Eadweard J. Muybridge
(American, b. England) 1830–1904
Landscape photographer who became known for his studies of locomotion.
Subject Matter Central America, Yosemite and the West (1860s–1870s), multi-print studies of animals and humans in motion (1880s).
Media Albumen prints from wet-collodion negatives, in formats up to about 16 x 20 inches. The motion studies published as collotypes.
Price Good vintage albumen prints – $10,000 to $40,000. Collotype plates – from around $700.

Nadar (Gaspard Félix Tournachon)
(French) 1820–1910
The pre-eminent French portrait photographer of the 19th century.

Subject Matter Portraits of Second Empire celebrities (Sarah Bernhardt, Daumier, Baudelaire). Also aerial views, the catacombs and sewers of Paris, medical photography (1850s–60s).
Media Salt and albumen prints. Woodburytypes published in the publication *Galerie Contemporaine*.
Price Good salt and albumen prints – $20,000 to $80,000 plus. Woodburytypes – from $2,000.

Charles Nègre
(French) 1820–1880
Eminent photographer of the 1850s.
Subject Matter Monuments and topographical views (Paris, Midi), street events, tradespeople, portraits (1850s–60s).
Media Salt and albumen prints from waxed paper and wet collodion negatives. Photogravures (Heliogravures).
Price Good vintage prints – $10,000–$300,000 plus. Photogravures – from $2,000.

Arnold Newman
(American) b. 1918
Innovative portrait photographer.
Subject Matter Mainly portraits of celebrities and artists. Also industrial photography, abstractions, still lives (1940s–1990s).
Media Silver gelatin prints, colour, some collages and assemblages.
Price Vintage silver gelatin – $8,000–$15,000 plus. Later prints – from $3,000.

Helmut Newton
(Australian, b. Germany) b. 1920
Controversial fashion and portrait photographer.
Subject Matter Fashion, nudes, portraits – often characterized by a dark, erotic twist (1970s–present).
Media Silver gelatin, type C colour prints, up to 6 x 4 feet or larger.
Price From $3,000–$80,000 plus. Cheaper, large edition prints (Eyestorm) – $500.

Walter Niedermayr
(Italian) b. 1952
Large format photographer of the Dolomites, in the "Düsseldorf School" manner.
Subject Matter Mountain scenes (The Dolomites and Alps), showing the environmental destruction caused by tourism and skiing. Institutional interiors (1990s to present).

Media Silver gelatin, type C colour prints, often arranged in diptychs or series.
Price From $5,000.

Nicholas Nixon
(American) b. 1947
Significant "New topographical" photographer.
Subject Matter Cityscapes, intimate portraits of couples and children, his wife Bebe and her four sisters (1970s–present).
Media Silver gelatin contact prints from 8 x 10 inch negatives.
Price From around $1,500.

Ruth Orkin
(American) 1921–1985
Photojournalist, social documentary photographer, and film maker.
Subject Matter Humanist editorial photography, portraits. Also a personal picture diary (1940s–70s).
Media Gelatin silver prints, some colour. Also posthumous estate prints.
Price Vintage silver gelatin – from around $3,000–$10,000 plus. Estate prints – from $800–$1,500.

Timothy O'Sullivan
(American) c. 1840–1882
Exceptional Civil War and landscape photographer of the West.
Subject Matter Civil War images (for Brady and Gardner) (1860s), Panama and Western landscapes (for US government surveys) (1870s).
Media Albumen prints from wet collodion negatives (stereographs to 11 x 14 inches).
Price From around $3,000–$15,000 plus.

Paul Outerbridge
(American) 1896–1958
Modernist and advertising photographer of the 1920s and 30s.
Subject Matter Abstractions, nudes, still lives, portraits, advertising and editorial photography (1920s–50s).
Media Platinum, colour carbro prints.
Price Good vintage examples – $20,000–$250,000.

Martin Parr
(English) b. 1952
Leading British colour social documentary photographer.

Subject Matter Modern manners and social mores, often focusing upon materialism and with a satirical eye (1970s to present).
Media Early silver gelatin prints. Later type C color, iris prints and color xerographs.
Price Vintage silver gelatin – from $600. Type C prints – from $600–$3,000 plus. Iris prints – $400. Colour xeroxes – $200.

Irving Penn
(American) b. 1917
Along with Richard Avedon, the leading American fashion and studio photographer.
Subject Matter Fashion, advertising, and celebrity portraits. Also portraits of social types, still lives and nudes (1940s–present).
Media Silver gelatin prints (some hand coloured), platinum-palladium prints, colour.
Price Vintage silver gelatin and platinum, palladium prints – from $5,000–$50,000 plus.

John Pfahl
(American) b. 1939
Photographer of both manipulated and "straight" landscapes.
Subject Matter Fabricated landscapes, landscapes from picture windows, power stations, waterfalls (1970s–present).
Media Type C colour prints.
Price From around $2,000, depending on size.

Pierre et Gilles
(French) active since 1976
The masters of photographic camp.
Subject Matter Exuberant constructed portrait tableaux, frequently exploring homoerotic themes (1980s–present).
Media Unique handpainted colour prints.
Price From around $10,000–$60,000 plus.

George Platt-Lynes
(American) 1907–1955
Fashion and advertising photographer known particularly for his male nudes.
Subject Matter Portraits of writers and artists, fashion, ballet, advertising, nude genre studies, surreal still lives (1930s–50s).
Media Silver gelatin contact prints from 8 x 10 inch negatives.
Price Vintage prints – $10,000–$50,000 plus.

Eliot Porter
(American) 1901–1990
Leading American nature photographer.
Subject Matter Landscape, birds, plants, Egyptian monuments, shot in colour (1940s–80s).
Media Dye transfer, type C colour prints.
Price Vintage dye transfers – from $3,000. Later prints – from $2,000.

Richard Prince
(American) b. 1949
Leading postmodern "appropriator" of photographs.
Subject Matter "Rephotography" – the rephotographing of existing imagery, mainly advertising selling the American Dream, and making new, ironic images (1970s–present).
Media Type C colour prints.
Price From around $5,000–$50,000 plus.

Arnulf Rainer
(Austrian) b. 1929
Artist who has made a long series of photographic self-portraits.
Subject Matter Chiefly self-portraits, covered with painted and drawn markings, but also photographic representations of paintings (Crucifixions) (1960s–present).
Media Silver gelatin prints, with overpainting and drawing.
Price From around $5,000.

Albert Renger-Patzsch
(German) 1897–1966
Leading European modernist photographer.
Subject Matter Still lives, industrial objects, landscapes, streetscapes, industrial scenes, plants, architecture (1920s–60s).
Media Silver gelatin prints.
Price From around $5,000–$60,000 plus.

Bettina Rheims
(French) b. 1952
Editorial, fashion, and erotic photographer.
Subject Matter Fashion, portraits, nudes, erotic tableaux (1980s to present).
Media Silver gelatin, type C colour prints.
Price From $3,000.

Herb Ritts
(American) 1952–2002
Prominent late 20th-century fashion and portrait

photographer.

Subject Matter Fashion, celebrity portraits, editorial, advertising photography (1980s to present)

Media Silver gelatin, type C colour prints.

Price From $3,000.

Alexander Rodchenko
(Russian) 1891–1956

Artist, photographer, and graphic designer in Soviet Russia.

Subject Matter Experimental and documentary photography, portraits, social life, photomontage (1920s–40s).

Media Silver gelatin prints, photomontages.

Price Vintage prints – from around $5,000–$100,000 plus.

Thomas Ruff
(German) b. 1958

Leading figure of the "Düsseldorf School".

Subject Matter Landscapes, cityscapes, portraits, re-photographed images from pornographic net-sites (1980s–present).

Media Silver gelatin, type C colour, silkscreen prints, up to 6 x 4 feet and larger.

Price From $10,000–$200,000 plus. Silkscreens – from $3,000.

Sebastião Salgado
(Brazilian) b. 1944

Photojournalist in the "concerned photographer" mould.

Subject Matter Third World problems, especially with regard to food, work, agriculture, globalization, people migration (1970s–present).

Media Silver gelatin prints, in small editions.

Price From around $3,000. Larger populist edition (Eyestorm) – $500.

Auguste Salzmann
(French) 1824–1872

Early archaeological photographer of the Holy Land.

Subject Matter Comparative architectural studies of ancient monuments from his book *Jérusalem* (1856).

Media Salt prints from waxed paper negatives, made by the Blanquart– Evrard factory in Lille.

Price Good examples – around $4,000 –$25,000 plus.

Lucas Samaras
(American) b. 1936

Leading sculptor and photographer of the 1970s and 80s.

Subject Matter Manipulated self portraits and other imagery using the Polaroid SX70 camera – Photo-Transformations, sittings 8 x 10, panoramas (1970s–present).

Media Polaroid colour, type C colour prints.

Price From $3,000.

August Sander
(German) 1876–1964

Arguably the greatest portrait photographer of the 20th century.

Subject Matter Portraits of social types in Weimar Germany. Landscapes (1920s–40s).

Media Silver gelatin contact prints from 8 x 10 inch negatives. Modern silver gelatin contact prints by Gerd Sander.

Price Good vintage prints – $10,000–$200,000 plus. Modern prints – $1,500–$3,000.

Jan Saudek
(Czechoslovakian) b. 1935

Leading Czech photographer of the nude.

Subject Matter Rabelaisian nude tableaux exploring human relationships, shot in basement studio. Some portraits (1970s to present).

Media Silver gelatin prints from 2¼ sq. inch negatives, hand coloured.

Price From $3,000.

Christian Schad
(German) 1894–1982

Painter and leading Dadaist artists, known for his cameraless "Schadographs."

Subject Matter "Schadographs" – photograms using found imagery, objects, and texts (1910s).

Media Silver gelatin prints.

Price From around $30,000–$100,000 plus.

Michael Schmidt
(German) b. 1945

Photographer of the German social landscape.

Subject Matter German social life and history, especially in Berlin – in the form of urban landscapes, portraits, nudes (1970s–present).

Media Silver gelatin prints, up to 3 x 2 feet or larger.

Price From around $3,000.

Andres Serrano

(American) b. 1950

Controversial photographic artist exploring transgressive themes.

Subject Matter Notable for large format images on the themes of sex, death, and religion (1980s–present).

Media Type C colour prints, photolithographs.

Price Type C – from $6,000. Photolithographs – from $1,000.

Charles Sheeler

(American) 1883–1965

Painter and photographer of the Precisionist school of the 1920s.

Subject Matter Mainly architectural and industrial photography (Ford motor plant, cityscapes, barns Chartes), still lives, museum sculpture (1910s–20s).

Media Usually silver gelatin contact prints from 8 x 10 inch negatives.

Price $25,000–$200,000 plus.

Cindy Sherman

(American) b. 1954

The quintessential postmodern photographer, and a contemporary market leader.

Subject Matter Self portraiture in series – with an emphasis on fantasy role playing and self-representation – (*Untitled Film Stills*, *History Portraits*, *Fairytales*, *Sex Pictures*) (1970s–present).

Media Silver gelatin, type C colour prints, up to 4 x 3 feet and larger.

Price From $25,000 up to $100,000 plus.

Stephen Shore

(American) b. 1947

Another of the triumvirate of photographers in the 1970s who demonstrated that colour photography was a serious medium.

Subject Matter Land-, urban landscapes (1970s–present). Also the Andy Warhol "Factory" (1960s).

Media Type C colour prints – up to 20 x 24 inches or larger from 8 x 10 inch negatives. Also some silver gelatin prints.

Price From $3,000.

Aaron Siskind

(American) 1903–1991

Social documentary photographer turned abstract modernist.

Subject Matter Early social documentary –

Harlem Document project (1940s). Abstracts – peeling walls, posters, natural forms (1940s–1980s).

Media Silver gelatin prints.

Price Vintage prints – $3,000 to $25,000 plus.

W. Eugene Smith

(American) 1918–1978

Life magazine's star photojournalist.

Subject Matter Photo-essays for editorial magazines, beginning with WWII, chiefly for *Life* – *Spanish Village, Country Doctor, Pittsburg, Minnemata* (1940s–1970s).

Media Silver gelatin prints, often highly worked.

Price Vintage prints – from $5,000–$30,000 plus.

Frederick Sommer

(American, b. Italy) 1905–1999

Idiosyncratic experimental modernist, exploring a wide range of styles and techniques.

Subject Matter Arizona landscapes, photographed collages, abstractions, photographic images made from cut paper and smoke on glass, nudes, portraits (1930s–70s).

Media Mainly silver gelatin prints (10 x 8 inch contacts). Some colour.

Price From around $15,000–$60,000 plus.

Albert Sands Southworth

(American) 1811–1894

Josiah Johnson Hawes

(American) 1808–1901

The leading firm of American daguerreotypists, based in Boston.

Subject Matter Mainly portraits of Boston society. Also some views of Boston and vicinity (1840s–50s).

Media Daguerreotypes (generally quarter-plate and whole-plate). Also some stereographs.

Price Authenticated work – from $25,000–$100,000 plus.

Edward Steichen

(American, b. Luxembourg) 1879–1973

Key modernist fashion and editorial photographer who became photography curator at MoMA.

Subject Matter Early pictorialism (1890s–1910s), modernism (1920s), fashion, advertising, portraiture (1920s–40s), U.S. Navy documentary (1940s).

Media Until *c*.1920s – platinum, palladium, gum bichromate and oil pigment prints.

Thereafter – silver gelatin prints and colour
(dye transfer etc.).
Price Silver gelatin prints – $25,000–$200,000
plus. Pictorial process prints – from $100,000.

Joel Sternfeld
(American) b. 1944

Large format photographer of the American scene.
Subject Matter Landscapes, cityscapes (*Roman
Campagna*, *Hart Island*), "crime scenes", street
portraits (1970s–present).
Media Type C colour prints, up to
4 x 3 feet, from 8 x 10 inch negatives.
Price From $3,000–$10,000 plus depending on
size and edition.

Alfred Stieglitz
(American) 1864–1946

Photographer, gallery owner, publisher of
Camerawork – the father of modernist
photography.
Subject Matter Early pictorialism (1890s–1900s),
nudes, portraits (1910s–30s), landscapes,
cityscapes (1920s–30s), semi–abstract
"equivalents" (1920s–30s).
Media Platinum, palladium, carbon, silver
gelatin prints, autochromes, photogravures.
Price Good examples – $50,000 to $300,000 plus.
Camerawork gravures – from $2,000. *The Steerage*
(large sized photogravure) – around $15,000.

Paul Strand
(American) 1890–1976

Great large format social documentary
photographer.
Subject Matter Early modernism – abstracts
and candid street portraits (1910s–20s). Later
work – portraits of communities using landscape,
still-lives and portraiture (1930s–60s).
Media Early platinum, palladium prints. Silver
gelatin prints, photogravures. Estate prints by
Richard Benson.
Price Good vintage prints – $30,000–$200,000
plus. Gravures – $1,000–$5,000 plus. Estate prints
– from $3,000.

Beat Streuli
(Swiss) b. 1957

Photo-artist who makes candid portraits of
anonymous individuals.
Subject Matter Candid portraits shot in outdoor
places – the street, the beach (1990s–present).

Media Type C colour prints.
Price From around $3,000.

Thomas Struth
(German) b. 1954

Leading member of the "Düsseldorf School",
approaching Gursky in market desirability.
Subject Matter Cityscapes, landscapes,
portraits, the *Museum* series (1970s–present).
Media Early silver gelatin prints, up to 30 x 20
inch. Later type C colour, up to 6 feet wide and
larger.
Price Vintage silver gelatin prints – from $3,000.
Type C – $15,000–$200,000 plus.

Jock Sturges
(American) b. 1947

Leading, and controversial photographer of the
"natural" nude.
Subject Matter Nudes of family groups and
adolescents, generally shot in naturist resorts
(1990s to present).
Media Silver gelatin prints, toned, up to 20 x 24
inch or larger, from 8 x 10 inch negatives.
Price From around $3,000.

Josef Sudek
(Czechoslovakian) 1896–1976

Czechoslovakia's premier modernist
photographer.
Subject Matter Prague and the Czech
countryside. Landscapes, cityscapes, still lives,
some portraits and nudes (1920s–1970s).
Media Silver–gelatin contact prints, from
6 x 7 cm. to 11 x 14 inch negatives. Also oil
pigments prints.
Price Silver gelatin prints – $2,000–$6,000 plus.
Pigment prints – $15,000–$25,000 plus.

Hiroshi Sugimoto
(Japanese) b. 1948

Former Bernd and Hiller Becher student and
leading maker of photographic series.
Subject Matter Formal series – *Dioramas,
Theatres, Seascapes, Wax Museums,
Architecture, Portraits* (1976–present).
Media Toned silver gelatin prints, to 20 x 24
inches and larger.
Price From $5,000–$20,000 plus.

Frank Meadow Sutcliffe
(English) 1853–1941
The great photographer of Whitby, Yorkshire.
Subject Matter Harbour, landscape, and townscape scenes in Whitby. Also genre studies of Whitby fisherfolk, children and citizens (1880s–1910s).
Media Albumen, carbon, platinum, and silver gelatin prints.
Price Vintage prints – from around $1,000–$10,000 plus.

Maurice Tabard
(French) 1897–1984
Experimental editorial and advertising photographer of the 1920 and 30s.
Subject Matter Illustrative and advertising photography, shot in an experimental modernist manner – photomontage, solarization (1920s–40s).
Media Silver gelatin prints.
Price Good vintage prints – from $5,000–$15,000 plus.

Sam Taylor-Wood
(English) b. 1967
Photographic, installation and video artist.
Subject Matter Staged photographed tableaux, often shot with a 360 degree panoramic camera, examining contemporary emotional isolation and related themes (1990s–present).
Media Type C colour prints, to 298 x 28 inch.
Price From $8,000.

Mario Testino
(Peruvian) b. 1954
Leading contemporary fashion, advertising, and celebrity portrait photographer.
Subject Matter Celebrity portraits (especially of women), fashion, commercial photography (1980s–present).
Media Silver gelatin, type C colour prints.
Price From $3,000–$15,000 plus.

Félix Teynard
(French) 1817–1892
Engineer who photographed on a trip to the Middle East.
Subject Matter Ancient monuments and landscapes from his book, *Egypte et Nubie* (1858)
Media Salt prints from waxed paper negatives.
Price Good examples – from $5,000–$40,000 plus.

John Thomson
(Scottish) 1837–1921
Leading 19th-century travel and social documentary photographer.
Subject Matter Travel and topographical views, mainly Far East (1860s–70s). Portraits, social documentary (*Street Life in London*) (1870s).
Media Albumen prints from wet collodion negatives.
Price Good albumen prints – from $2,000–$8,000 plus. *Street Life* woodburytypes – from $750.

Wolfgang Tillmans
(German) b. 1968
Contemporary fashion, lifestyle, and installation photographer.
Subject Matter Friends, youth culture denizens, modern urban life. Also experimental photography – abstractions, cameraless photographs (1990s–present).
Media Silver gelatin, type C colour, inkjet prints, up to 6 x 4 feet or larger.
Price From around $3,000.

Shomei Tomatsu
(Japanese) b. 1930
Arguably the most important Japanese photographer, documenting post-war Japan.
Subject Matter Japanese social upheavals – post-WWII American occupation, the atom bomb, the Okinawa naval base struggles (1950s–present).
Media Silver gelatin, type C colour prints.
Price Vintage prints – from around $5,000. Later prints – from around $3,000.

Linnaeus Tripe
(English) 1822–1902
Early, and superior photographer of India.
Subject Matter Art, architecture, topographical views in Madras and other southern states of India, and Burma (1850s).
Media Salt and albumen prints from waxed paper negatives.
Price Good prints – from $4,000–$30,000 plus.

Jerry N. Uelsmann
(American) b. 1934
1970s master of multiple imagery in the darkroom.
Subject Matter Mainly multiple image personal imagery, fantastic and surrealist in nature (1960s–present).
Media Silver gelatin prints, some handcoloured.

Price Vintage prints – from around $5,000 to $15,000 plus. Later prints – from $1,000 to $2,000.

Doris Ulmann
(American) 1884–1934
Intriguing combination of pictorialist and documentary photographer.
Subject Matter Chiefly rural life in Appalachia and South Carolina. Also landscapes, portraits, still lives (1910s–30s).
Media Mainly platinum prints. Some gum bichromate and carbon prints.
Price From around $8,000–$35,000 plus.

Jeff Wall
(Canadian) b. 1946
Artist known for his photographic pieces in the "directorial" mode.
Subject Matter Tableaux examining the bleak, often surrealistic nature of modern life. Contemporary "history painting" using photography (1980s–present).
Media Colour transparencies mounted in lightboxes, up to 12 feet wide and more. Silver gelatin, type C colour prints.
Price From around $5,000–$40,000 plus.

Andy Warhol
(American) 1928–1987
Most of Warhol's work, his silkscreen "paintings" as well as his photography, was camera based.
Subject Matter Portraits, celebrities, flowers, electric chairs, "pop" objects, nudes (1960s–80s).
Media Photo-silkscreens (on canvas and paper), Polaroid SX70 prints, silver gelatin, type C colour prints.
Price From around $3,000–$2 million plus.

Carleton E. Watkins
(American) 1829–1916
Monumental early photographer of the West Coast.
Subject Matter Landscapes – Yosemite, the West Coast – topographical and commercial views (1860s–70s).
Media Albumen stereocards, albumen and salt prints, up to 22 x 18 inch.
Price Good large early (pre-1875) work – $20,000–$100,000 plus. Late series prints – $5,000 plus. Small prints and stereocards – $50–$1,000.

Bruce Weber
(American) b. 1946
Leading contemporary advertising, fashion, and editorial photographer.
Subject Matter Fashion, advertising, portraits, nudes – often featuring finely muscled young men (1970s–present).
Media Silver gelatin prints, up to about 4 x 4 feet.
Price From $5,000.

Weegee (Arthur Fellig)
(American, b. Austro-Hungary) 1899–1968
The great "on the spot" news photographer of the *Naked City*.
Subject Matter Mainly crime and disaster in New York, but also city life, infra-red photography, photo caricatures, distortions, and commercial work (1940s–50s).
Media Silver gelatin (often press) prints. Posthumous reprints.
Price Good vintage prints – $2,000–$10,000 plus. Reprints – around $1,500.

William Wegman
(American) b. 1943
Photo-artist renowned for his humorous images, many featuring dogs.
Subject Matter Fashion and photo tableaux, often featuring his dog, Man Ray, and successors (1980s–present).
Media Type C colour prints, Polaroid colour prints.
Price From around $3,000.

Terri Weifenbach
(American) b. 1957
Landscape photographer whose work is characterized by differential focusing,
Subject Matter Gardens, flowers, parks, landscapes, shot in bright colour and utilizing differential focusing (1990s–present).
Media Type C colour prints.
Price From $1,500–$4,000, depending on size.

Brett Weston
(American) 1911–1993
The highly accomplished son of Edward Weston.
Subject Matter Landscape, still life, abstractions – Brett was generally more abstract in approach than his father (1930s–80s)
Media Silver gelatin and some colour prints.
Price Vintage prints (early)– $30,000 plus. Later prints – from $3,000.

Edward Weston
(American) 1886–1958
The quintessential "straight" modernist photographer.
Subject Matter Nudes, portraits, landscapes, still lives, abstract close-ups – Mexico (1920s), California (1930s–50s).
Media Platinum, silver gelatin prints, some colour. Contact prints from 8 x 10 inch negatives. Estate prints by son, Cole.
Price Platinum – from $30,000–$300,000 plus. Silver gelatin – from $8,000–$250,000 plus. Cole Weston reprints – $1,500.

Clarence H. White
(American) 1871–1925
Colleague of Stieglitz and distinguished American pictorialist.
Subject Matter Genre scenes, nudes, portraits, still lives, landscapes (1890s–1910s).
Media Platinum, palladium, gum bichromate prints.
Price From around $10,000–$50,000 plus.

Minor White
(American) 1908–1976
Influential photographer, teacher, theoretician, curator and magazine editor in the Stieglitz mould.
Subject Matter Landscape, still-life, portrait and abstraction functioning as metaphors (1940s–70s).
Media Silver gelatin prints.
Price $5,000–$20,000 plus.

Garry Winogrand
(American) 1928–1984
Sharp shooting New York street photographer and chronicler of the American social landscape.
Subject Matter The street, social gatherings – parties, demonstrations, rodeos, parades (1950s–80s).
Media Silver gelatin prints.
Price From around $5,000. Vintage prints – from $5,000–$20,000 plus.

Joel-Peter Witkin
(American) b. 1939
Controversial photographer of modern genre studies.
Subject Matter Staged reworkings of paintings, emphasizing death, sex, and the grotesque (1970s–present).

Media Silver gelatin prints from 2¼ square inch small negatives, to 28 x 28 inch or larger – toned, manipulated, scratched, drawn upon.
Price Smaller prints – from $3,000, larger prints – from $6,000.

Francesca Woodman
(American) 1958–1981
Extremely promising young self-portraitist who died in her early twenties.
Subject Matter Self-portraits, exploring the nature of self and her own psychology (1970s).
Media Silver gelatin prints.
Price From around $5,000–$60,000 plus.

Galleries and Dealers

The directory below lists 200 places where collectors can buy photography, organized in order of country. We have included auction houses, galleries, and dealers, as well as photography fairs – though all art fairs also show a lot of photography. Major auction houses like Christie's and Sotheby's have branches world wide. However, we have listed only the London and New York branches, which are the usual venues for photographic sales. More and more, auctions are being scheduled to coincide with the major photographic fairs.

The relevant contact details are indicated, together with a brief description of the dealer's speciality. We have also included some dealers in rare photographic books, although the majority of those listed sell photographs.

No such listing could ever be fully comprehensive, so we apologize to those not included here. For other galleries or dealers, it is advisable to check the Internet. An especially good site is www.photography-guide.com, which is quite comprehensive, and which, most usefully, lists which dealers sell which photographs.

AUSTRALIA
Josef Lebovic Gallery
34 Paddington Street
Paddington, NSW 2012
Sydney
+61 (2) 9332 1840 (t)
+61 (2) 9331 7431 (f)
josef@joseflebovicgallery.com
www.joseflebovicgallery.com
Australian and international original photography and other works on paper.

Byron Mapp Gallery
Level One, Argyle Stores
18-24 Argyle Street
The Rocks
Sydney, NSW 2000
+61 (2) 9252 9600 (t)
+61 (2) 9252 9800 (f)
info@byronmappgallery.com.au

www.byronmappgallery.com.au
Australian and international, 19th-, 20th-century, and contemporary photographers.

AUSTRIA
Galerie Johannes Faber
Brahmsplatz 7
Vienna 1040
+43 (1) 505 75 18 (t/f)
office@jmcfaber.at
www.jmcfaber.at
Vintage 19th- and 20th-century photographs, with an emphasis on Czech and Austrian photography as well as American classic and contemporary photography.

Galerie Trabant
Ruprechtsplatz 1
Vienna 1010
+43 (1) 587 5265 (t/f)
Contemporary art and photography.

BELGIUM
Fifty One Fine Art Photography
Zirkstraat 20
2000 Antwerp
+32 (3) 289 84 58 (t)
+32 (3) 289 84 59 (f)
51@pandora.be
www.gallery51.com
20th-century vintage masterworks and contemporary photography with an emphasis on fashion and African photography.

Taché-Lévy Gallery
74 rue Tenbosch
1050 Brussels
+32 (2) 344 2368 (t)
+32 (2) 343 5127 (f)
info@tache-levy.be
www.tache-levy.be
Contemporary photography.

CANADA
Stephen Bulger Gallery
700 Queen Street West
Toronto, M6J 1E7
+1 (416) 504 0575 (t)
+1 (416) 504 8929 (f)
sbulger@interlog.com
www.bulgergallery.com
Historical and contemporary
Canadian photography and
books on photography.

Jane Corkin Gallery
Suite 302, 179 John Street
Toronto, M3C 3A3
+1 (416) 979 1980 (t)
+1 (416) 979 7018 (f)
info@janecorkin.com
www.janecorkin.com
19th- and 20th-century photo-
graphy and contemporary art.

CZECH REPUBLIC
Czech Centre of Photography
Náplavni 1
Prague 2
120 00
+42(0) 224 922 726 (t/f)
ccf@volny.cz
Classical and contemporary
Czech photography.

FRANCE
14/16 Verneuil
14/16 rue de Verneuil
75007 Paris
+33 (0) 1 44 55 01 90 (t)
+33 (0) 1 44 55 01 91 (f)
info@1416verneuil.com
www.1416verneuil.com
19th-century photography,
modern vintage, and
contemporary photography.

Galerie 1900 – 2000
8 rue Bonaparte
75006 Paris
+33 (0) 1 43 25 84 20 (t)
+33 (0) 1 46 34 74 52 (f)
info@galerie1900-2000.com
www.galerie1900-2000.com
20th-century art and
photography with an emphasis
on Dada and Surrealism.

A l'Image du Grenier sur l'eau
45 rue des Francs-Bourgeois
75004 Paris
+33 (0) 1 42 71 02 31 (t)
+33 (0) 1 42 71 89 66 (f)
image.di-maria@wanadoo.fr
19th- and 20th-century
photography.

**A.P.H. (Atelier de
Photographies Historiques)
Christian Bouqueret**
21 rue Beaurepaire
75010 Paris
+33 (0) 1 40 03 02 73 (t/f)
aph.bouqueret@free.fr
Vintage prints of 1930 and 50s
modernist photographers.

Galerie Au Bonheur Du Jour
11 rue Chabanais
75002 Paris
+33 (0) 1 42 96 58 64 (t)
www.curiositel.com/aubonheur
dujour
Also weekends at
Marché Dauphine-Porte de
Clignancourt
Stand 11, rez-de-chaussée
rue des Rosiers
Saint-Ouen 93400
19th- and 20th-century vintage
photographs, particularly nudes.

Galerie Camera Obscura
12 rue Ernest-Cresson
75014 Paris
+33 (0) 1 45 45 67 08 (t)
+33 (0) 1 45 45 67 90 (f)
cameraobscura@free.fr
20th-century and contemporary.

Galerie Michèle Chomette
24 rue Beaubourg
75003 Paris
+33 (0) 1 42 78 05 62 (t)
+33 (0) 1 42 72 62 05 (f)
mc.galerie@free.fr
Major historical photographs
and contemporary French and
international photo-artists.

**Galerie 213, Marion de
Beaupré**
213 boulevard Raspail
75014 Paris
+33 (0) 1 43 22 83 23 (t)
+33 (0) 1 43 22 03 31 (f)
marion@galerie213.com
www.galerie213.com
Contemporary photography,
rare and out-of-print books.

Galerie Jérôme de Noirmont
36-38 avenue Matignon
75008 Paris
+33 (0) 1 42 89 89 00 (t)
+33 (0) 1 42 89 89 03 (f)
info@denoirmont.com
www.denoirmont.com
Contemporary art and
photography.

**Bernard Dudoignon
photographies**
133 rue de Charonne
75011 Paris
+33 (0) 1 40 09 91 17 (t)
+33 (0) 1 43 71 42 91 (f)
dudoignon@photoconnexion.
com
www.photoconnexion.com
Vintage and contemporary
photography.

**Liliane & Michel Durand-
Dessert**
28 rue de Lappe
75011 Paris
+33 (0) 1 48 06 92 23 (t)
+33 (0) 1 48 06 92 24 (f)
lm.durand-dessert@wanadoo.fr
Contemporary art and
photography.

Galerie Agathe Gaillard
3 rue du Pont Louis-Phillipe
75004 Paris
+33 (0) 1 42 77 38 24 (t)
+33 (0) 1 42 77 78 36 (f)
info@agathegaillard.com
www.agathegaillard.com
20th-century and contemporary
photography, particularly
classic French photojournalism.

Galerie Marian Goodman
79 rue du Temple
75003 Paris
+33 (0) 1 48 04 70 52 (t)
+33 (0) 1 40 27 81 37 (f)
marian.goodman@wanadoo.fr
www.mariangoodman.com
Contemporary art and
photography.

Galerie Karsten Greve
5 rue Debelleyme
75003 Paris
+33 (0) 1 42 77 19 37 (t)
+33 (0) 1 42 77 05 58 (f)
g-karsten-greve@wanadoo.fr
International avant-garde
photography, after 1945.

Galerie Laurent Herschtritt
5 rue Jacques Callot
75006 Paris
+33 (0) 1 56 24 34 74 (t/f)
laurent.herschtritt@libertysurf.fr
19th- and 20th-century vintage
photographs.

Galerie Hypnos
52 rue de l'Université
75007 Paris
+33 (0) 1 45 44 99 71 (t/f)
hypnos@hypnos-photo.com
www.hypnos-photo.com
Also weekends at
Marché Dauphine-Porte de
Clignancourt
Stand 194 (Photothème)
rue des Rosiers
Saint-Ouen 93400
+33 (0) 1 40 12 18 08 (t)
19th- and early 20th-century.

Galerie du jour agnès b
44 rue Quincampoix
75004 Paris
+33 (0) 1 44 54 55 90 (t)
+33 (0) 1 44 54 55 99 (f)
jour@agnesb.fr
www.galeriedujour.com
Contemporary art and
photography.

Galerie Le Réverbère
38 rue Burdeau
69001 Lyon
+33 (0) 4 72 00 06 72 (t/f)
galerie-le-reverbere@
wanadoo.fr
Contemporary photography.

Baudoin Lebon
38 rue Sainte-Croix-de-la-
Bretonnerie
75004 Paris
+33 (0) 1 42 72 09 10 (t)
+33 (0) 1 42 72 02 20 (f)
baudoin.lebon@wanadoo.fr
www.baudoin-lebon.com
19th- and 20th-century
photography, contemporary art
and photography.

Magnum Photos
19 rue Hégésippe Moreau
75018 Paris
+33 (0) 1 53 42 50 00 (t)
+33 (0) 1 53 42 50 03 (f)
india@magnumphotos.fr
www.magnumphotos.com
Vintage and modern prints by
Magnum members.

Galerie Thierry Marlat
2 rue de Jarente
75004 Paris
+33 (0) 1 44 61 79 79 (t)
+33 (0) 1 44 61 79 89 (f)
t_marlat@club-internet.fr
19th- , 20th-century, and
contemporary photographers.

Galerie Kamel Mennour
60 rue Mazarine
75006 Paris

+33 (0) 1 56 24 03 63 (t)
+33 (0) 1 56 24 03 64 (f)
kmennour@noos.fr
www.galeriemennour.com
Contemporary art and
photography.

Galerie F + A Paviot
57 rue Sainte-Anne
75002 Paris
+33 (0) 1 42 60 10 01 (t)
+33 (0) 1 42 60 44 77 (f)
gfp@paviotfoto.com for
Françoise Paviot
apo@paviotfoto.com for Alain
Paviot
www.paviotfoto.com
19th- and 20th-century, vintage
and contemporary photography.

Serge Plantureux
4 Galerie Vivienne
75002 Paris
+33 (0) 1 53 29 92 00 (t)
+33 (0) 1 47 03 08 85 (f)
plantu@noos.fr
www.sergeplantureux.fr
Vintage 19th- and 20th-century
photographs and photographic
literature.

Vu, la Galerie
2 rue Jules Cousin
75004 Paris
+33 (0) 1 53 01 85 81 (t)
+33 (0) 1 53 01 85 80 (f)
gilou@abvent.fr
www.agencevu.com/fr/galerie
Vintage and contemporary
photography.

Galerie Esther Woerdehoff
36, rue Falguière
75015 Paris
+33 (0) 1 43.21.44.83 (t)
+33 (0) 1 43 21 45 03 (f)
galerie@ewgalerie.com
www.ewgalerie.com
Contemporary German and
French photography, 1950s and
1960s French and American
vintages.

Zéro, L'Infini
10 Bd August Blanqui
75013 Paris
+33 (1) 43 37 42 39 (t)
+33 (6) 80 21 33 03 (m)

3 rue du Clos
70150 Etuz
+ 33 (3) 81 57 62 00 (t)
+ 33 (3) 81 57 62 16 (f)
Vintage and contemporary
photography.

GERMANY
Galerie Daniel Blau
Maximilianstrasse 26
80539 München
+49 89 29 74 74 (t)
+49 89 29 58 48 (f)
danielblau@compuserve.com
www.danielblau.de
19th-century photography and
20th-century art.

Büro für Fotos
Schaafenstraße 25
50676 Köln
+49.221 7392936 (t/f)
art@burofurfotos.de
www.burofurfotos.de
20th-century and contemporary.

Galerie Conrads
Kronprinzenstr. 9
40217 Düsseldorf
+49 211 323 07 20 (t)
+49 211 323 07 22 (f)
mail@galerieconrads.de
www.galerieconrads.de
Contemporary art and
photography.

Galerie David
Am Zwinger 14
33 602 Bielefeld
+ 49 521 179 233 (t)
+ 49 521 139 977 (f)
davidgal@aol.com
www.galerie-david.de
20th-century German modern
photography, contemporary art
and photography.

Galerie Ulrich Fiedler
Lindenstrasse 19
50674 Cologne
+49 (221) 923 0800 (t)
+49 (221) 249 601 (f)
info@ulrichfiedler.com
www.ulrichfiedler.com
Vintage modern and
contemporary photography.

J. J. Heckenhauer
Holzmarkt 5
72070 Tübingen
+49 7071 23 018 (t)
+49 7071 23 651 (f)
Rare photography books.

Fehrbelliner Str. 86
10119 Berlin (by appointment
only)
+ 49 30 440 31145 (t)
Limited and fine photography
books – prints and collectors'
editions.
info@heckenhauer.de
www.heckenhauer.de

Antiquariat E. Kemmer
Eppendorfer Weg 248
20251 Hamburg
+49 (40) 4203961 (t)
+49 (40) 4208613 (f)
info@kemmer-books.de
www.kemmer-books.de
By appointment only.
Photographic literature.

Kicken Berlin
Linienstr. 155
10115 Berlin-Mitte
+49 (30) 28 87 78 82 (t)
+49 (30) 28 87 78 83 (f)
kicken@kicken-gallery.com
www.kicken-gallery.com
Vintage 19th-, 20th-century,
and contemporary photography.

m Fotographie Bochum
Schloßstrasse 1a
44795 Bochum
+49-234-43997 (t)
+49-234-9432228 (f)

info@m-fotografie.de
www.m-fotografie.de
20th-century art and
photography.

Galerie Priska Pasquer
Goebenstr. 3, III flor
50672 Cologne
+49 (221) 9526313 (t)
+49 (221) 9526373 (f)
priskapasquer@t-online.de
20th-century and contemporary
photography with an emphasis
on German and East European
photography.

PhotoArt
Stresemannstrasse 29
22769, Hamburg
+49 (40) 460 17 82 (t)
+49 (40) 460 17 83 (f)
erma@photo-art-hamburg.de
By appointment only.
20th-century vintage and
contemporary photography.

Heidi Reckermann
Photographie
Albertusstr. 16
D-50667 Köln
+49 (0) 221 257 48 68 (t)
+49 (0) 221 257 48 67 (f)
heidireckermann@aol.com
www.heidireckermann.com
20th-century and contemporary
photography.

Schaden.com .
Burgmauer 10
50667 Cologne
+49 (221) 925 2667 (t)
+49 (221) 925 2669 (f)
books@schaden.com
www.schaden.com
Rare, new, and old photographic
books; collectors' editions.

Sabine Schmidt Galerie
An der Schanz 1a
50735 Cologne
+49 (221) 257 8441 (t)
+49 (221) 258 0979 (f)

galerie@sabineschmidt.com
www.sabineschmidt.com
Contemporary art and 19th-century photography.

Thomas Zander Gallery
Schönhauserstrasse 8
50968 Köln
+49 (0)221 9 34 88 56 (t)
+49 (0)221 9 34 88 58 (f)
mail@galeriezander.com
www.galeriezander.com
20th-century and contemporary photography.

HUNGARY
Vintage Gallery
Magyar utca 26
1053 Budapest
+36 (1)337 0584 (t/f)
vintage@c3.hu
www.vintage.hu
Modern and contemporary Hungarian photography.

ISRAEL
Vision Gallery
18 Yosef Rivlin Street
P.O. Box 2101
91020 Jerusalem
+972 (2) 622 2253 (t)
+972 (2) 622 2269 (f)
folberg@netvision.net.il
www.neilfolberg.com
19th-century vintage and contemporary photography.

ITALY
The Box Associati
Via San Francesco Da Paola 36
10123 Torino
+39 (11) 8134616 (t)
+39 (11) 8125935 (f)
info@theboxassociati.com
www.theboxassociati.com
Contemporary photography with emphasis on Italian, French, and American artists.

Photology
Via Della Moscova, 25
20121 Milano
+39 (02) 659 5285 (t)
+39 (02) 654 284 (f)
photology@photology.com
www.photology.com
Vintage and contemporary photography.

JAPAN
Gallery Koyanagi
1-7-5 Ginza Chuo-Ku
Tokyo 104-0061
+81 (3) 35 61 18 96 (t)
+81 (3) 35 63 32 36 (f)
Contemporary art and photography.

Photo Gallery International
4-12-32 Shibaura, Minato-ku
Tokyo, 108-0023
+81 (3) 3455 7827 (t)
+81 (3) 3455 8143 (f)
info-e@pgi.ac
www.pgi.ac
Contemporary and 20th-century photography, including Japanese artists.

Picture Photo Space, Inc.
Miyako Building, 4th Floor
1-10-19 Nishi-shinsaibashi
Chuo-ku
Osaka 542-0086
+81 (6) 6251 3225 (t)
+81 (6) 6251 3245 (f)
YHY12636@nifty.ne.jp
20th-century and contemporary photography.

LUXEMBOURG
Galerie Clairfontaine
Espace 1
7 Place de Clairefontaine
1341 Luxembourg
Espace 2
21 rue du St. Esprit
1475 Luxembourg
+352 47 23 24 (t)
+352 47 25 24 (f)
galerie.clairefontaine@gms.lu
www.galerie-clairefontaine.lu
Mainly contemporary photography.

THE NETHERLANDS
Galerie Paul Andriesse
Prinsengracht 116
1015 EA Amsterdam
+31 20 623 6237 (t)
+31 20 639 0038 (f)
Andriesse@euronet.nl
www.galeries.nl/andriesse
International contemporary art and photography.

Flatland Gallery
Lange Nieuwstraat 7
Abraham Dolehof
3512 PA Utrecht
+31 (30) 2315181 (t)
+31 (30) 2368424 (f)
flatlandgallery@planet.nl
www.flatlandgallery.com
International contemporary art.

Antiquariaat L. van Paddenburgh
Diefsteeg 18
2311 TS Leiden
+31 (0)71 514 9805 (t/f)
padburgh@xs4all.nl
www.antiqbook.nl/paddenburgh
Rare and out-of-print photographic literature.

Ton Peek Photography
Oude Gracht 295
3511 PA Utrecht
+31 (30) 2312001 (t)
+31 (30) 2367898 (f)
photo@tonpeek.com
www.tonpeek.com
19th- and 20th-century vintage photography with an emphasis on portrait, architecture, and landcape.

Galerie Serieuze Zaken / Robert Malasch
Elandstraat 90
1016 SH Amsterdam
+31 (20) 427 5770 (t/f)
info@serieuzezaken.com
www.serieuzezaken.com
International contemporary photography.

Torch Gallery
Lauriergracht 94
1016 RN Amsterdam
+ 31 20 626 02 84 (t)
+ 31 20 623 88 92 (f)
mail@torchgallery.com
www.torchgallery.com
International contemporary art
and photography.

Van kranendonk Gallery
Westeinde 29
2512 GS Den Haag
+31 (0)70-3650406 (t)
+31 (0)70-3623605 (f)
gallery@art-house.nl
www.art-house.nl
Contemporary photography,
mainly Dutch.

Van Zoetendaal Gallery
Lijnbaansgracht 109
1016 KT Amsterdam
+31 (20) 624 9802 (t)
+31 (20) 423 2197 (f)
basalt@ision.nl
www.vanzoetendaal.nl
Contemporary Dutch
photography.

SOUTH AFRICA
Photo ZA Gallery
177 Oxford Road, Upper level
Mutual Square
Rosebank
Johannesburg 2132
+ 27 (83) 229 4327 (t)
+ 27 (11) 880 2885 (f)
info@photoza.co.za
www.photoza.co.za
Contemporary photography
from South Africa.

SPAIN
Galería Juana de Aizpuru
C/Barquillo 44
28004 Madrid
+34 (91) 3105561 (t)
+34 (91) 3195286 (f)
aizpuru@navegalia.com
Contemporary photography,
mainly Spanish.

Kowasa Gallery
Mallorca 235
08008 Barcelona
+34 (93) 215 8058 (t)
+34 (93) 2158054 (f)
gallery@kowasa.com
www.kowasa.com
Vintage and contemporary
photography.

SWITZERLAND
Ars Futura Galerie
Bleicherweg 45
8002 Zurich
+41 (1) 2018810 (t)
+41 (1) 2018811 (f)
info@arsfutura.com
www.arsfutura.com
Contemporary art and
photography.

Galerie Bob van Orsouw
Limmatstrasse 270
8005 Zurich
+41 (1) 273 11 00 (t)
+41 (1) 273 11 01 (f)
mail@bobvanorsouw.ch
www.artgalleries.ch/bobvanors
ouw/index.html
Contemporary art and
photography.

Galerie Zur Stockeregg
Stockerstrasse 33
8022 Zürich
+41 (1) 202 69 25 (t)
+41 (1) 202 82 51 (f)
info@stockeregg.com
www.stockeregg.com
20th-century vintage and
contemporary photography.

UNITED KINGDOM
artandphotographs Ltd
13 Mason's Yard, Duke Street
London SW1Y 6 BU
+ 44 (0) 207 321 0495
+ 44 (0) 207 321 0496
info@artandphotographs.com
www.artandphotographs.com
19th-, 20th-century, and
contemporary photography.

Tom Blau Gallery
21 Queen Elizabeth Street
Butlers Wharf
London SE1 2PD
printsales@tomblaugallery.com
www.tomblaugallery.com
Vintage from the archive of
Camera Press, contemporary
photography.

Zelda Cheatle Gallery
99 Mount Street
London, W1K 2TF
+44 (0) 20 7408 4448 (t)
+44 (0) 20 7408 1444 (f)
photo@zcgall.demon.co.uk
www.zcgall.demon.co.uk
Vintage and contemporary
British and European
photography.

Sadie Coles HQ
35 Heddon Street
London W1B 4BP
+44 (0) 20 7434 2227 (t)
+44 (0) 20 7434 2228 (f)
sales@sadiecoles.com
www.sadiecoles.com
Contemporary art and
photography.

Simon Finch Rare Books
61a Ledbury Road
London W11 2AL
+44 (0)20 7792 3303 (t)
+44 (0)20 7243 2134 (f)
www.simonfinch.com
Rare photography books.

Focus Gallery
3-4 Percy Street
London W1T 1DF
+44 (0) 20 7631 1150 (t)
+44 (0) 20 7631 1140 (f)
info@focusgallery.co.uk
www.focusgallery.co.uk
Vintage and contemporary
photography.

Eric Franck Fine Art

7 Victoria Square
London SW1W 0QY
+44 (0) 20 7630 5972 (t)
+44 (0) 20 7630 6885 (f)
e.franck@btclick.com
By appointment only.
Specializing in 20th-century
photography and photographic
literature.

HackelBury Fine Art Limited

4 Launceston Place
London W8 5RL
+44 (0) 20 7937 8688 (t)
+44 (0) 20 7937 8868 (f)
reception@hackelbury.co.uk
www.hackelbury.co.uk
20th-century and contemporary
photography.

Hamilton's

13 Carlos Place
London W1Y 2EU
+44 (0) 20 7499 9493 (t)
+44 (0) 20 7629 9919 (f)
art@hamiltonsgallery.com
www.hamiltonsgallery.com
20th-century and contemporary
photography.

Haunch of Venison

6 Haunch of Venison Yard
London W1K 5ES
+44 (0) 20 7495 5050 (t)
+44 (0) 20 7495 4050 (f)
info@haunchofvenison.com
www.haunchofvenison.com
Contemporary art and
photography.

Robert Hershkowitz Ltd.

Cockhaise
Monteswood Lane
Near Lindfield
Sussex RH16 2QP
+44 (0) 1444 482 240 (t)
+44 (0) 1444 484 777 (f)
prhfoto@hotmail.com
By appointment only.
Masterworks of early European
photography.

Hirschl Contemporary Art

5 Cork Street
London W1S 3LQ
+44 (0)20 7495 2565 (t)
+44 (0)20 7495 7535 (f)
hirschl@dircon.co.uk
www.hirschlcontemporary.co.uk
Contemporary art and
photography.

Michael Hoppen Gallery Ltd.

3 Jubilee Place, 1st Floor
London SW3 3TD
+44 (0) 20 7352 3649 (t)
+44 (0) 20 7352 3669 (f)
gallery@michaelhoppen-
photo.com
www.michaelhoppen-photo.com
20th-century vintage and
contemporary photography.

Ken & Jenny Jacobson

"Southcotts" Petches Bridge
Great Bardfield
Essex CM7 4QN
+44 (0) 1371 810 566 (t)
+44 (0) 1371 810 845 (f)
ken@jacobsonphoto.com
www.jacobsonphoto.com
By appointment only.
19th-century photography.

Magnum Photos

5 Old Street
London EC1V 9HL
+44 (0) 20 7490 1771 (t)
+44 (0) 20 7608 0020 (f)
magnum@magnumphotos.
co.uk
www.magnumphotos.com
Vintage and modern prints by
Magnum members.

Victoria Miro Gallery

16 Wharf Road
London N1 7RW
+44 (0) 20 7336 8109 (t)
+44 (0) 20 7251 5596 (f)
info@victoria-miro.com
www.victoria-miro.com
Contemporary art and
photography.

The Photographers' Gallery

5 & 8 Great Newport Street
London, WC2H 7HY
+44 (0) 20 7831 1772 (t)
+44 (0) 20 7836 9704 (f)
printsales@photonet.org.uk
www.photonet.org.uk
20th-century vintage and
contemporary photography.

Rocket

13 Old Burlington Street
London W1S 3AJ
+44 (0) 20 7434 3043 (t)
+44 (0) 20 7434 3384 (f)
js.rocket@btinternet.com
Contemporary art and
photography; limited edition
books.

Shine Gallery

3 Jubilee Place, 2nd Floor
London SW3 3TD
+44 (0) 20 7352 4499 (t)
+44 (0) 20 7352 3669 (f)
shine@shinegallery.co.uk
www.shinegallery.co.uk
Contemporary photography.

**The Special Photographers
Company**

236 Westbourne Park Road
London W11 1EL
+44 (0)20 7221 3489 (t)
+44 (0)20 7792 9112 (f)
info@specialphotographers.com
www.specialphotographers.com
20th-century photography.

Mike Wells

Unit 11, Spectrum House
32-34 Gordon House Road
London NW5 1LP
+ 44 (0)207 284 3306 (t)
+ 44 (0)207 485 6347 (f)
mikewells@compuserve.com
By appointment only.
Out-of-print photography books.

White Cube

48 Hoxton Square
London N1 6PB

+44 (0) 20 7930 5373 (t)
+44 (0) 20 7749 7460 (f)
enquiries@whitecube.com
www.whitecube.com
Contemporary art and
photography.

USA
Arizona
Etherton Gallery
135 South 6th Street
Tuscon, AZ 85701
+1 (520) 624 7370 (t)
+1 (520) 792 4569 (f)
ethertongallery@mindspring.
com
www.artnet.com/etherton.html
19th-, 20th-century, and
contemporary photography.
Specializing in Native American
and western landscape.

California
Joseph Bellows Gallery
7661 Girard Avenue
La Jolla, CA 92037
+1 (858) 456 5620 (t)
+1 (858) 456 5621 (f)
jbellows@pacbell.net
www.josephbellows.com
19th- and 20th-century vintage
photography.

J. J. Brookings Gallery
669 Mission Street
San Francisco, CA 94195
+1 (415) 546 1000 (t)
+1 (415) 357 11000 (f)
info@jjbrookings.com
www.jjbrookings.com
Contemporary photography,
painting and sculpture.

Stephen Cohen Gallery Inc.
7358 Beverly Boulevard
Los Angeles, CA 90036
+1 (323) 937 5525 (t)
+1 (323) 937 5523 (f)
sc@stephencohengallery.com
www.stephencohengallery.com
20th-century vintage and
contemporary photography.

Fahey/Klein Gallery
148 North La Brea Avenue
Los Angeles, CA 90036
+1 (323) 934 2250 (t)
+1 (323) 934 4243 (f)
fahey.klein@pobox.com
www.faheykleingallery.com
20th-century vintage and
contemporary photography.
Photojournalism/reportage
photography.

Peter Fetterman Gallery
Bergamot Station
2525 Michigan Avenue, A7
Santa Monica, CA 90404
+1 (310) 453 6463 (t)
+1 (310) 453 6959 (f)
peter@peterfetterman.com
www.peterfetterman.com
20th-century vintage and
contemporary photography
with an emphasis on
humanist photography
and photojournalism.

Fraenkel Gallery
49 Geary Street
San Francisco, CA 94108
+1 (415) 981 2661 (t)
+1 (415) 981 4014 (f)
mail@fraenkelgallery.com
www.fraenkelgallery.com
19th-, 20th-century, and
contemporary photography,
mainly American.

Ursula Gropper Associates
10 Laurel Lane
Sausalito, CA 94965
+1 (415) 331 2414 (t)
+1 (415) 331 3203 (f)
info@ursulagropper.com
www.ursulagropper.com
By appointment only.
20th-century photography
with an emphasis on
photojournalism.

Charles A. Hartman Gallery
166 Geary Street, Suite 507
San Francisco, CA 94108

+1 (415) 392 7368 (t)
+1 (415) 392 7364 (f)
charles@hartmangallery.com
www.hartmangallery.com
By appointment only.
19th- and 20th-century
photography and rare
photographic books.

G. Ray Hawkins Gallery
300 N. Crescent Heights Bd.
Los Angeles CA 948
+1 (323) 655 4180 (t)
+1 (323) 655 4280 (f)
hawkins@artnet.net
http://artscenecal.com/GRayHa
wkins.html
Vintage and contemporary
photography and auction house.

**Debra Heimerdinger/Fine
Art Photographs**
The Phelan Building, Suite 258
760 Market Street
San Francisco, CA 94102
+1 (415) 566 1910 (t)
+1 (415) 566 1915 (f)
dhfineart@aol.com
Public hours during exhibitions,
otherwise by appointment only.
20th-century and contemporary
photography.

Paul M. Hertzmann Inc.
PO Box 40447
San Francisco, CA 94140
+1 (415) 626 2677 (t)
+1 (415) 552 4160 (f)
pmhi@hertzmann.net
By appointment only.
19th- and 20th-century vintage
photography.

Jan Kesner
164 North La Brea Avenue
Los Angeles, CA 90036
+1 (323) 938 6834 (t)
+1 (323) 938 1106 f)
jkesner@pacbell.net
www.jankesnergallery.com
20th-century master and
contemporary photography.

Robert Koch Gallery
49 Geary Street
San Francisco, CA 94108
+1 (415) 421 0122 (t)
+1 (415) 421 6306 (f)
info@kochgallery.com
www.kochgallery.com
19th-, 20th-century, and
contemporary photography with
an emphasis on modernist and
experimental work from the
1920s and 1930s.

Paul Kopeikin Gallery
138 North La Brea Avenue
Los Angeles, CA 90036
+1 (323) 937 0765 (t)
+1 (323) 937 5974 (f)
pkgallery@earthlink.net
www.paulkopeikingallery.com
19th-, 20th-century, and
contemporary photography.

Gallery Luisotti
2525 Michigan Ave, Unit A-2
Santa Monica, CA 90404
+1 (310) 453 0043 (t)
+1 (310) 264 4888 (f)
rampub@gte.net
Contemporary and selected
20th-century photography.

Vance Martin
653 Guerrero Street
San Francisco CA 94110
+1 (415) 621 2139 (t)
+1 (415) 621 0352 (f)
photoart@vancemartin.com
www.vancemartin.com
By appointment only.
20th-century and contemporary
photography, specializing in
portraits, and male and female
nudes.

Thomas V. Meyer – Fine Art
169 25th Avenue
San Francisco, CA 94121
+1 (415) 386 1225 (t)
+1 (415) 386 1634 (f)
meyerart@pacbell.net
www.thomasvmeyerfineart.com

By appointment only.
Early 20th-century and
contemporary photography.

Scott Nichols Gallery
49 Geary Street, Suite 415
San Francisco, CA 94108
+1 (415) 788 4641 (t)
+1 (415) 788 8438 (f)
scott@scottnicholsgallery.com
www.scottnicholsgallery.com
Vintage, modern, and
contemporary photography
with an emphasis on classic
Californian masters.

Rose Gallery
2525 Michigan Avenue, G-5
Santa Monica, CA 90404
+1 (310) 264 8440 (t)
+1 (310) 264 8443 (f)
rose.gallery@gte.net
www.rosegallery.net
20th-century vintage and
contemporary photography.

Saret Gallery
111a East Napa Street
Sonoma, CA 95476
+1 (707) 996 3492 (t)
+1 (707) 996 1495 (f)
madameami@aol.com
www.saretgallery.com
Vintage and contemporary fine
art photography.

Shapiro Gallery
The Phelan Building, Suite 248
760 Market Street, #248
San Francisco, CA 94102
+1 (415) 398 6655 (t)
+1 (415) 398 0667 (f)
info@shapirogallery.net
20th-century and contemporary
photography.

Barry Singer Gallery
7 Western Avenue
Petaluma, CA 94952
+1 (707) 781 3200 (t)
+1 (707) 781 3030 (f)
singer@singergallery.com

www.singergallery.com
20th-century vintage and
contemporary photography

Weston Gallery
Dolores St At 6th Ave
Carmel, CA 93921
+1 (831) 624 4453 (t)
+1 (310) 624 7190 (f)
info@westongallery.com
www.westongallery.com
19th- and 20th-century vintage
and contemporary photography.

Colorado
The Camera Obscura Gallery
1309 Bannock Street
Denver, CO 80204
+1 (303) 623 4059 (t/f)
hgould@iws.net
www.cameraobscuragallery.com
19th- and 20th-century
photography.

Joel Soroka Gallery
400 East Hyman Avenue
Aspen, CO 81611
+1 (970) 920 3152 (t)
+1 (970) 920 3823 (f)
soroka@rof.net
20th-century vintage and
contemporary photography.

Connecticut
Ezra Mack
P.O Box 5090
Greenwich, CT 06831
+1 (212) 861 8410 (t)
+1 (212) 861 3293 (f)
By appointment only.
Vintage 19th- and 20th-
century, and contemporary
photography.

William L.Schaeffer/
Photographs
P.O.Box 296
Chester, CT 06413
+1 (860) 526 3870 (t)
19th- and 20th-century
vintage and daguerreotypes.

District of Columbia
Gary Edwards Gallery
9 Hillyer Court, NW
Washington, DC 20008
+1 (202) 232 5926 (t)
+1 (202) 232 2523 (f)
garyedwardsgallery@erols.com
www.garyedwardsgallery.com
19th- and 20th-century
photography.

Kathleen Ewing Gallery
1609 Connecticut Avenue
Washington DC 20009
+1 (202) 328 0955 (t)
+1 (202) 462 1019 (f)
ewingal@aol.com
www.kathleenewinggallery.com
19th- and 20th-century vintage
and contemporary photography.

The Ralls Collection
1516 31st Street, NW
Washington, DC 20007
+1 (202) 342 1754 (t)
+1 (202) 342 0141 (f)
maralls@aol.com
www.rallscollection.com
Contemporary photography.

TARTT Washington
1710 Connecticut Avenue, NW
Washington, DC 20009
+1 (202) 332 5652 (t)
+1 (202) 797 9853 (f)
jctjr@earthlink.net
By appointment only.
Pre-1950s vintage photography.

Georgia
Fay Gold Gallery
764 Miami Circle
Atlanta, GA 30324
+1 (404) 233 3843 (t)
+1 (404) 365 8633 (f)
info@faygoldgallery.com
www.faygoldgallery.com
20th-century masters,
contemporary emerging artists
from south-east USA.

Jackson Fine Art
3115 East Shadowlawn Avenue
Atlanta, GA 30305
+1 (404) 233 3739 (t)
+1 (404) 233 1205 (f)
info@jacksonfineart.com
www.jacksonfineart.com
20th-century vintage and
contemporary photography.

Illinois
Stephen Daiter Gallery
311 West Superior Street #404
Chicago, IL 60610
+1 (312) 787 3350 (t)
+1 (312) 787 3354 (f)
stephen@stephendaitergallery.
com
Vintage 20th-century European
and American avant-garde and
documentary photographs; rare
photographic books.

Catherine Edelman Gallery
300 West Superior Street
Chicago, Il 60610
+1 (312) 266 2350 (t)
+1 (312) 266 1967 (f)
ceg@edelmangallery.com
www.edelmangallery.com
Contemporary photography and
mixed media photo-based
works.

Indiana
Lee Marks Fine Art
2208 East 350 North
Shelbyville, IN 46176
+1 (317) 398 9212 (t)
+1 (317) 398 2242 (f)
lee@leemarksfineart.com
www.leemarksfineart.com
By appointment only.
19th-, 20th-century, and
contemporary photography.

Louisiana
**A Gallery For Fine
Photography**
241 Chartres Street
New Orleans, LA 70130
+1 (504) 568 1313 (t)

+1 (504) 568 1322 (f)
joshuamann@wordlnet.att.net
www.agallery.com
Rare photographs and books.

Maryland
Sandra Berler Gallery
7002 Connecticut Avenue
Chevy Chase, MD 20815
+1 (301) 656 8144 (t)
+1 (301) 656 8182 (f)
Sandra.Berler@verizon.net
20th-century vintage and
contemporary photography
and portfolios.

Massachusetts
Robert Klein Gallery
38 Newbury Street
Boston, MA 02116
+1 (617) 267 7997 (t)
+1 (617) 267 5567 (f)
inquiry@robertkleingallery.com
www.robertkleingallery.com
19th-, 20th-century, and
contemporary photography.

Michigan
The Halsted Gallery
576 N. Old Woodward Avenue
Birmingham, MI 48009
+1 (248) 644 8284 (t)
+1 (248) 644 3911 (f)
halsted@halstedgallery.com
www.halstedgallery.com
Vintage and contemporary
photography.

Missouri
The Center for Photography
232 North Kingshighway
St Louis, MO 63108
+1 (314) 361 7770 (t)
+1 (314) 361 2403 (f)
By appointment only.
Vintage and contemporary
photography.

New Mexico
Scheinbaum & Russek Ltd.
369 Montezuma Avenue, #345
Sante Fe, NM 87501

+1 (505) 988 5116 (t)
+1 (505) 988 4346 (f)
srltd@photographydealers.com
www.photographydealers.com
Contemporary and vintage
20th-century photography.

Andrew Smith Gallery
202 West San Francisco Street
Santa Fe, NM 87501
+1 (505) 984 1234 (t)
+1 (505) 983 2428 (f)
info@andrewsmithgallery.com
www.andrewsmithgallery.com
19th- and 20th-century vintage
and contemporary photography,
mainly American.

New York
Timothy Baum
PO Box 595
Lenox Hill Station
New York, NY 10021
+1 (212) 879 4512 (t)
+1 (212) 861 1397 (f)
By appointment only.
Genre and fantasy photography,
especially Dada and Surrealism.

Deborah Bell Photographs
511 West 25th Street,
Room 703
New York, NY 10001
+1 (212) 691 3883 (t)
+1 (212) 691 3222 (f)
deborahbell@rcn.com
www.photoarts.com
12-6 on Saturdays or by
appointment.
20th-century vintage and
contemporary photography.

Bonni Benrubi Gallery
52 East 76th Street
New York, NY 10021
+1 (212) 517 3766 (t)
+1 (212) 288 7815 (f)
benrubi@bonnibenrubi.com
www.bonnibenrubi.com
20th-century American
photography and contemporary
photography.

Janet Borden Inc.
560 Broadway
New York, NY 10012
+1 (212) 431 0166 (t)
+1 (212) 274 1679 (f)
mail@janetbordeninc.com
www.janetbordeninc.com
20th-century vintage and
contemporary photography.

**Robert Burge/20th Century
Photographs Ltd.**
315 East 62nd Street
New York, NY 10021
+1 (212) 838 4108 (t)
+1 (212) 838 4390 (f)
By appointment only.
20th-century photography,
art advisory, and consultation
services.

Commerce Graphics Ltd., Inc.
506 East 74th Street, Suite 4SE
New York, NY 10021
+1 (212) 517 7648 (t)
+1 (212) 517 7649 (f)
ComGraphicsLtd@aol.com
20th-century master
photography.

Paula Cooper Gallery
534 West 21st Street
New York, NY 10011
+1 (212) 255 1105 (t)
+1 (212) 255 5156 (f)
anthony@paulacoopergallery.
com
Contemporary art and
photography.

Keith de Lellis Gallery
47 East 68th Street
New York, NY 10021
+1 (212) 327 1482 (t)
+1 (212) 327 1492 (f)
defoto@earthlink.net
Vintage photographs for
museums and collectors.

Henry Feldstein
PO Box 398
Forest Hills, NY 11375

+1 (718) 544 3002 (t)
+1 (718) 544 7139 (f)
henryfe@ix.netcom.com
By appointment only.
19th- and 20th-century
photography and rare
photographic literature.

Wm. Floyd
16 East 77th Street
New York, NY 10021
+1 (212) 988 0082 (t)
+1 (212) 988 8370 (f)
www.floydgallery.com
By appointment only.
20th-century and contemporary
photography.

Marian Goodman Gallery
24 West 57th Street
New York NY 10019
+1 (212) 977 7160 (t)
+1 (212) 581 5187 (f)
goodman@mariangoodman.
com
www.mariangoodman.com
Contemporary art and
photographic based art.

Howard Greenberg Gallery
120 Wooster Street
New York, NY 10012
+1 (212) 334 0010 (t)
+1 (212) 941 7479 (f)
clientservices@howardgreen
berg.com
www.howardgreenberg.com
Classic 20th-century
photography with an emphasis
on photojournalism, New York
School, European and American
modernism, fashion, and the
Photo-Secession.

Edwynn Houk Gallery
745 Fifth Avenue
New York, NY 10151
+1 (212) 750 7070 (t)
+1 (212) 688 4848 (f)
info@houkgallery.com
www.houkgallery.com
20th-century photography with

an emphasis on the 1920s and 1930s, and contemporary American photography.

Hyperion Press Limited
200 West 86th Street
New York, NY 10024
+1 (212) 877 2131 (t)
+1 (212) 769 3907 (f)
hyperionpr@aol.com
By appointment only.
20th-century vintage and contemporary photography. Limited edition portfolios.

Steven Kasher Gallery
54 North Moore Street
New York, NY 10013
+1 (212) 966 3978 (t)
+1 (212) 226 1485 (f)
steven.kasher@verizon.net
www.stevenkasher.com
By appointment only.
19th-, 20th-century, and contemporary photography.

Klotz/Sirmon Gallery
511 West 25th Street
New York, NY 10001
+1 (212) 741 4764 (t)
+1 (212) 741 4760 (f)
klotz@photocollect.com
www.photocollect.com
19th-, 20th-century, and contemporary photography.

Hans P. Kraus, Jr., Inc.
25 East 77th Street
New York, NY 10021
+1 (212) 794 2064 (t)
+1 (212) 744 2770 (f)
info@sunpictures.com
By appointment only.
Old masters of photography.

Janet Lehr, Inc.
891 Park Avenue
New York, NY 10021
+1 (212) 288 6234 (t/f)
janetlehr@janetlehrinc.com
www.janetlehrinc.com
By appointment only.

Lewis Lehr, Inc.
444 East 86th Street
New York, NY 10028
+1 (212) 288 6765 (t)
daguerre39@aol.com
By appointment only.
19th- and 20th-century photography for collectors, museums, and curators.

Leica Gallery
670 Broadway, Suite 500
New York, NY 1001
+1 (212) 777 3051 (t)
+1 (212) 777 6960 (f)
leicaphoto@aol.com
www.leica-camera.com
Affiliated with Leica cameras, specializing in contemporary and vintage photography, with an emphasis on photojournalism, documentary, and reportage.

Magnum Photos
151 West 25th Street
New York, NY 10001-7204
+1 (212) 929 6000 (t)
+1 (212) 929 9325 (f)
photography@magnumphotos.com
www.magnumphotos.com
Vintage and modern prints by Magnum members.

Robert Mann Gallery
210 11th Avenue
New York, NY 10001
+1 (212) 989 7600 (t)
+1 (212) 989 2947 (f)
mail@robertmann.com
www.robertmann.com
20th-century vintage and contemporary photography.

Matthew Marks Gallery
523 West 24th Street
New York, NY 10011
+1 (212) 243 0200 (t)

+1 (212) 243 0047 (f)
info@matthewmarks.com
www.matthewmarks.com
International contemporary art and photography.

Metro Pictures Gallery
519 West 24th Street
New York, NY 10011
+1 (212) 206 7100 (t)
+1 (212) 337 0070 (f)
gallery@metropicturesgallery.com
www.artnet.com/metropictures.html
Contemporary art and phototography.

Laurence Miller Gallery
20 West 57th Street
New York, NY 10019
+1 (212) 397 3930 (t)
+1 (212) 397 3932 (f)
lmg@laurencemillergallery.com
www.laurencemillergallery.com
Specializing in American photography since 1940, Asian photography since 1950, European photography from the 19th century, and contemporary photo-based art from Europe.

Robert Miller Gallery
524 West 26th Street
New York NY 10001
+1 (212) 366 4774 (t)
+1 (212) 366 4454 (f)
rmg@robertmillergallery.com
www.robertmillergallery.com
19th-, 20th-century, and contemporary photography.

Pace/MacGill Gallery
32 East 57th Street
New York, NY 10022
+1 (212) 759 7999 (t)
+1 (212) 759 8964 (f)
info@pacemacgill.com
19th- and 20th-century photography.

Candace Perich Gallery
27 Katonah Avenue
Katonah, NY 10536
+1 (914) 232 3966 (t/f)
email@perichgallery.com
www.perichgallery.com
20th-century and contemporary
photography.

Prakapas Gallery
I Northgate, 6B
Bronxville, NY 10708
+1 (914) 961 5091 (t)
+1 (914) 961 5192 (f)
eugeneprakapas@earthlink.net
By appointment only.
Vintage photographs by the
20th-century avant-garde.

Ricco/Maresca Gallery
529 East 20th Street, 3rd Floor
New York, NY 10011
+1 (212) 627 4819 (t)
+1 (212) 627 5117 (f)
info@riccomaresca.com
www.riccomaresca.com
Contemporary and vintage
photography.

Yancey Richardson Gallery
535 West 22nd Street, 3rd Floor
New York, NY 10011
+1 (646) 230 9610 (t)
+1 (646) 230 6131 (f)
info@yanceyrichardson.com
www.yanceyrichardson.com
Contemporary and 20th-century
photography.

Julie Saul Gallery
535 West 22nd Street, 6th Floor
New York, NY 10011
+1 (212) 627 2410 (t)
+1 (212) 627 2411 (f)
mail@saulgallery.com
www.saulgallery.com
Contemporary and vintage
photography.

Howard Schickler Gallery
45 Main Street, Studio 402
Brooklyn, NY 11201

+1 (212) 431 6363 (t)
+1 (212) 343 2644 (f)
gallery@schicklerart.com
www.schicklerart.com
20th-century Russian and
European avant-garde. 19th-and
20th-century astronomy and
space exploration. Rare books.

Charles Schwartz Ltd
21 East 90th Street
New York, NY 10128
+1 (212) 534 4496 (t)
+1 (212) 534 0313 (f)
csltd@cs-photo.com
www.cs-photo.com
By appointment only.
19th- and 20th-century vintage
photography.

Michael Senft Masterworks
P.O. Box 3117
East Hampton, NY 11937
+1 (631) 907 0904 (t)
+1 (631) 907 9795 (f)
mmsenft@att.net
By appointment only.
Vintage photographs by Man
Ray and other surrealists.

SoHo Triad Fine Arts
107 Grand Street
New York, NY 10013
+1 (212) 965 9500 (t)
+1 (212) 965 0537 (f)
sohotriad@msn.com
www.sohotriad.com
20th-century and contemporary
photography, specializing in
photojournalism, music, and
dance.

Staley+Wise Gallery
560 Broadway
New York, NY 10012
+1 (212) 966 6223 (t)
+1 (212) 966 6293 (f)
photo@staleywise.com
www.staleywise.com
Fashion photography,
Hollywood portraiture,
landscape, still life, and nudes.

John Stevenson Gallery
338 West 23rd Street
New York, NY 10011
+1 (212) 352 0070 (t)
+1 (212) 741 6449 (f)
mail@johnstevenson-
gallery.com
www.johnstevenson-gallery.com
Hand-crafted prints and fine
rare processes.

Throckmorton Fine Art, Inc.
145 East 57th Street, 3rd Floor
New York, NY 10022
+1 (212) 223 1059 (t)
+1 (212) 223 1937 (f)
throckmorton@earthlink.net
www.throckmorton-nyc.com
Specializing in vintage and
contemporary Latin American
photography.

Winter Works on Paper
160 Fifth Avenue, #718
New York, NY 10010
+1 (212) 352 9013 (t)
+1 (718) 388 5217 (f)
winterwp@aol.com
By appointment only.
Twentieth-century vernacular
photography with an emphasis
on crime and science.

Zabriskie Gallery
41 East 57th Street, 4th Floor
New York, NY 10022
+1 (212) 752 1223 (t)
+1 (212) 752 1224 (f)
vzny@zabriskiegallery.com
www.zabriskiegallery.com
Modern and contemporary
American and European art,
vintage and contemporary
photography.

North Carolina
**Andrew Cahan Bookseller
Ltd**
3000 Blueberry Lane
Chapel Hill, NC 27516
+1 919-968-0538 (t)
+1 919-968-3517 (f)

acahan@cahanbooks.com
www.cahanbooks.com
By appointment only.
Rare and out-of-print
photographic literature.

Ohio
Wach Gallery
31860 Walker Road
Avon Lake, OH 44012
+1 (440) 933 2780 (t)
+1 (440) 933 2781 (f)
wachgallery@attbi.com
www.wachgallery.com
By appointment only.
19th- and 20th-century
photography.

Pennsylvania
Charles Isaacs Photographs Inc.
2145 Valley Hill Road
Malvern, PA 19355
+1 (610) 827 9500 (t)
+1 (610) 827 0878 (f)
issacsfoto@aol.com
By appointment only.
American and European
masterworks 1849–1950.

Richard T. Rosenthal
4718 Springfield Avenue
Philadelphia, PA 19143
+1 (215) 726 5493 (t)
+1 (215) 726 5926 (f)
rtrphoto@philly.infi.net
www.vernacularphotography.com
By appointment only.
19th- and 20th-century
vernacular photography. Rare
and out-of-print books.

Vintage Works, Ltd.
258 Inverness Circle
Chalfont, PA 18914
+1 (215) 822 5662 (t)
+1 (215) 822 8003 (f)
anovak@comcat.com
www.vintageworks.net
www.iphotocentral.com
By appointment only.

19th- and 20th-century vintage
photography, mainly by
American, English, and
European masters.

Texas
Afterimage Gallery
The Quadrangle # 141
2800 Routh Street
Dallas, TX 75201
+1 (214) 871 9140 (t)
+1 (801) 858 5282 (f)
images@afterimagegallery.com
www.afterimage.com
20th-century and contemporary
photography.

Stephen L. Clark Gallery
1101 West Sixth Street
Austin, TX 78703
+1 (512) 477 0828 (t)
+1 (512) 477 0934 (f)
slcgallery@aol.com
www.artnet.com/slclark.html
Contemporary photography.

John Cleary Gallery
2635 Colquitt
Houston, TX 77098
+1 (713) 524 5070 (t)
+1 (713) 524 4456 (f)
clearygallery@ev1.net
www.johnclearygallery.com
20th-century, vintage, and
contemporary photography.
Rare photography books.

Photographs Do Not Bend Gallery
3115 Routh Street
Dallas, TX 75201
+1 (214) 969 1852 (t)
+1 (214) 969 5464 (f)
gallery@photographsdonotbend.com
www.photographsdonotbend.com
20th-century vintage and
contemporary photography.

Washington
G. Gibson Gallery
514 East Pike Street
Seattle, WA 98104
+1 (206) 587 4033 (t)
+1 (206) 587 5751 (f)
gail@gibsongallery.com
www.ggibsongallery.com
19th-, 20th-century, and
contemporary photography.

AUCTION HOUSES

Christie's
8 King Street
St. James's
London SW1Y 6QT
United Kingdom
+44 (0) 20 7839 9060 (t)
+44 (0) 20 7839 1611 (f)

20 Rockefeller Plaza
New York NY 10020
USA
+1 (212) 636 2000 (t)
+1 (212) 636 2399 (f)

info@christies.com
www.christies.com

Phillips, de Pury & Luxembourg
49 Grosvenor Street
London W1K 3HP
United Kingdom
+44 (0) 20 7318 4021 (t)
+44 (0) 20 7493 6396 (f)

3 West 57th Street
New York NY 10019
USA
+1 (212) 940 1240 (t)
+1 (212) 688 147 (f)
inquiry.desk@phillips-dpl.com
www.phillips-dpl.com

Neumeister
Barer Strasse 37
80799 Munich
Germany
+49 (89) 23 17 10 0 (t)
+49 (89) 23 17 10 55 (f)
info@neumeister.com
www.neumeister.com

Villa Grisebach Auktionen
Fasanenstrasse 25
10719 Berlin
Germany
+49 (30) 885 915 0 (t)
+49 (30) 882 41 45 (f)
auktionen@villa-grisebach.de
www.villa-grisebach.de

Sotheby's
34-35 New Bond Street
London W1A 2AA
United Kingdom
+44 (0) 20 7293 5000 (t)
+44 (0) 20 7293 5989 (f)

1334 York Avenue
New York NY 10021
USA
+1 (212) 606 7000 (t)
+1 (212) 606 7107 (f)
www.sothebys.com

Swann Galleries Inc.
104 East 25th Street
New York NY 10010
USA
+1 (212) 254 4710 (t)
+1 (212) 979 1017 (f)
swann@swanngalleries.com
www.swanngalleries.com

PHOTOGRAPHY FAIRS

AIPAD – New York (February)
The Association of International Photography Art Dealers Inc. (AIPAD)
1609 Connecticut Avenue NW # 200
Washington DC 20009
USA
+1 (202) 986 0105 (t)
+1 (202) 986 0448 (f)
AIPAD@aol.com
www.photoshow.com

The Armory Show – New York (October)
59 9th Avenue, Suite 201
New York NY 10011
USA
+1 (212) 645 6440 (t)
+1 (212) 741 2063 (f)
info@thearmoryshow.com
www.thearmoryshow.com

Paris Photo – Paris (November)
11 rue du Colonel Pierre-Avia
75726 Paris cedex 15
France
+33 (0) 1 41 90 47 80 (t)
+33 (0) 1 41 90 47 89 (f)
parisphoto@reedexpo.fr
www.parisphoto.fr

Photo LA – Los Angeles (January)
Contact – Stephen Cohen Gallery
7358 Beverly Boulevard
Los Angeles, CA 90036
USA
+1 (323) 937 5525 (t)
+1 (323) 937 5523 (f)
info@stephencohengallery.com
www.stephencohengallery.com

Photo San Francisco (July)
Contact – Stephen Cohen Gallery
7358 Beverly Boulevard
Los Angeles, CA 90036
USA
+1 (323) 937 5525 (t)
+1 (323) 937 5523 (f)
fairs@stephencohengallery.com
www.stephencohengallery.com

Bibliography

The select bibliography is a guide to forming a basic photography collector's library, covering the history of photography, books on collecting, technical books, and other potentially useful books. Monographs on individual photographers are not included for reasons of space – almost any photographer of note these days has at least one monograph dedicated to his or her work – and we have not included any book specifically on photographic aesthetics. However, most of the volumes below inevitably deal with the aesthetics of the medium and all its contradictions.

The bibliography concentrates on books published or republished since around the mid-20th century. Some are now out of print, but can still be found for sale on the Internet or in second-hand bookstores. It is also worth ordering a copy of the Association of International Photographic Art Dealers (AIPAD) booklet, *On Collecting Photography*.

Auction and dealers' catalogues are valuable sources of information for collectors. Collectors should always be on the lookout for old catalogues. They can often be found for a few dollars, and are an estimable adjunct to a book collection.

GENERAL HISTORIES OF PHOTOGRAPHY

Michael Braive, *The Photograph; A Social History* (Thames and Hudson, London, 1966)

Michel Frizot, ed., *A New History of Photography* (Könemann, Cologne, 1998)

Helmut Gernsheim, *A Concise History of Photography* (Thames and Hudson, London, 1965)

Helmut and Alison Gernsheim, *The History of Photography from the Camera Obscura to the Beginning of the Modern Era* (Thames and Hudson, London, 1969)

Vicki Goldberg, ed., *Photography in Print: Writings from 1816 to the Present* (University of New Mexico Press, Albuquerque, 1988)

Sarah Greenhough, Joel Snyder, David Travis and Colin Westerbrook, *On the Art of Fixing a Shadow* (National Gallery of Art, Washington, D.C., and The Art Institute of Chicago, 1989)

Ian Jeffrey, *A Concise History of Photography* (Thames and Hudson, London and New York, 1981)

Naomi Rosenblum, *A World History of Photography* (Abbeville Press, New York, 1987)

Naomi Rosenblum, *A History of Women Photographers* (Abbeville Press, New York, 1994)

Robert Sobieszek, *Color as Form: A History of Color Photography* (International Museum of Photography at George Eastman House, Rochester, 1982)

John Szarkowski, *Photography Until Now* (Museum of Modern Art, New York, 1989)

THE BEGINNINGS OF PHOTOGRAPHY

H. J. P. Arnold, *William Henry Fox Talbot, Pioneer of Photography and Man of Science* (Hutchinson Benham, London, 1977)

Gail Buckland, *Fox Talbot and the Invention of Photography* (David R. Godine, Boston, 1980)

Helmut Gernsheim, *The Origins of Photography* (Thames and Hudson, London, 1982)

André Jammes, *William H. Fox Talbot, Inventor of the Negative-Positive Process* (Collier Books, New York, 1973)

Beaumont Newhall, *Latent Image: The Discovery of Photography* (Doubleday and Co., New York, 1967)

Larry J. Schaaf, *Out of the Shadows: Herschel, Talbot and the Invention of Photography* (Yale University Press, New Haven, 1992)

PHOTOGRAPHY IN THE 19TH CENTURY

Richard R. Brettell, with Roy Flukinger, Nancy Keeler, and Sidney Mallett Kilgore, *Paper and Light: The Calotype in France and Great Britain 1839-1870* (David R. Godine, Boston, 1984)

Helmut Gernsheim, *The Rise of Photography* (Thames and Hudson, London, 1988)

Mark Haworth-Booth, Michael Weaver, eds., *The Golden Age of British Photography 1839–1900* (Aperture Inc., New York, 1984)

André Jammes and Eugenia Parry Janis, *The Art of French Calotype with a Critical Dictionary of Photographers, 1845–1870* (Princeton University Press, Princeton, 1983)

Mike Weaver, ed., *British Photography in the Nineteenth Century: The Fine Art Tradition* (Cambridge University Press, Cambridge, 1989)

PHOTOGRAPHY IN THE 20TH CENTURY

Bruce Bernard, *Century* (Phaidon, London, 2000)

Keith F. Davis, *An American Century of Photography: From Dry-Plate to Digital* (Hallmark Cards Inc., in association with Harry N. Abrams Inc., New York, 1999)

Christof Doswald, *Missing Link: The Image of Man in Contemporary Photography* (Editions Stemmle, Zurich and New York, 2000)

Andy Grunberg and Kathleen McCarthy Gauss, *Photography and Art: Interactions Since 1945* (Abbeville Press Publishers, New York, 1987)

Paul Hill and Thomas Joshua Cooper, *Dialogue With Photography* (Dewi Lewis Publishing, Stockport, 1995)

Jonathan Green, *American Photography: A Critical History, 1945 to the Present* (Harry N. Abrams Inc., New York, 1984)

Nathan Lyons, *Photography in the Twentieth Century* (Horizon Press, New York, and George Eastman House, Rochester, 1966)

Thomas Weski and Heinz Liesbrock, *How You Look At It: Photographs of the 20th Century* (Sprengel Museum, Hannover, Thames and Hudson, London, DAP, New York, 2000)

BOOKS ON COLLECTING PHOTOGRAPHS

Stuart Bennett, *How to Buy Photographs* (Phaidon, Oxford, 1987)

Richard Blodgett, *Photographs: A Collector's Guide* (Ballantine Books, New York, 1979)

George Gilbert, *Collecting Photographica: The Images and Equipment of the First Hundred Years* (Hawthorn Books, New York, 1976)

William Wetling, *Collector's Guide to Nineteenth Century Photographs* (Macmillan Publishing, New York, 1976)

Lee D. Witkin and Barbara London, *The Photograph Collector's Guide* (McGraw Hill, New York, and Secker & Warburg, London, 1979)

BOOKS ON MUSEUM COLLECTIONS

James Borcoman, *Magicians of Light* (National Gallery of Canada, Ottowa, 1993)

Mark Haworth-Booth, *Photography, An Independent Art* (Victoria and Albert Museum, London, 1998)

Therese Mulligan and David Wooters, eds., *George Eastman House: Photography From 1839 to Today* (Taschen, Cologne, 1998)

Françoise Heilbrun and Philippe Néagu, *Musée d'Orsay: Chefs-d'oeuvre de la collection photographique* (Philippe Sers, Réunion des Musées Nationaux, Paris, 1986)

Richard Pare, *Photography and Architecture, 1839–1939* (Canadian Centre for Architecture, 1982)

Pam Roberts, *Photogenic: From the Collection of the Royal Photographic Society* (Scriptum Editions, London, 2000)

BOOKS ON PRIVATE AND CORPORATE PHOTOGRAPHIC COLLECTIONS

Pierre Apraxine, *Photographs From the Collection of the Gilman Paper Company* (White Oak Press, 1985)

Pierre Apraxine, *Une passion française: photographies de la collection Roger Thérond* (Filipacchi, Paris, 1999)

Maria Morris Hambourg, Pierre Apraxine, Malcolm Daniel, Jeff L. Rosenheim, Virginia Heckert, *The Waking Dream: Photography's First Century: Selections From the Gilman Paper Company Collection* (Metropolitan Museum of Art, New York, 1993)

Marie-Thérèse and André Jammes, *The First Century of Photography. Niépce to Atget, From the Collection of André Jammes* (The Art Institute of Chicago, Chicago, 1977)

Susanne Lange, *Degrees of Stillness: Photographs from the Manfred Heiting Collection* (Die Photographische Sammlung/SK Stiftung Kultur, Cologne, 1998)

Robert Sobieszek, *Masterpieces of Photography From the George Eastman House Collection* (Abbeville Press Publishers, New York, 1985)

Larry J. Schaaf, *Sun Pictures Catalogue Eight, The Rubell Collection* (Hans P. Krause Jr., New York, 1997)

John Szarkowski, *Looking At Photographs: 100 Pictures from the Collection of the Museum of Modern Art* (Museum of Modern Art, New York, 1976)

John Szarkowski, *A Personal View: Photography in the Collection of Paul F. Walter* (Museum of Modern Art, New York, 1985)

Sam Wagstaff, *A Book of Photographs From the Collection of Sam Wagstaff* (Gray Press, New York, 1978)

Thomas Walther, *Other Pictures: Photographs From the Collection of Thomas Walther* (Twin Palms Publishers, Santa Fe, 1999)

BOOKS ON PHOTOGRAPHIC BOOKS

Helmut Gernsheim, *Incunabula of British Photographic Literature 1939–1875* (Scholar Press, London and Berkeley, 1984)

Lucien Goldschmidt and Weston Naef, *The Truthful Lens: A Survey of the Photographically Illustrated Book 1844–1914* (Gollier Club, New York, 1980)

Horacio Fernandez, *Fotografía Pública: Photography in Print 1919–1939* (Museo Nacional Centro de Arte Reina Sofia, Madrid, 1999)

Robert Lebeck and Bodovon Dewitz, *Kiosk: A History of Photojournalism* (Steidl, Göttingen, 2001)

Andrew Roth, *The Book of 100 Books: Seminal Photographic Books of the Twentieth Century* (PPP Editions and Roth Horowitz LLC, New York, 2001)

TECHNICAL BOOKS

Gordon Baldwin, *Looking at Photographs: A Guide to Technical Terms* (The J. Paul Getty Museum, Malibu, and the British Museum Press, London, 1991)

William Crawford, *Keepers of Light* (Morgan & Morgan, New York, 1979)

Lawrence E. Keefe and Dennis Inch, *The Life of a Photograph: Archival Processing, Matting, Framing, Storage* (Focal Press, London, 1990)

Life Library of Photography, *Caring for Photographs* (Time-Life Books, New York, 1972)

Siegfried Rempel, *The Care of Photographs* (Nick Lyons Books, 1987)

Robert Weinstein and Larry Booth, *Collection, Use and Care of Historical Photographs* (American Association for State and Local History, Nashville, 1977)

Henry Wilhelm, *The Permanence and Care of Color Photographs* (Preservation Publishing Company, 1993)

(no author cited) *Conservation of Photographs* (Eastman Kodak Co., Rochester, 1985)

Index

glass, framing prints 105, 117
glues, mounting prints 109
Gohlke, Frank 130
Goldin, Nan 130
 Vivienne in the Green Dress, New York
 116
Graham, Paul, *Roundabout, Anderstown,*
 Belfast 90
Greenberg, Howard 15, 16, 39
Greene, John Beasley 123
 Temple du Dandour 24
Grey, Howard 99
Grossman, Sid 127
gum bichromate prints **138**
gum platinum prints **138**
Gursky, Andreas 15, 19, 47, 131
 Montparnasse 11, *19*, 131

H

halftones **138–9**
handling photographs 103–5
Hawes, Josiah J. 122
Haworth-Booth, Mark 113
heat, damaging prints 106–7
Heiting, Manfred 48
heliogravures 65
heliotypes 65, **139**
Herschel, Sir John 122, 124
Hetling, Francis 99
Hill, David Octavius 122, 123
 The Reverend Mr. Thomas Henshaw
 Jones 93
Hine, Lewis W. 96, 100, 126
 Child Worker 66
historical periods, building a collection
 44–7
Hosoe, Eikoh 129
 Barakei (Killed by Roses) *114*
humidity, damaging prints 106–7
Hunt, W.M. 23, 43

I

Imprimerie Photographique, Lille 123
inkjet prints 78, 80–1, 111, **139**
inks, digital prints 80
Institute of Design, Chicago 128
insurance 117–18
intensification, restoring prints 114–15
International Museum of Photography,
 Rochester, New York 8, 128, 130
Internet 77
 buying photographs 83, 92, 94–6
 online auctions 83, 94, 95–6
 online databases 87–8
investment, photographs as 39–40, 49–57,
 70–3
iris prints 110, **139**

J

Jackson, Jane 19
Jackson, William Henry 124
Jammes, André 57, 65, 131
Jammes, Isabelle 123

Jammes, Thérèse 131
Japan, photobooks 49
Jenkins, William 130
John, Elton 131
Jones, Charles 53

K

Kassel 94
Keita, Seidou, *Untitled 82*
Keith, Dr. Thomas, *Greyfriars Churchyard,*
 Monument to John Byres of Coates 59
Kerouac, Jack 129
Kertész, André 127
 Distortion No. 40 71
King, Clarence 124
Klein, William 128
Kodak 125, 128
Koudelka, Josef, *Ireland 110*
Krauss, Hans P. Jr. 73
Krull, Germaine 127

L

Lambda prints **139**
Lamotte, Patrick 106
Land, Edwin 128
landscape photography 43
Lange, Dorothea 96, 127, 128
 Migrant Mothers, Nipomo, California
 115, 127
Langlois, Charles 123
later prints 68, 99–100, **139**
Le Gray, Gustave 18, 39, 51, 52, 57, 96, 114,
 122, 123
 La Grande Vague – Sète 7, 11, 131
Le Secq, Henri 123
Lee, Russell 127
Lehr, Janet 70
Leibovitz, Annie, *John Lennon and Yoko*
 Ono 55
Leica 126
Levinstein, Leon, *Handball Players 46*
Lévy, Gerard 39
Levy, Julien 127, 129
libraries, buying photographs from 83, 96
Library of Congress 96
Liesbrock, Heinz 131
Life 127
light damage 105–6
 colour prints 110–11
 digital prints 80
limited edition prints 59, 60, 73–7, **137**
Lipper, Susan, *Untitled 18*
London, auctions 87
London, Barbara 103
Louvre, Paris 117
Lumière, Auguste and Louis 125
Lunn, Harry Jr. 51–2

M

MacPherson, Robert 124
magazines 48
Magnum co-operative 128
mail order 83

Martin, Paul 125
Matthis, Michael 100
Maxwell, Sir James Clerk 124
May, Brian 44
Mayhew, Henry 125
Mestral, O. 123
metal frames 115
Mishima, Yukio 129
Mission Héliographique 123
modern prints 68, 70, **139**
Moholy-Nagy, László 126, 128
Monet, Claude 35
Monroe, Marilyn 129
Morgan, Barbara 128
Morgan, J.P. 126
Moriyama, Daido 129, 130
mould growths 106
mounts
 acid free 107–9
 framing prints 117
 handling photographs 105
 remounting prints 109
 window mats 113
Murray, Dr. John, *'Nynee Tal', Study with*
 Ruined House 103
museum cases 114
Museum of Modern Art (MoMA), New York
 8, 11, 110, 111, 117, 128, 129, 130, 131
museums 18, 51
 buying photographs from 96
 temperature and humidity control 106–7
Muybridge, Eadweard 125

N

Nadar 124
Naef, Weston 130
Nakahira, Takuma Untitled *98*, 129
Napoleon III, Emperor 124
National Gallery of Art, Washington, D.C.
 130
National Portrait Gallery, London 99
negatives **140**
 copy negatives 64, 65–6, **136**
 making prints 61
 original prints 64
 vintage prints 68
Nègre, Charles 65
Neue Sachlichkeit 126
New York
 auctions 87
 photo fairs 94
Newhall, Beaumont 128
newspaper photography 43–4, 48
Niépce, Isidore 121
Niépce, Joseph Nicéphore 121, 131
Nixon, Nicolas 130
Noble, David, *Butlin's Ayr, The Continental*
 Bar 89
Novak, Alex 92
nudes 43

O

oil pigment prints **140**
online auctions 83, 94, 95–6

Acknowledgements

This book is the brainchild of Basil Hyman, photography collector and businessman. When Basil began to collect some years ago, he was surprised to find that there was little published advice available to the would-be collector, and that photography dealers in Europe didn't prove a good source for general guidance. It was only when he went to New York, he recalls, that he found dealers willing to take time to help a neophyte collector such as himself gain the vital knowledge needed to collect well. Here he also discovered Lee Witkin and Barbara London's *Photograph Collector's Guide*, and several other books published during the first flush of collecting enthusiasm in the late 1970s. Invaluable as he found the Witkin and London book, it was 30 years out of date. Feeling that more people would be keen to collect photographs if a straightforward, contemporary guide were available, he set about making it happen. While we hope *Collecting Photography* will serve the whole field, buyers and sellers alike, this book is conceived as a guide for new collectors seeking knowledge to complement enthusiasm and inspiration.

Special thanks are due to the all the experts who have given their time and permission to be quoted in the book. It should be noted that their opinions have been edited from question and answer sessions. They do not by any means reflect all they have to say about the subject of collecting photography.

We would like to thank all the many people across the world of photography who have contributed to the making of this book. Particular thanks are due to W. M. Hunt (Ricco/Maresca Gallery, New York), Philippe Garner (Phillips, de Pury and Luxembourg, London), Thomas Weski (Ludwig Museum, Cologne), Helena Kovak (Focus Gallery, London), Vivian Constantinopoulos, Mike Wells, and Margaret Walters, whose support and involvement has been invaluable.

Further thanks are due to the following for their generous help: Pierre Apraxine (Gilman Paper Company Collection, New York), Roger Ballen, Richard Barclay, Jonathan Bayer, Catherine Belloy (Marian Goodman Gallery, New York), John Bennette, Hilary Bird, Rory Blain (Haunch of Venison, London), Dorothy Bohm, Sián Bonnell (Trace, Weymouth), Janet Borden (Janet Borden Inc., New York), Noël Bourcier (Patrimoine Photographique, Paris), Neil Burgess (nb pictures, London), Alison Card (Metro Pictures, New York), Zelda Cheatle (Zelda Cheatle Gallery, London), Thomas Joshua Cooper, Hamish Crooks (Magnum Photos, London), Victoria Cuthber (Matthew Marks Gallery, New York), Daniella Dangoor (Daniella Dangoor, London), Thomas Demand, Susan Derges, Rineke Dijkstra, Winston Eggleston, Elliott Erwitt, Kaspar Fleischmann (Galerie Zur Stockeregg, Zurich), Geoffrey Fraenkel & Megan Lewis (Geoffrey Fraenkel Gallery, San Francisco), Sondra Gilman, Celso Gonzalez-Falla, Paul Graham, Howard Greenberg & Nathan Anderson (Howard Greenberg Gallery, New York), Sophie Greig (White Cube, London), Maria Morris Hambourg (Metropolitan Museum of Art, New York), Mark Haworth-Booth (Victoria and Albert Museum, London), Manfred Heiting, Adam Hooper, Ian Jeffrey, Claudia Kishler (The Ansel Adams Publishing Rights Trust), Hans P. Kraus Jr. (Hans P. Kraus Jr., Inc., New York), Susan Lipper, André Magnin, Kamel Mennour (Galerie Kamel Mennour, Paris), Rupert Mole & Renata Sextro (Room for Living, London), Anthony Montoya & Anna Jaksch (Paul Strand Archive, Aperture Foundation), Martin Parr, Venita Paul (Science & Society Picture Library, London), Julie Saul (Julie Saul Gallery, New York), Michael Schmidt, Stephen Shore, Andrew Silewicz (Victoria Miro Gallery, London), Jem Southam, David and Jonathan Stevenson (Rocket Gallery, London), Hiroshi Sugimoto, Shomei Tomatsu, Jeff Wall, Helga Weckop-Conrads (Galerie Conrads, Düsseldorf), and all those collectors who wish to remain anonymous.

Collectingphotography

A book by Collecting Photography Ltd

www.collectingphotography.com

First published in the UK and USA in 2003
by Mitchell Beazley
an imprint of Octopus Publishing Group Ltd
2–4 Heron Quays
London E14 4JP

Produced by Chris Boot
Editorial co-ordination by Frédérique Dolivet
Design by SMITH

© Collecting Photography Ltd, 2003
This edition © Mitchell Beazley Ltd, 2003

A CIP catalogue record for this book is available from the British Library

ISBN 1-84000-726-5

Printed in Italy by EBS, Verona